William Blake's Theory of Art

PRINCETON ESSAYS ON THE ARTS

For a complete list of titles see page 219.

William Blake's THEORY OF ART

MORRIS EAVES

PRINCETON UNIVERSITY PRESS
PRINCETON, NEW JERSEY

Publication of this book has been aided by a grant from the Paul Mellon Fund
of Princeton University Press

This book has been composed in Linotron Caslon Old Face

Clothbound editions of Princeton University Press books are printed on
acid-free paper, and binding materials are chosen for strength and durability

Printed in the United States of America by Princeton University Press,
Princeton, New Jersey

To GEORGIA
True Friend for Life

CONTENTS

LIST OF ILLUSTRATIONS

ACKNOWLEDGMENTS

Many friends have helped teach me what I needed to know. David Bindman, Frances Carey, David Erdman, Robert Essick, and Morton Paley helped me through the stage when conversations and letters begin turning into books. John Grant and Stuart Curran gave sound advice on an early version of the section on the romantic audience. Michael Fischer, Jean Hagstrum, Marvin Morillo, and Hugh Witemeyer helped me separate the right book from the wrong one by exorcising the manuscript of false starts and phantom sentences, and by guiding me out of numerous dead ends. Meanwhile, at Arizona State University, Brown University, Louisiana State University, Mills College, Northwestern University, and Tulane University, early drafts found friendly audiences who asked prying questions about cracks in the argument. The chapter entitled "Audiences" was published in an earlier form as "Romantic Expressive Theory and Blake's Idea of the Audience" in *PMLA*, 95 (1980). In Christine K. Ivusic and Rita Gentry, Fine Arts Editor and Manuscript Editor at Princeton University Press, the book and its author found the heartening combination of support and skill that only the best editors possess. Finally, Dashiell and Obadiah Eaves are the friends who never let me forget that there may be more important things to do.

ABBREVIATIONS

anno. Blake's annotations to [Berkeley, etc.]
AR Blake's annotations to Joshua Reynolds' *Discourses on Art*
DC *A Descriptive Catalogue of Pictures*
E *The Poetry and Prose of William Blake*. Edited by David V. Erdman. 4th ed. rev. New York: Doubleday, 1970.
FZ *The Four Zoas*
J *Jerusalem*
Letters *The Letters of William Blake*. Edited by Geoffrey Keynes. Cambridge, Mass.: Harvard Univ. Press, 1968.
M *Milton*
MHH *The Marriage of Heaven and Hell*
PA *Public Address*
VLJ *A Vision of the Last Judgment*
W Sir Joshua Reynolds. *Discourses on Art*. Edited by Robert R. Wark. San Marino, Calif.: Huntington Library, 1959. Wark's copytext is the 1797 edition, edited by Edmund Malone, which Reynolds helped to prepare. Blake, however, annotated the first volume of Malone's corrected second edition, *The Works of Sir Joshua Reynolds*, 1798. I quote from Blake's copy of the first volume of the 1798 edition and note the corresponding page in Wark's edition. Thus the citation "II, 46; W 36" means "Discourse II, page 46 in the 1798 edition annotated by Blake; Wark page 36."

William Blake's Theory of Art

INTRODUCTION

I began—more than a decade ago—by trying to explain the medium that Blake calls "illuminated books" in "illuminated printing." Quickly I was out of my depth in problems of poetry, art, commerce, technology, and science. Moving against those original problems by digging deeper, I found that progress came only with simultaneous retrogression—what Blake's scientific contemporary Gauss must have experienced if he said, as reported, that he had the solution but did not yet know how he was going to arrive at it. Sailing backwards, I regressed from context to context so far that I landed where this book begins—on the shore where devouring classicisms encounter prolific romanticisms—with a goal almost too clearly set: to define Blake's idea of the artist, then of the work of art, and finally of the audience; and thus to establish with some system and documentation what had previously been established piecemeal, the rudiments, structure, and implications of Blake's artistic theory in its most informative contexts.

To achieve this goal I have drawn some boundaries. I emphasize artistic theory largely to the exclusion of practice, or perhaps I should say that I use artistic practice only to illustrate theory. The result is a predictable gain in concentration offset by a certain loss of potential richness. I have been willing to pay that price because, in my opinion, previous studies have often sacrificed some useful theoretical coherence by preferring richness to sharpness. Whatever richness there may be in the following pages comes not from the interplay of Blake's theory with his practices but from the interplay of his theory with allied and competing theories. Furthermore, even within the realm of Blake's theories about art, I have relied primarily on his direct statements rather than on the conceptual content that can be mined

from his poems and designs. Certainly, many of his poems and designs are about art in one way or another, but I believe that progress in understanding how to read his work has been so slow that we presently know little about the meaning of even *The Marriage of Heaven and Hell*, much less *Jerusalem*. My skepticism is reflected in my conservative selection of documents for this book.

I argue that Blake reestablishes Enlightenment principles on romantic grounds; that he replaces the assumptions of mimetic theory, on which the dominant Enlightenment ideas about art are based, with the assumptions of expressive theory; and that the new theory requires a redefinition of the time-honored meanings and a reorientation of the traditional relations of artist, art, and audience. I approach these meanings and relations primarily not as abstract concepts but as controlling metaphors with the power to generate plots, which, if poetic, become stories, if conceptual, become theories. I look for the coherence of such theories in metaphors arranged as trains of thought or association. Because this procedure is frequently employed in many kinds of analysis but rarely described, the reader will find my practice more conventional than my description of it. Nothing more complicated must be said than that this book was written with the idea of providing a context in which Blake's artistic ideas can reveal their coherence. What they chiefly require to make them understandable is sufficient scope.

The three parts of the argument—the discussions of artist, work, and audience—follow the logic of expressive theory outward from the artist, as a book on mimetic theory might start with nature or society. This simple framework may be rescued from the worst of conventionality and reduction by, first, my concentration on its radical aspects and, second, the pressure applied to the conceptual spaces between the three elements. Most theories of art differ, that is, not only in their conceptions of artist, art, and audience but also in their conceptions of the relations among them, as revealed in the form of key metaphors. While the elements almost never occur outside their relations, elements and relations have to be separated analytically in order to be clearly defined. Commentators who confuse metaphors of identity with metaphors of transaction inevitably fail at explaining theories of art such as Blake's.

As for key metaphors, one finds them by systematically ig-

noring the sound presumption of the artist James Barry, "that reasonable men look for nothing further than mere information in the writings of artists." But of course an isolated metaphor, no matter how potentially significant, does not want to show its significance out of context, which is to say, out of action. The primary context is usually a counter metaphor from an opposing theory. Played out in theory and practice, the dialectic of metaphor and counter metaphor becomes one dynamic component in the history of the arts. When discussing an artist's place in the history, critics customarily look to the past and the present rather than to the future. But I have often found it clarifying to consider not only Enlightenment classicism, and English romanticism, but also the fin de siècle and the modern period. It seemed useful, for example, when discussing phases of decorum, to define Blake's attitude and its implications by surrounding them with alternative possibilities from twentieth-century screenwriters as well as eighteenth-century artists.

While my chief aim has been to explain Blake's artistic theory by putting it into significant contexts, I have also tried occasionally to clarify the contexts by putting Blake into them. For someone making that attempt, at least two features of his ideas about art are especially advantageous. His unusual access to esthetic traditions is a major advantage that has been, however, a persistent source of confusion as well. The issues he raises are typically those raised by the history of painting and printmaking rather than by the history of literature, and the basic metaphors of his theory come from the visual arts. A reader coming to Blake from his poetry will have more difficulty figuring out Blake's objections to generalization than someone who thinks of it as Blake did: as a blurred line unable to decide its own identity. The complication is that Blake, who did not think of his principles as visual rather than literary, applied them to both arts and implicitly to all arts. Because art historians have a clear view of one aspect of the history behind Blake's theory, they have tended to conclude that the theory is simpler than it is. Because literary historians see it in a distorted context, they have tended to conclude that it is more bizarre than it is, or no proper theory at all but some kind of "apocalyptic humanism" that "can hardly be pressed into literary or even general aesthetic service." Since in this view Blake is more gnostic than artist, he "connects less with the literary tradition than with cabbalistic and visionary

theories of knowledge."[1] I attempt to show the way to the broader view that Blake, although working most of the time with critical oppositions from the history of art, creates an expressive theory that brings him finally into the orbit of English romanticism.

Blake's second advantage has to do with my approach, which is to scrutinize the root metaphors in the theory. Blake is able to clarify certain ideas because he tends to mold definitions in the form of metaphors of identity. As I point out in one of the chapters below, if the subject is imagination, Coleridge prefers the grammar of process that tells what the imagination does, Blake the grammar of identity that tells what the imagination is. Root metaphors are radical by definition, and Blake is thus essential to any account of romantic expressive theory that aims to formulate sine qua non theoretical extremes rather than eclectic moderate positions. In defining those extremes here, I am aware that I select from other poets and painters only what fits the context provided by Blake and that a more complex description of their views is possible. My aim is to follow one line of thought to its terminal point.

Toward the same end, I sometimes simplify in other ways. I use terms such as "romanticism" and "Enlightenment" and even names such as "Reynolds" and "Blake" as shorthand expressions. I occasionally treat important intellectual currents as if they were the entire stream with all its tributaries, and treat the most visible profile of some important ideas as if they could be interpreted from no other angle than mine. No one who reads this book must be told that there are other ways to see Joshua Reynolds (or Wordsworth, or Titian) than as Blake saw him. Yet I see no critical advantage in attempting to explain one of the great pugilists of intellectual history by appointing myself referee. On some of the ideas discussed, I have no opinion whatever; on others, I disagree with Blake; and on others, I agree with him heartily. But filtering Blake's ideas and opinions through my own would obscure rather than clarify the matters of most importance. Since the success of the effort actually depends more upon the separation of myself from Blake than upon the opposite, I trust that no reader will confuse real agreement with the empathic rhetoric demanded by critical pragmatism. By holding

[1] W. K. Wimsatt, Jr. and Cleanth Brooks, *Literary Criticism: A Short History* (New York: Random House, 1957), p. 424.

myself strictly to the task of explaining Blake's ideas about art—
regarding them from his own point of view, even to the extent
of taking Blake at his own estimation—I have intended to put
readers in a better position to restore, by their own lights rather
than mine, the balance and objectivity that they may feel is miss-
ing from Blake's account.

I.

Artists

ARTISTS IDENTIFYING THEMSELVES

Line: the locus of a point having one degree of freedom

Even the copy from Raphael's Cartoon of St. Paul preaching, is a firm, determinate outline. —Blake, on the drawings of Thomas Malkin (E 671)

A firm and determined outline is one of the characteristics of the great style of painting. —Joshua Reynolds, *Discourses on Art* (III, 75; W 52)

Blake . . . created the last Enlightenment style to emerge in English poetry . . . a man of genius, but also something of a crackpot. Formally, neither his poetry nor his painting have much of the truly innovative about them. They are still, though for the most part created well within the nineteenth century, controlled by decisions derived from Enlightenment values. —Morse Peckham, *Man's Rage for Chaos*

Classical Outline and Romantic Identity

Although Blake's love of the line ranks with his hatred of generalization and his promotion of nudity as one of his most frequently discussed esthetic affections, his noisy advocacy of the "bounding line" and its inevitable companion, the "minute particular," has not been placed firmly in its contexts. While all who read Blake recognize that his idea of line is a key artistic principle, all who get beyond Blake's own statements discover immediately that he is only one of many artists who favor line and drawing over the painterly elements of tone and color. This discovery has occasionally lent force to the accusation that only Blake's stubbornness blinds him to the similarities between his

own principles and, for instance, Reynolds', which also favor line: "For though the painter is to overlook the accidental discriminations of nature, he is to exhibit distinctly, and with precision, the general forms of things. A firm and determined outline is one of the characteristics of the great style of painting; and let me add, that he who possesses the knowledge of the exact form which every part of nature ought to have, will be fond of expressing that knowledge with correctness and precision in all his works" (III, 74-75; W 52). Sometimes Blake's advocacy of line is used to associate him with the Greek revival promoted by British neoclassicism in the visual arts, especially the work in pure outline by George Cumberland and John Flaxman, friends of Blake. And finally, since the line and drawing are conventionally associated with academic art and classical esthetics—both associated in turn with Enlightenment notions of art—Blake's attitude toward line may seem to strengthen Morse Peckham's broad claim that Blake is not a "truly innovative" romantic poet or artist but a late Enlightenment reactionary whose work is "controlled by decisions derived from Enlightenment values."[1]

The question, then, is whether Blake's idea of artistic line helps make him the exponent of a "vitalized classicism," as Northrop Frye once said.[2] Does the advocacy of line reinforce David Bindman's "growing personal conviction, that Blake's attitudes toward art are in a profound sense eighteenth century in spirit, and are predominantly determined even to the end of his career by classical idealism"?[3] Despite apparent affinities, the answer is no. Nor, in this instance, is "classical idealism" a phrase to trust, because it is used, with "Platonism," as an umbrella to shelter Blake and Reynolds and thus to bring us back again to the charge that a less obstinate Blake would notice that Reynolds is, in significant respects, a theoretical ally. On the whole it is considerably closer to the truth to say that Blake reestablishes certain Enlightenment values on romantic grounds. Such shifts make him a puzzle to critics who try to see him as part of neoclassicism in the visual arts or of Wordsworthian

[1] Morse Peckham, *Man's Rage for Chaos: Biology, Behavior, and the Arts* (Philadelphia: Chilton, 1965), p. 290.
[2] "Blake after Two Centuries," *Fables of Identity: Studies in Poetic Mythology* (New York: Harcourt, 1963), p. 145.
[3] "Blake's Theory and Practice of Imitation," *Blake in His Time*, ed. Robert N. Essick and Donald Pearce (Bloomington: Indiana Univ. Press, 1978), p. 98.

romanticism in literature. The puzzles begin to disappear when we align the basic tenets of Blake's artistic theory in their right relation to each other and to their ideological allies and antagonists.

THE CONTOUR OF TRUTH

First, at its most superficial the argument about the primacy of line over color is an argument about the audience for art. Line is considered the more difficult to appreciate but closer to something like the truth, whereas color is considered immediately interesting and captivating, as here, in Hume's *Notices of the Life and Works of Titian* (1829):

The Editor of the Tuscan edition of Vasari, page 19 of the Life of Titian, in observing on the difference between the Roman and Venetian schools, and considering whether the palm should be bestowed on fine colouring and *la bella maniera*, in preference to correctness of outline, gives it as his opinion, that a well coloured picture, though indifferently drawn, would find readier purchasers, than such as are faultless in that respect, but feebly and ordinarily coloured. It cannot be denied that there is a sort of enchantment in colour, similar to harmony in music, which diffuses a delightful sensation over the mind, and to which the Dutch school is indebted for a large share of that popularity which attaches to the works of Rembrandt, Cuyp, Ostade, Gerard Dow, Maas, de Hooge, &c.[4]

Thus line is for an intelligent and educated elite that prefers the unvarnished truth, whereas color has the sort of popular appeal that can sell a picture. At its crudest this opposition of Poussinistes and Rubenistes is a marketing consideration, snob versus mob. One step higher, the debate is over superior and inferior representations of reality and parallels an argument I recall Dwight Macdonald making several years ago for the superiority of black-and-white cinema over color on the grounds that black, white, and gray in a theater somehow look more like the real world than the colors of the real world do—though of course masscult enthusiasms will generate commercial pressures to drive filmmakers away from stern reality toward gaudy dreams.

Macdonald's position is a late cinematic variation on a stand-

[4] Sir A. Hume, *Notices of the Life and Works of Titian* (London, 1829), p. 124.

ard argument against color in painting that was already old,
though still a favorite, in Blake's time. The argument aligns
color (as the language of the senses) against line (as the language
of the intellect) in an opposition that conveniently accommodates
one of the great abiding doctrines of Western intellectual his-
tory: the intellect must preside over senses that are otherwise
wayward and dangerous. Since the traditional carriers of the
doctrine are sexual metaphors, most writers who broach the sub-
ject move quickly to picture the senses as at best a vulnerable
female needing the guidance and protection of male reason, at
worst a whore seducing customers in the dark. Like a preacher
with a drowsy congregation, Fuseli ornaments his Academy lec-
tures on color in painting with some colorful play on this met-
aphorical logic, turning his dull subject into a sexual fable pro-
tected by conventional moralizing. He warns his audience against
"the debaucheries of colour and blind submission to fascinating
tints."[5] Design, not color, is the basis of the highest forms of
painting, which address the senses as a means only to "reach the
intellect and heart," while lesser kinds of painting are the
"handmaid" of the senses "to charm their organs for their
amusement only." Color is the basis of those lesser kinds: "When
they [artists] stoop to be the mere playthings, or debase them-
selves to be the debauchers of the senses, they make *colour* their
insidious foundation."[6] Where do such artists and their audi-
ences live and thrive? Since the painterly traditions born in Sodom
and Gomorrah died traceless with them, the answer is clear:

The third, or ornamental style, could scarcely arise in any other state
of Italy than Venice. Venice was the centre of commerce, the reposi-
tory of the riches of the globe, the splendid toy-shop of the time; its
chief inhabitants princely merchants, or a patrician race elevated to
rank by accumulations from trade or naval prowess; the bulk of the
people mechanics or artisans, administering the means, and, in their
turn, fed by the produce of luxury. Of such a system, what could the
art be more than the parasite? . . . Such was, such will always be the
birthplace and the theatre of colour.[7]

[5] James Barry, John Opie, and Henry Fuseli, *Lectures on Painting, by the Royal
Academicians: Barry, Opie, and Fuseli*, ed. Ralph N. Wornum (London: Bohn,
1848), p. 520.
 [6] *Lectures on Painting*, ed. Wornum, pp. 503-04.
 [7] *Lectures on Painting*, ed. Wornum, p. 519.

The carnal appetites of the Venetians are usually contrasted either with the spiritual hunger of the Renaissance Romans, fed by Michelangelo, or, especially, with the intellectual hunger of the ancient Greeks. The rationale for the neoclassical admiration of ancient Greek art uses the standard linearist argument in one of its most emphatic forms, as here in Winckelmann, translated by Fuseli: "But even supposing that the imitation of Nature could supply all the artist wants, she never could bestow the precision of Contour, that characteristic distinction of the ancients."[8] Neoclassicism asks the genetic question—what is the origin of line?—and answers with a strong dichotomy between mind and matter, intellect and nature. The imitation of nature cannot supply precision of contour because nature herself lacks contour. Although Blake agrees that lines are absent from nature—"Nature has no Outline" (*The Ghost of Abel*; E 268)—the doctrine is not his own invention but a commonplace of which Wordsworth is offering a modified version when he condemns Macpherson's imagery as "spurious" on the grounds that "in nature every thing is distinct, yet nothing defined into absolute independent singleness."[9] Precision of contour is thus not natural but intellectual, and who was more intellectual than the Greeks? This is the usual association in neoclassical theory.

When the primacy of line over color takes its place as an orthodox doctrine of the European academies of art,[10] which

[8] Abbé J. J. Winckelmann, *Reflections on the Painting and Sculpture of the Greeks: With Instructions for the Connoisseur, and An Essay on Grace in Works of Art*, trans. Henry Fuseli (London, 1765), p. 22.

[9] Essay, Supplementary to the Preface of 1815, *The Prose Works of William Wordsworth*, ed. W.J.B. Owen and Jane Worthington Smyser (Oxford: Clarendon, 1974), III, 77. Blake annotates this passage; see E 655.

[10] The academic position on line has occasionally been mentioned in connection with Blake. David Bindman, *Blake as an Artist* (Oxford: Phaidon, 1977), sees an eclecticism in Blake's styles of the late 1790s that Bindman relates to a broader "shift in taste towards the Venetians [that] began to occur [in England] in the 1790s, and the rigid division made by academic writers between the intellectualism of the Florentines and the sensuality of the Venetians was modified for many artists by close experience of the Venetians' artful use of colour." Bindman's point is that "Were it not for Blake's later dogmatic rejection of Venetian and Northern art, there would be nothing unexpected in his eclecticism" in the 1790s (p. 127). As for that "later dogmatic rejection," Martin Butlin writes that "Blake agreed with much that Reynolds said. . . . What he attacked were Reynolds' deviations from strict academic doctrine" (*William Blake* [London: Tate Gallery, 1978], p. 16).

associate drawing with permanent daytime realities and coloring with fleeting impressions, the old opposition between the intellect and the senses is reinforced and modernized by the empirical analysis of matter into primary and secondary "qualities." The estheticians of academic classicism indebt themselves heavily to the scientists and philosophers in the tradition of Galileo, Bacon, Locke, and Newton. Thus, in one of his lectures at the Royal Academy, James Barry calls drawing "the highest and most comprehensive mechanic excellence of the art" and asserts its primacy: "Drawing has always been considered as the necessary foundation of painting, without which it is but a mere confused daubing of colours." But this commonplace doctrine (John Opie repeats the sentiment in his own lecture on design) is based firmly on nature and the scientific attitude toward it. Opie directs his audience: Take "those laws of gravity, by which only all bodies can be sustained in whatever action and motion by the necessary regulation of an equilibrium in their parts"; add "the perspective appearance of this proportionate arrangement of figure, as viewed from one point only." "This is called *drawing*."[11]

For the academicians, drawing is primary because the qualities it best represents—mathematical qualities of extension, motion, rest, and so on—are primary. The reasons that make color secondary in the scientific theory make it secondary in the esthetic theory as well: color is a sensory quality associated with mere appearances and subjective impressions.[12] Drawing thus becomes the artistic counterpart of scientific techniques of measurement. Art should imitate nature by imitating the picture of the external world envisioned by science; scientific principles thus vouch for the soundness of esthetic principles, scientific facts for esthetic facts. At this phase the traditional theory of line

[11] *Lectures on Painting*, ed. Wornum, p. 119 (Barry, from his lecture on design), p. 249 (Opie, from his lecture on design).

[12] Or, in Lewis Mumford's words, "What the physical sciences call the world is not the total object of common human experience: it is just those aspects of this experience that lend themselves to accurate factual observation and to generalized statements. . . . In other words, physical science confined itself to the so-called primary qualities: the secondary qualities are spurned as subjective"; he documents this conclusion with a long and fascinating quotation from Galileo. *Technics and Civilization* (1934; rpt. with new intro., New York: Harcourt, 1963), pp. 46-47, 48.

yields its motto: the line of intellect reveals the scientific truth underneath natural appearances.

THE COLOR OF BEAUTY

Retreating from the hard and fast opposition between line and color, moving toward moderate compromises, we hear Anthony Pasquin (a pseudonym for John Williams), in a review of the Royal Academy exhibition of 1796, criticize Joseph Farington: "He will so pertinaciously continue to make a harsh outline, to the most delicate parts of vegetation."[13] Pasquin's position, which is easily mistaken for an outright rejection of line, is rather a moderate adjustment of severe classicist doctrine. His criticism is motivated by an unspoken fear that the strong line of unbridled Enlightenment classicism has the power to turn paintings into cold science lessons. His remedy lies in changing the standard of accuracy from a scientific truth beyond immediate appearances (as in an analysis of matter into qualities) to the appearances themselves. The standard implied in Pasquin's criticism of Farington is a close relative of the one defined in Matthew Pilkington's *Dictionary of Painters* (1770-1805): "OUTLINE, is that which traces the circumference of objects in a picture. The outline is to be drawn as thin and fine as possible, so as scarcely to be discerned by the eye; and it ought to be observed, that a correct outline may excite pleasure, even without any colouring, but no colouring can afford equal satisfaction to a judicious eye, if the outline be incorrect; for, no composition, no colouring, can merit praise, where the outline is defective."[14] Pilkington thus keeps art on the side of truth by confirming the idea that "no composition, no colouring, can merit praise, where the outline is defective" but keeps truth true to appearances by calling for an "outline . . . thin and fine . . . so as scarcely to be discerned."

Pilkington's favorable definition of outline is part of a theoretical orientation that is subjective in emphasizing not truth to nature as it is, nor the artist's rational mind as an instrument

[13] Pasquin, "A Critical Guide to the Exhibition of the Royal Academy, for 1796. . ." (London, 1796), p. 11.

[14] *A Dictionary of Painters from the Revival of Art to the Present Period*, rev. ed., ed. Henry Fuseli (London, 1805), pp. xix-xx. The first edition was published in 1770.

for depicting that truth, but the perception of nature by human observers (who may be artists, audiences, or both). According to Pilkington, the painting aims to "excite pleasure" (in a spectator) and to "afford . . . satisfaction to a judicious eye" (of a spectator). To accomplish that aim, a "correct outline"—"correct" here meaning true to the appearances of nature as we perceive it—becomes part of an artistic effort to bring the truth about nature and the appearance of nature into alignment as two aspects of a single thing, thus exciting pleasure in the spectator's "judicious" eyes. Judicious eyes are not the hungry, heat-seeking organs of Fuseli's Venetian merchants but socialized receptors trained to sense the natural appearances arising from the conjunction of natural truth and commonsense perception. In his *Theory of Painting* (1725), Jonathan Richardson explains the place of color in painting by comparing the artist's eye to the musician's ear: "He that would be a good colourist must [have] a good eye in the sense, as one is said to have a good ear for music" because "Colours are to the eye what sounds are to the ear, tastes to the palate, or any other objects of our senses are to those senses." Thus the conjunction of color and line adds truth to the imitation of nature and pleasure to the experience of the spectator: "Good colouring therefore in a picture is of consequence, not only as it is a truer representation of nature . . . but as administering a considerable degree of pleasure to the sense."[15]

On this subjective side of the eighteenth-century argument over line and color, the term that modifies natural appearances for art is not science (epistemology, psychology, or optics) but beauty, so that "imitation of nature" means imitation of beautiful nature. Perceptual consensus, imitated through the skills of the artist, is the source of physical beauty associated with the senses and with pleasure, but always the kind of pleasure that arises from truth. Therefore truth—outline—is not eliminated; the threshold is lowered to its commonsense level. Pasquin's complaint about the harsh outlines around Farington's delicate vegetation assumes that, because delicate vegetation does not have harsh outlines when observed in nature, harsh outlines are not beautiful in paintings. The motto of this moderate theoretical

[15] Jonathan Richardson, *The Theory of Painting*, in *The Works of Jonathan Richardson*, ed. Horace Walpole (London, 1792), pp. 67, 65.

phase—line reconciled with color yields truth reconciled with appearance—praises truthful beauty.

If, on the scale that slides from line at one end to color at the other, we move from the reconciling middle toward irreconcilable opposition at the pole where the primacy of color replaces line, Joseph Strutt, author of *A Biographical Dictionary . . . of All the Engravers* (1785-86), can be overheard attacking the engraving style of Dürer, whose heavy outlines Strutt characterizes with the standard pejoratives "stiff" and "Gothic." He concludes that "it is evident, at least to me, that exact lines of any kind, even if they be drawn in the serpentine form [i.e., the S-curve of Hogarth's "line of beauty"], cannot give the perfect expression of beauty and elegance."[16] Lines—"*exact* lines of *any* kind"—cannot express natural beauty because nature, the standard of beauty, has no outline.

Strutt anticipates Delacroix. Strutt's objections to line eventually serve as the basis of the simplest form of the romantic revolt against academic classicism. Delacroix asks his rhetorical question: "I am at my window, and I see the most beautiful landscape: the idea of a line does not come to my mind. The lark sings, the river sparkles with a thousand diamonds, the foliage murmurs; where are any lines to produce these charming sensations?"[17] This is conventional antiacademicism. Delacroix speaks of "charming sensations" just as Hume's book on Titian imagines "enchantment in colour . . . which diffuses a delightful sensation over the mind" and just as Fuseli pictures color most memorably as the "handmaid" who "charms . . . organs." Nature is the same person she has always been, color and tone without line. Delacroix's rebellious posturing depends on the simple Byronic technique of retaining the conventional terms of an argument while rejecting the conventional morality that accompanies them. Delacroix thus puts the academy in the position of tedious moralizer and himself in the position of frank romantic sensualist who will go for the charming sensations of his

[16] *A Biographical Dictionary Containing an Historical Account of All the Engravers from the Earliest Period of the Art of Engraving to the Present Time*, 1 (London, 1785), 19-20.

[17] Quoted in W.J.T. Mitchell, "Style as Epistemology: Blake and the Movement toward Abstraction in Romantic Art," *Studies in Romanticism*, 16 (Spring 1977), 154. Mitchell does not discuss the conventional basis of Delacroix's antiacademic position.

hostess, nature. She is the same woman, but he makes the new promise to take her as she is. Because color produces sensation directly, color revitalizes mimesis by making possible a more direct imitation of nature than the academic line can achieve. At such a radical phase, which asserts its faith in natural appearances and in the power of tone and color alone to yield them, line is merely sensation processed by intellect and oppressed by concept.

THE LINEAMENTS OF IMAGINATION

The following chart summarizes the metaphors of line and color that have surfaced in the discussion so far by offering them as answers to parallel questions about identity: Who is line? and Who is color? The controlling metaphor of the chart is therefore human, the organization dialectical, and the point of view linearist.

	Who is line?	*Who is color?*
sex:	male	female
organ:	head, brain	heart, genitals
faculty:	intellect	senses
activity:	reasoning	feeling
weight:	heavy	light
density:	high (concentrated)	low (diffuse)
biological status:	host	parasite
arts:	philosophy, history, science	drama, music, oratory
music:	melody	harmony
artistic school:	classical	modern
social class:	patrician	plebian
habitation:	Greece, Rome, Florence, the church that enlightens a community of truth-seekers	Flanders, Holland, Venice, the theater that entertains a center of commerce
communal form:	symposium in debate	sexual couple in copulation
ethical propensity:	virtue	vice

goal:	imitation of truth, discovery, enlightenment	imitation of appearance, entertainment, seduction, enchantment

For all its redundant and reductive categories, even this hasty anatomy reveals at least several pairs of metaphors that Blake shares with the standard argument, along with several others that he does not. We can begin with the essential points of agreement and move outward into more characteristic Blakean territory. Blake has been placed correctly in art history, with the two-dimensional linearists. Although he joins the linearists by employing the conventional association between line and intellect, his linearism is romanticized by his internalization of the world of ideas said to produce line and his replacement of reason as a measure of intellect with imagination. Imagination, envisioned as a person rather than a mental faculty or process, organizes personal identity and, through identity, organizes the work of art. The recovery by personal identity of the projections of imagination makes way for the transformation of the beautiful and the good into attributes of identity.

In art history Blake has been placed on the side of the two-dimensional linearists in the old esthetic battle between linear and painterly schools.[18] The fundamental artistic act is thus making a line, drawing: "He who Draws best must be the best Artist" (*PA*; E 571). Everything else is more or less superfluous—reinforcement at best, at worst a disguise for inept drawing:

[18] See Nikolaus Pevsner, "Blake and the Flaming Line," chapter 5 of *The Englishness of English Art* (New York: Praeger, 1956), pp. 117-46; chapter 4 of Robert Rosenblum, "The International Style of 1800: A Study in Linear Abstraction" (Doctoral Diss., New York Univ., Institute of Fine Arts, 1956); and Rosenblum's *Transformations in Late Eighteenth-Century Art* (Princeton: Princeton Univ. Press, 1967), pp. 154-59, 189-91. Also relevant are the positions taken by W.J.T. Mitchell, "Blake's Composite Art," and Jean Hagstrum, "Blake and the Sister-Arts Tradition," in *Blake's Visionary Forms Dramatic*, ed. David V. Erdman and John E. Grant (Princeton: Princeton Univ. Press, 1970), pp. 57-81, 82-91, a discussion followed up by Mitchell in the opening sections of *Blake's Composite Art: A Study of the Illuminated Poetry* (Princeton: Princeton Univ. Press, 1978). The most recent assessments have been made by David Bindman, *Blake as an Artist* (Oxford: Phaidon, 1977); Robert N. Essick, *William Blake, Printmaker* (Princeton: Princeton Univ. Press, 1980); and Morton D. Paley, *William Blake* (Oxford: Phaidon, 1978).

"The great and golden rule of art, as well as of life, is this: That the more distinct, sharp, and wiry the bounding line, the more perfect the work of art; and the less keen and sharp, the greater is the evidence of weak imitation, plagiarism, and bungling" (*DC*; E 540).

Blake joins this traditional battle by employing the conventional association between line and intellect. Lines are "receptacles of intellect" (*DC*; E 535). The polemical opposition between a sound intellect favoring line and an unsound one favoring color follows naturally. The people who call for color are like monkeys: "What kind of Intellects must he have who sees only the Colours of things & not the Forms of Things" (*PA*; E 567).

The line, then, carries the weight of Blake's version of the traditional intellectual and artistic values of clarity, precision, and simplicity, as opposed to the shapes given those values by the Enlightenment idea of truth to nature. "Clearness and precision have been the chief objects in painting these Pictures. Clear colours unmudded by oil, and firm and determinate lineaments unbroken by shadows, which ought to display and not to hide form" (*DC*; E 521). As a metaphor, the line in art is part of a family with members in history, philosophy, and science, such as metaphors of accuracy and precision ("definition," for instance) as distinguished, perhaps, from metaphors of intensity and profundity. Metaphors of precision have very close relatives, too, in teleological metaphors of ultimate truth, of final distinctions, in Christian theology. A universal man—a man who is the universe, such as the figure of Christ who appears at the beginning of Revelation as a conglomerate of divinity-humanity-animal-vegetable-mineral—carries out the Last Judgment with a two-edged sword as his organ of discourse, discourse consisting mainly, I suppose, of sharp distinctions of the sort that Blake, soaring as he shows how many uses he can think of for his metaphor, describes as follows:

How do we distinguish the oak from the beech, the horse from the ox, but by the bounding outline? How do we distinguish one face or countenance from another, but by the bounding line and its infinite inflexions and movements? What is it that builds a house and plants a garden, but the definite and determinate? What is it that distinguishes honesty from knavery, but the hard and wiry line of rectitude and certainty in the actions and intentions. Leave out this line and you leave out life itself; all is chaos again, and the line of the almighty

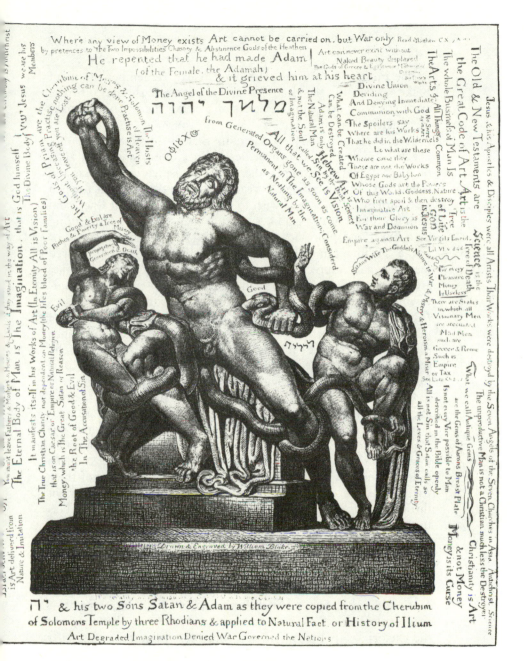

1. William Blake, *Laocoön* (ca. 1820), 26.2 × 21.6 cm., engraving.

must be drawn out upon it before man or beast can exist. (*DC*; E 540)

At the most general level, the point worth remembering about Blake's idea of the line in art is that it is the ultimate artistic act, an act with overtones of seeking the truth and making final judgments.

It is a cliché of art criticism in Blake's time that lines are "heavy," and the criticism of heavy lines often reflects an anti-intellectual fear of meaning and a strong suspicion that ideas and beauty do not mix. Blake is reacting to the commonplace when he complains, "Moderns wish to draw figures without lines, and with great and heavy shadows; are not shadows more unmeaning than lines, and more heavy?" (*DC*; E 532). In the language of art, a shadow can only be a blurred line carrying a blurred meaning, and imprecision cannot be lighter than precision. Lines are never harsh or heavy; shadows are heavy, mechanical uniformity is heavy ("An Even Tint . . . produces Heaviness," *PA*; E 564), while the "bounding line" is athletic in its "infinite inflexions and movements" (*DC*; E 540). Shadows are lines gone soft, and in true art there is no softness, as in true philosophy there are no undefined terms; or, put another way, art like philosophy seeks definition, and mystery is the spectre of both.

Characterizing the line as intellectual is not sufficient, however, to distinguish Blake from the ancient Greeks or from neoclassical artists and commentators like George Cumberland, author of *Thoughts on Outline* (1796), and Flaxman, whose devotion to classical outline is memorialized in his outline drawings. Blake did some engraving for both projects, and he seems one of their party when he comments in a letter to Cumberland, "Do not throw aside for any long time the honour intended you by Nature to revive the Greek workmanship. I study your outlines as usual, just as if they were antiques" (26 August 1799, *Letters*, p. 32); or when, in a letter to Dr. Trusler around the same time, he claims that "the purpose for which alone I live . . . is . . . to renew the lost Art of the Greeks" (16 August 1799, *Letters*, p. 27). Some critics have read such declarations as if they come from Blake's heart; I strongly suspect that they are the rhetoric of polite diplomacy with built-in ambiguities.[19] At

[19] Bindman (*Blake as an Artist*), Paley (*William Blake*, and earlier in "The Truchsessian Gallery Revisited," *Studies in Romanticism*, 16 [1977], 165-77),

any rate, finally—even if not until a decade later—Blake's version of the intellectual line profoundly alters classical and neoclassical versions in a direction that can only be called romantic. The remainder of this chapter shows how he incorporates intellect and line into an expressive theory of art, opposed at all essential points to classical and neoclassical mimesis.

Blake internalizes the world of ideas of which the line is supposed to be a product, altering the Platonic metaphor that allows Platonism to blend easily with traditional Judaism and Christianity by giving ideas their ultimate home as forms in some external realm. The older he gets the more clearly Blake sees the implications of ideas about the human and the divine that appear in his work at least as early as *There is No Natural Religion* and *All Religions are One* (ca. 1788). *The Marriage of Heaven and Hell* (ca. 1790-93) develops closely related ideas at greater length. Everyone notices the prominence of heaven and hell, angels and devils, in *The Marriage*, but when angels and devils argue, their real theme is God, who is indeed the real theme and central character of *The Marriage*, though he is for the most part *deus absconditus*. A missing God at the center of *The Marriage*, in fact, largely accounts for its odd structure, which is a series of apparently disconnected episodes tied less to each other than to the invisible God at the center. The essential questions that *The Marriage* raises are who is God and where does he live? Plate 11, the story of the ancient poets and the priesthood, the decline from true poetry to religion, is the center of the plot. Its theme is remarkably common in romantic literature, and the story told in plate 11 is repeated many times—for example, by Shelley in his *Defence*: "At a certain period after the prevalence of a system of opinions founded upon those promulgated by him, the three forms into which Plato had dis-

and Essick (*William Blake, Printmaker*) have in various ways suggested recently that during the period ca. 1795-1805 Blake's artistic principles changed, and that various colorist and chiaroscurist experiments indicate an important deviation from his loyalty to artistic line. Essick, for instance, puts Blake's color-printing experiments of the mid-1790s in this phase (pp. 147-51). Though there is no question that about 1809 Blake felt that he was rediscovering something that he had known all along, I believe that the deviation is exaggerated. Blake's color printing—to take only one example—does not violate his idea of line as I understand it. Moreover, Blake's supposed devotion to renewing Greek art around 1799 would tend to contradict any colorist and chiaroscurist tendencies in his art during the same period.

tributed the faculties of mind underwent a sort of apotheosis, and became the object of the worship of the civilized world."[20] Shelley later identifies the faculties of mind as Hell, Purgatory, and Paradise.[21] Plato is certainly not one of Blake's ancient poets. He is well on his way to becoming a priest, even if he worships only ideas. But Shelley and Blake's historical formulations and the lessons drawn from them are similar: "These [Greek] Gods," Blake says, "are visions of the eternal attributes, or divine names, which, when erected into gods, become destructive to humanity. . . . They ought to be made to sacrifice to Man, and not man . . . to them" (*DC*; E 527). Blake's conclusion could appear in Shelley's *Defence* as well as in *The Marriage*: "Thus men forgot that All deities reside in the human breast" (*MHH* pl. 11; E 37).

Everything that Blake knows about the same ideas three decades later he squeezes into the aphorisms of the engraved Laocoön (ca. 1820), one of the most extreme and unqualified statements ever written of the premises of romantic humanism, in which humanity is the center and circumference of everything, and its measure is imagination (Figure 1). The basic strategy is what Northrop Frye has called the romantic "recovery of projection," radical internalization,[22] the necessary result of which

[20] *A Defence of Poetry*, in *Shelley's Critical Prose*, ed. Bruce R. McElderry, Jr. (Lincoln: Univ. of Nebraska Press, 1967), p. 21.

[21] *Shelley's Critical Prose*, ed. McElderry, p. 23.

[22] The "recovery of projection" is Frye's phrase and the theme of his essays on English romanticism, especially "The Drunken Boat: The Revolutionary Element in Romanticism," *Romanticism Reconsidered: Selected Papers from the English Institute*, ed. Frye (New York: Columbia Univ. Press, 1963), pp. 1-25; expanded later as "The Romantic Myth," in Frye, *A Study of English Romanticism* (New York: Random House, 1968), pp. 3-49. "Internalization" is the term adopted by Harold Bloom in, for example, his essay "The Internalization of Quest-Romance," *Romanticism and Consciousness: Essays in Criticism*, ed. Bloom (New York: Norton, 1970), pp. 3-24; and by M. H. Abrams, *Natural Supernaturalism: Tradition and Revolution in Romantic Literature* (New York: Norton, 1971). Morse Peckham has discussed similar changes in all versions of, and additions to, his theory of romanticism, beginning with "Toward a Theory of Romanticism," *PMLA*, 66 (1951), 5-23. Michael G. Cooke's "universality" and "inclusion" are terms strongly allied with "internalization" and the "recovery of projection"; *Acts of Inclusion: Studies Bearing on an Elementary Theory of Romanticism* (New Haven: Yale Univ. Press, 1979). The extent to which romantic internalization is taken into account may profoundly affect the interpretation of romantic manifestoes. A good example is Earl R. Wasserman's "Shelley's Last Poetics: A Reconsideration," *From Sensibility to Romanticism: Essays Presented to Frederick A. Pottle*, ed.

is a series of identifications that draw the cultural projections of imagination back into the mind from external heavens and hells:

> The Eternal Body of Man is The IMAGINATION.
> God himself
> that is [Yeshua] JESUS we are his Members
> The Divine Body
> It manifests itself in his Works of Art (In Eternity All is Vision)
> All that we See is VISION from Generated Organs gone as soon as
> come
> Permanent in The Imagination; considered as Nothing by the
> NATURAL MAN (E 271)

Blake replaces reason as a measure of intellect with imagination and attributes line to it, eliminating the logical, and especially the mathematical, associations of Grecian line. "Nature has no Outline": thus far Blake repeats the commonplace. "But Imagination has" (*The Ghost of Abel*; E 268): the commonplace acquires a romantic shape. These transformations are characteristic of Blake, and they must be followed closely. Such an aphoristic invention as "the clearer the organ the more distinct the object" (*DC*; E 532) is easily misapplied to everyday eyes and natural objects, as if it were a version of Wordsworth's epitome of "the eye of the Poet . . . steadily fixed upon his object," a romantic admonition that has given several postromantic generations of writers something to say to their apprentices. "A blind man," Wordsworth continues, "might easily depict these appearances with more truth."[23] The mimetic strain in romantic literature usually fits here, measuring truth by natural appearances, as exemplified by Wordsworth's statement that "the appropriate business of poetry . . . is to treat of things not as they *are*, but as they *appear*: not as they exist in themselves, but as they *seem* to exist to the *senses*, and to the *passions*." He is distinguishing the business of poetry from the business of science and claiming that if poetry accomplishes this duty, it is "as permanent as pure science."[24] But poetry (of this kind) and pure sci-

Frederick W. Hilles and Harold Bloom (London: Oxford Univ. Press, 1965), pp. 487-511. Wasserman argues that Shelley's "Platonism" in the *Defence* is put in the service of internalization (or, as Wasserman calls it, "intuition").

[23] Essay, Supplementary to the Preface of 1815, *Prose Works*, ed. Owen and Smyser, III, 73.

[24] Essay, Supplementary to the Preface of 1815, *Prose Works*, ed. Owen and Smyser, III, 63.

ence are equally permanent, and equally objective, in the extent
to which they may be based on scientific methods, evidence, or
conclusions, as shown by nineteenth-century artistic movements
involving Turner, Ruskin, the impressionists, and the literary
realists and naturalists, among many others. All that changes is
the science required, from physics and sociology for the objec-
tive worlds of nature and society to, say, optics and the psy-
chology of perception for the subjective world of the perceiver.
Certainly the tendency of Wordsworth to couch his ideas about
poetry in the vocabulary of contemporary psychology is one of
the things that Blake notices. He dislikes it because he sees that
it puts Wordsworth, against the main drift of his argument or
even his intentions, into the camp of those who would align the
truth of art with the truth of science. Understanding better than
any other artist of his time the power of scientific technique,
Blake recognizes that the probable end of that line of thought
will be to make art an inferior subcategory of science.

But for Blake the organ of sight in question is not the "per-
ishing mortal eye" and the object is not located in "mortal and
perishing nature." The sight could indeed be a blind man's—
could be Milton's—because the organs are "imaginative and im-
mortal organs" and the objects seen are "a Spirit and a Vision"
of the kind seen by "the Prophets" and "the Apostles" (*DC*; E
532). The objects are seen not because they are externally pres-
ent but because they have been well imagined: "He who does
not *imagine* in stronger and better lineaments, and in stronger
and better light than his perishing mortal eye can see does not
imagine at all" (my emphasis, *DC*; E 532). The strength of
artistic intellect is the power not of reason but of imagination.
The prophets and the apostles then are not persons with strong
faith in visions sent to them on earth by an external God in
heaven, but persons with strong imaginations and strong faith
in the visions they produce.

Drawing an outline is the appropriate response of artists to
the visions in their imaginations, and the Last Judgment exe-
cuted by artists on themselves comes as a firm outline. If some-
thing can be seen, it can be drawn: "If they cant see an outline
pray how can they make it" (E 502). The emphasis on drawing
what you see would put Blake together with Wordsworth and
Ruskin if not for Blake's firm belief that the only things worth
seeing are in the mind: "The want of this determinate and

bounding form evidences the want of idea in the artist's mind" (*DC*; E 540). If artists can't see an outline, it may very well be because they are looking in the wrong place, in nature instead of the mind. The mind is the source of everything that for Blake can be called idea: "Mental Things are alone Real" (*VLJ*; E 555). Everything in nature is simply something in someone's mind—imagination in a degraded form that cannot be recycled into art, because the artist does not trade in secondhand ideas: "Nature becomes to its Victim nothing but Blots & Blurs" (*PA*; E 563). Nature, however, is not an inspiring collection of forests and wildflowers but a vision of the external world created and controlled by societies in history. It makes no sense to retreat there in search of freedom from the picture of human life offered by society, because nature is part of that picture. Thus the romantic tendency to oppose nature and society is mistaken. Nature and society are allied in opposition to the artist's imagination, and the country, like the city, is simply one more alluring obstacle in the way of artists who are trying to see clearly what is in their minds. For a romantic like Wordsworth art promises to restore a harmony of mind and nature that society disrupts, whereas for Blake art promises to restore a potential integrity of imagination (and personality) that society and nature disrupt. I am of course exaggerating the terms of the contrast.

The metaphors of internal and external are fundamental to both formulations. For Wordsworth art envisions the liberation of both internal mind and external nature from social encroachment and their restoration to a state of natural unity. For Blake what is both external and good is not nature but art itself, which represents not the fusion of external and internal but the integrity of the internal. The artistic line is the sign, the "evidence" as Blake calls it (*DC*; E 540), of that integrity.

The culture, through its agents the "Cunning sures" (connoisseurs) and "Aim at yours" (amateurs), works to disorient the coordination between the artist's hand and inner eye, so that finally nobody can see straight but the drunkard and the madman:

All Pictures thats Panted with Sense & with Thought
Are Painted by Madmen as sure as a Groat
For the Greater the Fool in the Pencil more blest
And when they are drunk they always pant best (E 502)

Turning on an obsolete spelling of "paint," Blake's jingle exploits the paradox that all pictures painted with sense and with thought are the pantings of madmen.[25] Artists who are sane and sober are true to the external world, which imposes its shadows upon them. Shelley grants in his *Defence of Poetry* that Homer may have been a drunkard and Raphael a libertine.[26] Madman, drunkard, and libertine are either extremes to which the artist is driven for internal freedom from the external artistic forms approved by the culture or, like hell and devil in *The Marriage of Heaven and Hell*, labels applied by the culture to its discontents. Blake's observations in the annotations to Reynolds' *Discourses* that "The Lives of Painters say that Rafael died of Dissipation. . . . Painters are noted for being Dissipated & Wild" (E 633) are matched by the conclusion that "Madmen see outlines & therefore they draw them" (E 502). The directness of the statement is the important thing here: see therefore draw. Let anything confuse that direct response, and what happens is no longer art.

But because the definition of the essential artistic task remains simple, it is easy for Blake in arguing with Reynolds to distinguish three kinds of copying. Fundamental to every artist's training are the direct "servile" copies "both of Nature & Art" that are the musical scales of the visual artist, learning "the Language of Art" (AR; E 634) by copying. This is the "Science" that is "just the same" in Raphael, Michelangelo, Rubens, Lebrun, and "even Vanloo" (PA; E 564). Second, there are copies of nature, in the esthetic applications of that word, as in the "imitation of Nature," the doctrine that Blake thought Reynolds really had up his sleeve while playing the esthetic shell game of the *Discourses*, and the object of Blake's inquiry in his *Descriptive Catalogue*: "Shall Painting be confined to the sordid

[25] Although both Keynes and Bentley in their editions of Blake's text supply editorial *i*'s to normalize Blake's obsolete spelling of "paint," the fact that he uses "pant" only in this jingle may be significant, due to the associations of "pant" with apparition, nightmare, and fantasy (Middle English *panten* from Old French *pantaisier*, ultimately Latin *phantasia*)—in short, imagination—in a jingle about panting by madmen, fools, and drunks. In addition, painting as panting is a personal, emotional act rather than an act of craft or reason. For an obsolete poetic use of "pant" meaning "to expel or drive *forth* or *out* by agitated gasping," the *OED* quotes Shelley: "My spirit / Was panted forth in anguish whilst my pain / Made my heart mad" (*Prometheus Unbound* III.iii.125).

[26] *Shelley's Critical Prose*, ed. McElderry, p. 33.

drudgery of fac-simile representations of merely mortal and per-
ishing substances?" (*DC*; E 532). Finally there is the opposite
of the imitation of nature, the copying of imaginative forms
from the artist's own mind, which is the copying that every
artist should be trying to do: "Men think they can Copy Nature
as Correctly as I copy Imagination this they will find Impossi-
ble. & all the Copies or Pretended Copiers of Nature from
Rembrat [sic] to Reynolds Prove that Nature becomes to its
Victim nothing but Blots & Blurs" (*PA*; E 563).

The distinguishing mark of these mental copies is clear and
determinate outline, which the whole force of training, experi-
ence, and imagination teaches artists to separate from the blurry
cultural ghosts and demons that haunt their minds. Demons (in
their New Testament form) are external forces that take up in-
ternal residence—a kind of mental parasite that causes the host
to be unlike itself. In Blake they may be simply other artists,
like Rubens, who act as custodians of nature (nature and Homer
are the same) for the culture. They have no identity of their
own. They are hirelings, cultural composites, who intrude upon
a real identity and cause it to want to be something other than
it really is. They are difficult to get rid of because their com-
posite identities live off the identities of their victims, making
it hard to distinguish the host from the intruder, who "hinders
all power of individual thought" (*DC*; E 538). In the *Descrip-
tive Catalogue* Blake emphasizes how much energy can be squan-
dered in "experimenting" with the undefined images of these
dark demons, and to Dr. Trusler he contrasts the laboriousness
of engraving someone else's work with the ease of engraving
one's own (*Letters*, pp. 30-31). Against Reynolds he emphasizes
the imaginative ease with which the painter can work when the
path from mind to hand is clear: "Vision is Determinate &
Perfect & he Copies That without Fatigue Every thing being
Definite & determinate" (AR; E 635). Here Blake is contra-
dicting the argument of Reynolds' second discourse: that because
art is the imitation of external forms, the artistic equivalent of
laying up treasures in heaven is stocking the mind with impres-
sions of external objects. "I cannot help imagining," Reynolds
says, "that I see a promising young painter, equally vigilant,
whether at home, or abroad, in the streets, or in the fields.
Every object that presents itself, is to him a lesson. He regards
all Nature with a view to his profession; and combines her beau-

ties, or corrects her defects." His bank of memories secures him from the fear of emptiness (which is ignorance) and allows him to work without anxiety: "The Artist who has his mind thus filled with ideas, and his hand made expert by practice, works with ease and readiness. . . . The well-grounded painter . . . has only maturely to consider his subject, and all the mechanical parts of his art follow without his exertion." The artist who fails to take this advice becomes prey to the demons that rise up from the imagination itself: "He who would have you believe that he is waiting for the inspirations of Genius, is in reality at a loss how to begin; and is at last delivered of his monsters, with difficulty and pain" (II, 46, 47; W 36, 37). Blake thinks this last is "a Stroke at [John Hamilton] Mortimer" (AR; E 635).

The flat assertion that everything in art is "Definite & determinate" and its negative counterpart that "there is no Such Thing as Softness in Art. . . . Softness is Produced Alone by Comparative Strength & Weakness in the Marking out of the Forms" (AR; E 635) bring us to one of the poles of Blake's artistic theory. Art is outline because mental forms are clearly defined when clearly imagined. This rationale sets Blake almost entirely apart from the traditional arguments over linear and painterly art, which are squarely set in the imitation of nature.

Blake imagines imagination not as a mental faculty or process but as a person. Man is imagination, imagination is God, God is Jesus, we are his members. "All that we See is Vision," and the permanent home of vision is the imagination. From this compact but startling nucleus almost everything else in the Laocoön aphorisms follows. Jesus and his Apostles, who paid very little mind to the external world, "the Goddess, Nature," were thus "all Artists," men of imagination. That is, "Christianity is Art"; in fact, "the whole Business of Man Is The Arts." The "whole Business of Man" is generated, then, from the imagination, the internal and "Eternal Body of Man" as opposed to the external "Natural Man" (E 271). The metaphorical starting place for such a series of identifications can be seen in a romantic conclusion drawn by Wordsworth in a letter of 1816: "Thus the Poetry . . . proceeds whence it ought to do from the soul of Man, communicating its creative energies to the images of the external world."[27] At some time in his life Blake may have started

[27] Wordsworth to Francis Wrangham, 18 Jan. 1816, *The Letters of William and Dorothy Wordsworth*, ed. Ernest de Selincourt, 2nd ed. rev. Mary Moorman and Alan G. Hill, III (Oxford: Clarendon, 1970), 276.

from a similar point, formulating his artistic principles in the terms of a Christian metaphor. But typical of Blake is his willingness to extend to their logical, or rather poetical, conclusions the metaphors in which such formulations are rooted. His radically metaphorical way of thinking is the characteristic that makes his art and his ideas seem so useful in getting to the heart of essential questions about the nature of art.

In art, personal identity provides the only unity worth having: organization from the inside out, imaginative organization. Without external interferences, the imagination organizes the personality—produces an identity—as it organizes the work of art: "The painter of this work asserts that all his imaginations appear to him infinitely more perfect and more minutely organized than any thing seen by his mortal eye." The imaginations that appear to the artist are "Spirits," and "Spirits are organized men" (DC; E 532). The artist is an organized man—organized around imagination—and what imagination produces is necessarily itself, that is, "organized men." This provides Blake's explanation of composition in painting—visual organization—in implicit opposition to conventional accounts revolving around mathematics and geometry and imposing unity from without, and certainly having nothing to do with the organization of personal identity.

In his argument for the organized imagination, Blake never names the opposition: the notion that the imagination is energetic but disorderly and disruptive, producing not clear and stable intellectual visions but "a cloudy vapour or a nothing" (DC; E 532), the chaos of wit, monstrous combinations against all nature and reason, etc. Blake is shifting the basis of order from the external to the internal, from nature to imagination. In Enlightenment formulations nature is the source of order, and reason is the mental faculty that has the power to perceive the order that is there; a more extreme formulation identifies the two, making nature and reason the same, with imagination a lively but untrustworthy and peripheral third term. In romantic theories artists take more on themselves. Imagination joins with nature in an artistic partnership. Imagination often imposes order on the external world—but equally often the order imposed seems to have been taught to the artists by nature in the first place. Shelley's reference to poets as "spirits of the most refined organization" sounds remarkably close to Blake on artists as organized men. Up to a point it is close, of course. But there is

also a considerable difference that, as usual, concerns the relation of poet to subject matter. When Shelley speaks of the poet as "more delicately organized than other men,"[28] he chiefly means more sensitive to impressions, which register more coherently on poets than on ordinary people, whose sensory organizations are numbed and confused by attention to everyday life.

In Shelley, the consequence of the poet's most refined organization is a more complete bond between the poet and the external world. The consequence of Blake's argument is a strong opposition between nature and imagination, expressed in the Laocoön aphorisms in terms of the Christian opposition between Satan or reason with his wife, the goddess nature, against Jesus, the imagination. The aphorisms also specify the plot that this metaphorical opposition generates: "Israel deliverd from Egypt is Art deliverd from Nature & Imitation" (E 272). While Blake's shift to imagination is characteristically romantic, his opposition of mind and nature is not. The opposition seeks resolution. In Coleridge and Wordsworth there is a need to resolve apparent conflicts between the internal and the external, usually by some gesture of the perceiver's imagination that is equated with a human emotion such as love, resulting in a cultural union, such as "marriage," of mind and nature.[29] Blake shares much of this romantic pattern, including the desire to resolve the opposition of internal and external. For Blake, however, the center of authority is imagination, which (to put it simply) finally realizes that the external is a metaphor invented by the imagination itself, with the result that the tyranny of the external world over the imagination disappears. In Wordsworth and Coleridge the problem is not to rid the mind of the tyranny of nature—except when misconstrued, nature is not the source of tyranny—but to recognize the legitimate authority of nature, as in *The Ancient Mariner*. In one way or another nature guides imagination. Perhaps imagination imitates the processes of nature, *natura naturans*, "nature naturing," or "nature being herself," as Coleridge suggests in his essay "On Poesy or Art."[30] At least the interplay

[28] *Defence of Poetry*, in *Shelley's Critical Prose*, ed. McElderry, pp. 31, 34.

[29] M. H. Abrams presents a detailed and subtle account of the romantic metaphor of marriage between mind and nature in *Natural Supernaturalism*. Abrams distinguishes Blake from the others, especially Wordsworth, on pp. 263-64, though he also shows how Blake fits the pattern.

[30] *Biographia Literaria* (and Coleridge's "Aesthetical Essays"), ed. John Shawcross, rev. ed. (London: Oxford Univ. Press, 1954), II, 257.

of mind and nature is so involved as to create a chicken-and-egg problem for the interpreter if not for the poet. Blake, Wordsworth, and Coleridge all fear the disruption of the integrity of the artistic process. In Wordsworth and Coleridge the disruption tends to come from the human side in a state of artificial separation from nature, the sort of thing that happens to "men in cities," who, losing the model of *natura naturans*, lose their appetite for plain food and develop "fickle appetites *of their own creation*" (my emphasis).[31] But Blake identifies these human disruptions with nature. Apologists for the social status quo claim that their institutions are founded on human nature and imitate nature itself. Blake regards this external court of appeal as their own self-serving creation.

Artists imitate their true selves by imitating their imaginations: "As a man is, So he Sees" (*Letters*, p. 30). This is the "organization of sight" (*DC*; E 540) and its result is clarity of vision. Those who imitate external nature instead are not artists but "Historians . . . who being weakly organized themselves, cannot see either miracle or prodigy; all is to them a dull round of probabilities and possibilities" (*DC*; E 534). Miracle and prodigy are nothing more than "the historical fact in its poetical vigour" (*DC*; E 534), or the fact organized by "Con or Innate Science" (AR; E 635), conscience, the moral vision of the individual imagination. Historians are weakly organized because they specialize in the study of nature, which is itself organized in a system of probabilities and possibilities that disorganize the imagination of the historian. The idea that this disorganization constitutes a loss of identity is not unfamiliar to us, though the reports are usually positive. One person's "weakly organized" is another's "disengaged," "detached," "objective"—all supposedly the attitudes appropriate to the professional student of the external world. The attitude may even have its uses at the personal level, as outlined in "A Free Man's Worship," where Bertrand Russell prescribes the modern scientific outlook as a remedy for personal distresses: the ratio of vast nature to the self is so extreme as to produce consolation through loss of identity. In Blake's terms this is a form of pity, which is among other things a strategy for avoiding action based on imagination—Con Science. Blake's notion of pity may seem to have nothing to do

[31] Preface to *Lyrical Ballads* (version of 1800), *Prose Works*, ed. Owen and Smyser, I, 128, 124.

with science, which is, however, another such strategy. A close study of nature leads one to believe that the norms of natural behavior are hostility, indifference, and cruelty, but the attitude of science toward the norms that it discovers is disengagement. Disengagement is loss of identity—absorption of imagination by the external world. Paradoxically, Blake's concept of selfhood is easiest to explain from this vantage point. Selfhood means not mere attention to what the self tells you—"selfishness"—but a state of nature in the mind, the mind in a state of domination by the principles of the external order. "The Selfhood deadly" lies "Beyond the outline of Identity" (*M* pl. 37:10; E 136) but is always threatening to supplant identity with the comforts of nonentity. We are used to hearing this process described favorably: "The merit of the new [scientific] order was to give man by projection an outer world which helped him to make over the hot spontaneous world of desire he carried within."[32]

Reason is the name for the mental technique that accompanies this attitude. Blake likes to emphasize the etymological relationship of "reason" to "ratio," as in "ratiocination," in order to bring out its associations with both mechanics and the external world. The product of imagination is a fact in its poetical vigor, which is a fact humanized. The product of ratiocination is a fact in proportion, a fact weighed, according to probabilities and possibilities, against other facts. The outcome is one of two: a blurred line or a mechanical (geometrical, mathematical) line. As firm and determinate lines are not the exclusive property of art, so probabilities and possibilities are not the exclusive property of scientists and historians. In art, where historians thrive as history painters and portrait painters, facts weighed become doubts and equivocations on the one hand and mathematical certainties on the other, the one represented by blurry lines and shadows, the other by mechanical lines.

Art expresses personal identity:[33] "It [the Eternal Body of

[32] Mumford, *Technics and Civilization*, pp. 329-30.

[33] Although my account requires only rudimentary notions of self and personal identity, the subject has an extensive literature, including Paul A. Jorgensen, *Lear's Self-Discovery* (Berkeley: Univ. of California Press, 1967), and Rolf Soellner, *Shakespeare's Patterns of Self-Knowledge* (Columbus: Ohio State Univ. Press, 1972), for Renaissance ideas of the self; for the eighteenth century, John O. Lyons, *The Invention of the Self: The Hinge of Consciousness in the Eighteenth Century* (Carbondale: Southern Illinois Univ. Press, 1978), Jean Perkins, *The Concept of the Self in the French Enlightenment* (Geneva: Droz, 1969), Patricia Meyer

Man, the Imagination, God, the Divine Body, Jesus] manifests
itself in his [Jesus', the Divine Body's, God's, the Imagina-
tion's, the Eternal Body of Man's] Works of Art." Imagination
does not operate on nature, imitate nature, or add anything to
nature. Imagination manifests itself. As the imagination in the
engraved Laocoön is the "Eternal Body of Man," so the "Poetic
Genius" in *All Religions are One* is the "true Man" (E 2). If
true selves are imaginative selves, then all people acting true to
themselves must express themselves in artistic line. True art is
thus a means of personal recognition—"Protogenes and Apelles
knew each other by this line" (my emphasis, *DC*; E 540)—and
a gesture of greeting—"a firm, determinate outline, struck at
once, as Protogenes struck his line, when he meant to make
himself known to Apelles" (Blake on Malkin; E 671). The
broader principle is biblical: "By their Works ye shall know
them" (*VLJ*; E 553; compare *DC*, E 529, and the references
to the works of the Churches in Rev. 2-3). The only way to
know who someone really is is to find out what kind of artist
someone is, and only the line can tell. Line is a natural partner
of identity, because it too is a metaphor of precision, as in "iden-
tical," with no room for approximation (cf. "imitation"). Blake
makes this connection directly in praising the drawings of the
young Malkin as "all firm, determinate outline, or identical
form." If identical form were a term in a mimetic theory fa-
voring line, it would designate an artistic form identical with a
natural form being represented. But, since for Blake form is
the artist, and identical form designates artistic form identical
with the identity of the artist doing the forming, his theory
reserves highest praise for an artist such as "this little boy," who
has had "that greatest of all blessings, a strong imagination, a
clear idea, and a determinate vision of *things in his own mind*"
(my emphasis, E 671).

 As the projections of imagination are recovered and put back

Spacks, *Imagining a Self: Autobiography and Novel in Eighteenth-Century England*
(Cambridge, Mass.: Harvard Univ. Press, 1976), and Stephen D. Cox, *"The
Stranger Within Thee": Concepts of the Self in Late-Eighteenth Century Literature*
(Pittsburgh: Univ: of Pittsburgh Press, 1980), with a chapter on Blake, pp.
127-56; for romanticism, among many other studies, Ernest Tuveson, *The Imag-
ination as a Means of Grace: Locke and the Aesthetics of Romanticism* (Berkeley:
Univ. of California Press, 1960), and Robert Langbaum, *The Mysteries of Iden-
tity: A Theme in Modern Literature* (New York: Oxford Univ. Press, 1977).

where they belong—in one's own mind and in "the human breast"—other categories that have been falsely externalized are similarly restored to their proper places. Take, for example, the beautiful. Conventionally—as in Pasquin, Pilkington, and Strutt—beauty is a property of the natural world being imitated by the devices of art. The standard of beauty being nature, and nature having no outline, beauty is soft and cannot be expressed by lines, which are conventionally regarded as heavy, harsh, and hard. Beauty and intellect thus tend to be opposing qualities associated with opposite sexes—beauty with the female, including the female aspects of nature, intellect with the male. Blake must either disassociate art from beauty or change the standard of beauty—which is of course what he does. His claim that "Every Line is the Line of Beauty" (*PA*; E 564) directly contradicts Strutt's counterclaim that "exact lines of any kind"— even the so-called serpentine "line of beauty"—"cannot give the perfect expression of beauty and elegance." For Blake, "The Beauty proper for sublime art, is lineaments." Because beauty is a property of the intellect rather than of nature, "what is truly Ugly" is "the incapability of intellect" (*DC*; E 535), which reveals itself in a painting as the incapability of drawing a line: "It is only fumble and Bungle which cannot draw a Line this only is Ugliness" (*PA*; E 564). Line is the artistic expression of truth to self, which is beautiful by definition. Beauty is characteristic; that is, being beautiful is being in character.

As beauty, so goodness. Blake honors the memory of Tommy Malkin, dead at seven, with the artistic equivalent of saint's-life panegyric. When artist replaces saint, the "great and golden rule of art" (*DC*; E 540) replaces the golden rules of virtue. The "greatest of all blessings" that Tommy Malkin had was not closeness to the God who issues rules, but closeness to "his own mind," which issues lines. Thus, although Blake maintains the conventional association (seen in Fuseli, for example) between the artistic line and virtue, virtue is redefined to fit the adjectival sequence *ethical (good) = esthetic (beautiful) = true = characteristic*.

Since it means something like the "state of mind in which one expresses one's true self," the meaning of "artist" in these applications takes on one of its typically broadened romantic forms to cover almost all significant behavior, including what we usually consider the province of ethics. The "distinct, sharp,

and wirey" line, which measures personal identity, reveals character as it reveals artistic image. Blake's pun on the line of identity as the rule of art and life makes the rule not something to be obeyed (rule as prescriptive law) but followed (rule as expressive line). Knowing and following one's true self are rules of life heard before in their derivative Greek versions; Blake would call his the Hebrew original. Since art and life both follow the same rule, they are potentially identical. Real ethics and morality grow out of character, and character grows out of imagination; therefore character and morality are, broadly speaking, artistic matters. While this line of thought may—and should—bring to mind the art-and-life one-liners of the fin de siècle, it is essential to see that Blake grounds art in character. "Moral" becomes (with "esthetic," if he used the word at all) virtually synonymous with "characteristic." The theory does not assume that all people have an artistic self that is fundamentally virtuous; it defines virtue as being-in-character.

When the leading ethical (and esthetic) imperative is "be yourself," the hierarchy of vices is rearranged at the top so that hypocrisy replaces pride. In the question "What is it that distinguishes honesty from knavery, but the hard and wiry line of rectitude and certainty in the actions and intentions [?]" honesty, rectitude, and certainty are aspects of being-in-character; knavery is hypocrisy, or being-out-of-character. In art, hypocrisy is called plagiarism. Since line reveals character, no artistic hypocrite, or plagiary, can produce real lines. Thus "the less keen and sharp" the bounding line is, "the greater is the evidence of weak imitation, plagiarism, and bungling. . . . Talk no more then of Correggio, or Rembrandt, or any other of those plagiaries of Venice and Flanders. They were but the lame imitators of lines drawn by their predecessors" (*DC*; E 540). In Fuseli's Venice artists like Correggio pander to the sensual vices of their audience. The great vice in Blake's Venice is plagiarism, the vice of artists who have no minds of their own. The mind of a plagiary is dominated by the faculty of memory, a storage tank for the works of other minds ("lines drawn by their predecessors"). As Blake says of Malkin, "Had the hand which executed these little ideas been that of a plagiary, who works only from the memory, we should have seen blots, called masses." Wandering plagiarists, stumbling repeatedly in the effort to negotiate the cities of imagination with the ever-obsolete maps of mem-

ory, smear lines into "blots . . . always clumsy and indefinite; the effect of rubbing out and putting in, like the progress of a blind man" (on Malkin; E 671). Blake's memory-guided blind artists belong with the mock pilgrims of Bunyan and Spenser. As spiritual parasites looking for a host, the plagiaries of Venice and Flanders color because they cannot draw.

THE APPLICATION

Faced with the distressing image of Blake as artist and poet *sui generis*, commentators were once fond of offering Blake's linearism as the credential that would bring him out of cold isolation by admitting him to membership in one of the great continuous traditions of Western art. More recent discussions emphasize discontinuity, not by revoking his membership but by binding him more and more tightly into a network of shifting influences. By denying the existence of a monolithic Blake, by marking shifts in Blake's theory and disparities between his theory and his practice, these discussions envision an artist who can be caught in contradiction much more often than his own sensitivity to the self-contradictions of others might lead one to expect.[34] The evident advantage of this approach lies in the protection that its historical sophistication can provide against our

[34] For a sampling of the best of recent critical discussion of Blake's theory and practice of line, see Bindman, *Blake as an Artist*, pp. 102-04, 125-31 et passim ("Although Blake insisted in the *Descriptive Catalogue* of 1809 upon absolute purity of outline, in the Lambeth Books [of the 1790s] his style avoided in practice the extreme linearity of Flaxman, because the exigencies of Illuminated printing made it difficult to achieve a sharp contour" [p. 102]); Martin Butlin, *William Blake* (London: Tate Gallery, 1978), pp. 14-17 ("Much damage is done to the appreciation of Blake's earlier art by seeing his whole output as a monolithic creation moulded by the theories he expounded in his later years" [p. 15]); Essick, *William Blake, Printmaker*, pp. 5-7, 190 et passim ("This traditional style [adopted by Blake for the Canterbury Pilgrims engraving] avoids the extremes of contemporary fashion—either severe outline or soft stipple" [p. 190]); Mitchell, *Blake's Composite Art*, pp. 44-53, 96-97 ("Did he in fact create a purely linear style of naked figures, and completely avoid the painterly concern with drapery, chiaroscuro, the picturesque, and the 'blotting and blurring' devices which produce tonality? Did he consistently subordinate color to line, and light to form?" [p. 45]); and Paley, *William Blake*, pp. 49-56 ("Although this sounds very much as if Blake's views were diametrically opposed to Reynolds's, . . . Blake rarely criticized those whose ideas had nothing in common with his own" [p. 49]).

swallowing a one-dimensional Blake. The disadvantage would seem to be in the danger that the real Blake, dismembered with sophistication, might be swallowed by history.

Blake's linearism seems especially vulnerable to misunderstanding, and the danger seems greatest at the juncture of theory and practice. Could a hypothetical critical theorist armed only with a perfect memory of Blake's statements about line identify the real Blake painting in a lineup? Could a hypothetical expert connoisseur with a lifetime of practical experience in identifying real Blake paintings in museum lineups derive from the works the theory that, according to Blake, lies behind them? For the theorist, the purest practical expression of Blake's ideas about line may seem to be drawings in pure outline in the manner of Flaxman—shadowless, toneless, colorless. But the practiced eyes of the connoisseur would know better than to base decisions about Blake's work on any such plain tendencies, even though pure outline is indeed a choice that the history of style offers to the mature Blake—the very Blake of firm statements about firm outline.

Specialized blindness may save my hypothetical theorist and connoisseur from the embarrassment reserved for real critics who must develop theories of their own to cover the apparent gap between promise and performance. A more adequate definition of line might support a more adequate account of the relation between Blake's theory and his practice. Useful reform would begin by using Blake's theoretical and practical linearism as a test of the integrity and stability of the categories theory and practice.

The commonplace that ideas are never quite so separable from action as we pretend for convenience is true, as I have heard from hell, and Blake is proof. His theory has a reality for him that it lacks for, say, critics who regard art objects as primary and theories as mere backdrops. Such critics, supposing that the object "itself" is a safer haven than the theory "behind" it for making credible distinctions between one painter's line and another's, may move too hastily from what are supposed to be the airy generalizations of theory to the concrete particulars of practice. But the confidence in that priority would not be strengthened, I think, by the discovery of Blake's habit of turning his artistic theory into a major theme of his artistic practice. The failure to take due account of the implications of this turn of

events has caused shortcomings in the assessment not only of Blake's work but of romanticism generally, despite widespread acknowledgment that romanticism brings with it a tendency toward self-reflexive art.

When Blake uses a pen to write the word "line," he does more than signify a thin, continuous geometrical entity in a painting; and when he uses a pen to draw one of those thin entities, he does more than create the signified that becomes the occasion to write or utter the signifier "line." Both word and thing energize metaphorical clusters, and the significance of both includes those clusters. Blake's theory designates the cluster appropriate to the practice—not, for example, the metaphors that cling to academic line. To understand Blake's practice, observers need more than art objects—more than the results of artistic practice—because to a certain extent real lines are always mere lines. Lines that cannot be usefully distinguished in practice— the line of an academic painter from one of Blake's lines—may be utterly distinctive in theory. Attempts to deny the significance of this fact, and to regard the dependence of supposedly autonomous works on contexts "outside" the works as an artistic flaw, usually rest on an oversimplified picture of a work as an object standing in front of a two-dimensional prop called the historical background. In fact, the self-reflexive tendency in romantic art comes into its very existence by making good artistic use of the ecological relation of theory to practice.

At the center of the associations animated by Blake's linearism is the metaphor *line* = *human being* (the "true Man" of imagination, the true Apelles, true Malkin, true Blake). In such highly figurative circumstances it is no more helpful to think of metaphors as imaginary vehicles transporting real tenors than to think of words as arbitrary signs representing real things. For Blake metaphors tend to become identities for which order is insignificant: as line is the true self, so true self is line. The infiltration of this theoretical metaphor into Blake's artistic practice doubles the object of any search for lines in Blake's paintings: lines appear not only as geometric entities but also as the true self of the artist, the presence of the one invoking the presence of the other. In the Bible, once we hear that Christ is the Lamb of God, alert readers anticipate the possibility not only of a lamblike Christ but also of a Christlike lamb. The further the plot moves away from realism toward myth, the less emphatic be-

comes any distinction between a tenor and a vehicle. In John's gospel, Christ is tenor and Lamb the vehicle; in Revelation, the two are more nearly interchangeable.

Wherever the true self of the artist is being expressed in a painting, that painting is (by reach of the metaphor) linear. The line is a geometric metaphor as the fall is a spatial metaphor, but line is no more restricted to signifying geometric entities than fall is restricted to signifying downward tumbles in space. With the word "line" Blake designates the autographic component in art. When he asserts that line is the golden rule of art, he is asserting that true art is founded on its autographic component. Zola says that "what I demand of the artist is . . . that he gives himself. . . . what I seek in front of a picture above all is a man, and not a painting."[35] Blake says that "the more distinct, sharp, and wiry the bounding line, the more perfect the work of art." Waiting for real bounding lines to dominate the works of art that Blake would call perfect may be as unsatisfying as waiting for a real "man, and not a painting" to materialize in front of the canvas that Zola admires.

Changes in Blake's theories may dictate changes in practice as directly as critics have recently proposed: "The dark, encrusted world created in the color prints of the mid-1790s and the characteristics of the Burkean sublime they exemplify were not consistent with Blake's aesthetic and spiritual principles from about 1805 to the end of his life. In his comments on Reynolds' *Discourses*, Blake redefines the sublime as the art of distinct line and formal clarity—the very antithesis to the blurred patches of color printing."[36] But the metaphorical scope of Blake's concept of line is one of several factors[37] that, for me, complicate the evi-

[35] Quoted in E. H. Gombrich, *The Ideas of Progress and Their Impact on Art* (New York: Cooper Union School of Art and Architecture, 1971), p. 78.

[36] Essick, *William Blake, Printmaker*, p. 150.

[37] It becomes increasingly clear that Blake's interest in color printing, though it wanes after an especially active period in the mid-1790s, nonetheless continues for many years—well into the nineteenth century. This fact makes it more difficult to associate color-printing techniques with some earlier phase of Blake's artistic theory that tolerates colorist and chiaroscurist devices. Furthermore, the idea that the medium of color printing and Blake's state of Experience are (in Blake's mind) made for one another has often seemed to be reinforced by the few *Songs* that he chooses to color print—always, it has been thought, designs from *Experience*, never from *Innocence*. In fact, however, Robert N. Essick has discovered at least two color-printed designs from *Innocence* that Blake may have intended to use in a series like the Large and Small Books of Designs. See Essick, "New Informa-

dence from which such conclusions are drawn. If the color prints reveal the true imaginative identity of the artist William Blake— and I know of no direct evidence that Blake comes to believe they do not—then they may be more linear in Blake's sense of the term than Flaxman's outlines, which by and large seem far less autographic than Blake's color prints, which are William Blake in the same way the illuminated books are the kind of man that Zola seeks in works of art.

Moreover, the oppressive shadow-world of the state of experience, the "dark, encrusted world" that seems to be the special province of certain color prints, may clarify itself in a lack of clarity. The clearest vision of experience may be a chiaroscurist vision that would not be clarified, only falsified, by Flaxman-esque outline. It may be essential to see that the world of experience seen clearly is obscure. Governors and false artists may claim that life at their level makes clarity possible, as Albion's Angel describes Orc rather clearly as a vicious beast threatening civilization with chaos. But true clarity lies in a vision of life that includes its dark and obscure parts.

It is also important to remember that the argument for a change in Blake's ideas of line cannot be limited to the medium of color printing. But I see no uniform alteration in Blake's pictorial styles. The distinctness of line and clarity of form vary greatly from work to work and from medium to medium within the same period. As for the loud theoretical pronouncements, what I hear—for instance, Blake's contempt for the engraving practices of Bartolozzi, Woollett, and Strange—sounds more like the firm restatement of long-held opinion than the new understanding of old observations. Blake's annotations to Reynolds, the *Descriptive Catalogue, Public Address,* and *Vision of the Last Judgment* seem to be the products of a new determination to assert his artistic principles vigorously in the face of personal

tion on Blake's Illuminated Books," *Blake/An Illustrated Quarterly*, 15 (Summer 1981), 4-13, especially illus. 6, 14, and 15, and the accompanying text. Finally, the recent discovery that one of Blake's color prints of *Newton* is on paper watermarked 1804, indicating a date of execution much later than previously supposed—see Martin Butlin, "A Newly Discovered Watermark and a Visionary's Way with His Dates," *Blake/An Illustrated Quarterly*, 15 (Fall 1981), 101-03— increases, to my mind, the evidence against any association between Blake's use of the color-printing medium and a supposed phase in the development of his artistic style characterized by colorist and chiaroscurist influences—and, conversely, by the absence of any devotion to linearist principles in the late 1790s.

temptation and hypocritical opposition rather than the products of a fundamental change in the principles themselves.

Moreover, since Blake does not separate the principles that govern one art from those that govern another, any principles of "distinct line and formal clarity" would presumably have serious effects on his poetry as well as his art after 1805. But again I see no alteration in Blake's poetic style to coincide with and reinforce any changes in the style and composition of his pictures. By the time Blake's linearism is in full force, we would expect to find changes in the direction of a more linear poetry. When we search for such changes, what we find, of course, is the obstinately metaphorical nature of Blake's linearism asserting itself: even those who are tempted to conclude that real lines are the only authentic sign of linearism in a painting must wonder what a distinct, sharp, and wirey bounding line will look like when discovered in the language of a poem.

Does Blake's poetry before or after 1805 reveal the verbal counterpart of pictorial distinct line and formal clarity? Saying yes would seem to require special pleading, since Blake's poetry, his later poetry especially, has been a stock example of verbal obscurity for generations. But admitting the obvious—that *Jerusalem* is obscure by conventional standards—is not conceding that Blake measures other artists with standards too high for himself to reach, nor that his artistic practice is necessarily at odds with his theory of line, but merely that his standards can be less conventional than they sound. The remainder of this book attempts to establish Blake's own standards in their own terms by extending the conceptual plot initiated by the metaphor of autographic line.

Line is the fundamental dynamic principle in Blake's artistic theory—"Leave out this line and you leave out life itself" (*DC*; E 540)—and the basic element in the fundamental artistic act. Making a line is outlining and containing. Lines become "lineaments," "receptacles," and, as human dwellings, even places of refuge: "For the Sanctuary of Eden. is in the Camp: in the Outline" (*J* pl. 69:41; E 221). Containing lines define images. Inward from the circumference of the image toward the center, bounding outlines become metaphors of satisfaction and completion. Circumferences enclose images in the "lineaments of Gratified Desire" (E 466, etc.). But seen in a widened field, outward

from the circumference, that initial integration of the line as an image is only a cornerstone of anticipated completeness, a required investment of artistic good faith without which "all is chaos again, and the line of the almighty must be drawn . . . before man or beast can exist" (*DC*; E 540). Minimally, making a line draws a boundary, and the result is a merciful "limit." Mediately, making a line expresses identity, and the result is identical form, activating the image with inward life. Ultimately, making a line signals readiness for relation, and the result is the opening of a line of communication, Protogenes "making himself known" to Apelles. Here the theory moves beyond the artist to the position filled in most esthetic theories by what is called the work or the object of art. The following chapter begins to discuss the form the work must take to satisfy Blake's demand that art be the paradigm of authentic communication based on comprehensive human relationships potentially capable of expressing the shape of gratified desire.

II.

Works, Part One

ARTISTS EXPRESSING THEMSELVES

AS WORKS OF ART

For me—and I hope for many others, a work of art is rather a personality, an individuality. What I demand of the artist is not that he should give me tender visions or horrible nightmares, but that he gives himself, body and mind, loudly affirming a strong and individual mind. . . . what I seek in front of a picture above all is a man, and not a painting. —Émile Zola

EXPRESSION AND CHARACTER

A number of positive romantic metaphors describe the work of art as the direct projection of the artist's imagination. When the imagination is also considered the source of personal identity, the "true Man," then the work of art is the artist. Coleridge's claim that "What is poetry? is so nearly the same question with, what is a poet? that the answer to the one is involved in the solution of the other"[1] is a modified form of the same equation. "Sincerity" and the "true voice of feeling" are evaluative terms that describe this kind of integrity, since they evaluate the work of art with criteria that can also be used to evaluate the character of the artist who made it, as when T. S. Eliot finds Blake's artistic genius to be a "peculiar honesty."[2] Such evaluative metaphors are directly related to Blake's line as a standard

[1] *Biographia Literaria* (and Coleridge's "Aesthetical Essays"), ed. John Shawcross, rev. ed. (London: Oxford Univ. Press, 1954), vol. II, chap. xiv, p. 12.
[2] "William Blake," in *Selected Essays: 1917-1932* (New York: Harcourt, 1932), p. 275.

of both good art and personal rectitude. Finally, there is the pervasive organic metaphor, used freely to describe both the creative process and the artistic results. Commentators who have called this double application indiscriminate have failed to notice that the theory, by tending to identify the poet with the poem, virtually demands it.

Another metaphor for the relation of artist to art is expression, and all esthetic principles that focus on the integrity of artist and the work of art may be grouped as expressive theories.[3] The artist expresses the work of art. As Coleridge says, "The Fine Arts . . . all, like poetry, are to express intellectual purposes, thoughts, conceptions, and sentiments which have their origin in the human mind";[4] or, in Shelley's *Defence*, "Poetry, in a general sense, may be defined to be 'the expression of the imagination.' "[5] When Blake writes Hayley in 1800 that he is sending "a proof of my attempt to Express your & our Much Beloved's Countenance" (*Letters*, p. 33), the use may seem incidental. But when he writes that "Passion & Expression is Beauty Itself" and that "Reynolds cannot bear Expression" (AR; E 642), we begin to see why Croceans have been attracted to Blake.

But of course Blake and his romantic successors do not invent the term "expression." When a notice of the death of Charles Grignion the engraver (1716-1810) asserts that "his best works not only possess in an eminent degree whatever constitutes character and expression,"[6] a dead engraver of the Enlightenment is

[3] M. H. Abrams outlines the basic characteristics of expressive theories of art in *The Mirror and the Lamp: Romantic Theory and the Critical Tradition* (New York: Oxford Univ. Press, 1953), pp. 21-26. He fills in the history of expressive criticism through the romantic period in his chapter 4, "The Development of the Expressive Theory of Poetry and Art," pp. 70-99. Despite the title of the chapter, Abrams' emphasis is almost entirely literary; and he does not mention Blake. Elsewhere in the book (p. 313) Abrams warns against making Blake or Shelley the center of a theory of romanticism. Blake has been given an essential role in a number of more recent accounts, including Frye's "The Drunken Boat: The Revolutionary Element in Romanticism," in *Romanticism Reconsidered: Selected Papers from the English Institute*, ed. Frye (New York: Columbia Univ. Press, 1963) and his *Study of English Romanticism* (New York: Random House, 1968).

[4] "On Poesy or Art," ed. Shawcross, II, 255.

[5] *Shelley's Critical Prose*, ed. Bruce R. McElderry, Jr. (Lincoln: Univ. of Nebraska Press, 1967), p. 4.

[6] John Pye [II], *Patronage of British Art, An Historical Sketch* (London: Longman, 1845), p. 317, n. 5; quoted by Pye from the *Annual Register* of Nov. 1810.

WORKS, PART ONE 47

not being eulogized with the esthetic praises of the new romantic art. "Character and expression" are conventional terms conventionally associated, especially in the visual arts, where there is considerably more preromantic use of them than in literary criticism. A few examples in chronological order will serve to sketch in the context.

In *An Essay on Criticism* (1711) Pope distinguishes "False eloquence" from "true expression": "It *gilds* all Objects, but it *alters* none. / Expression is the *Dress* of *Thought*."[7] In literature expression is style, as distinguished from substance, and style is the light that reveals objects and perhaps gilds them, "but it alters none." The focus is on the primary qualities of objects; secondary qualities such as color do not essentially change objects. As the "dress of thought," expression is clearly a secondary consideration.

But in the fine arts "expression" is a term used throughout the eighteenth century (and, for that matter, today) with more weight and precision. Every fine arts handbook and dictionary finds a place to define it; here, for example, is the definition from Pilkington's *Dictionary of Painters*:

EXPRESSION principally consists in representing the human body, and all its parts, in the action suitable to it; in exhibiting in the face the several passions proper to the figures, and marking the motions they impress on the other external parts. Frequently, the term Expression is confounded with that of Passion; but the former implies a representation of an object agreeably to its nature and character, and the use or office it is intended to have in the work; and passion, in painting, denotes a motion of the body, accompanied with certain airs of the face, which mark an agitation of soul. So that every passion is an expression, but not every expression a passion.[8]

Expression is associated with the human body, particularly the face; with passion; and especially with the appropriateness of the representation to the thing presented: "the action *suitable* to it," "the several passions *proper to* the figures," "a representation of

Among Grignion's other accomplishments were the engravings of Bentley's designs for Gray's *Elegy*.

[7] *Pastoral Poetry and An Essay on Criticism*, ed. E. Audra and Aubrey Williams, Twickenham Edition of the Poems of Alexander Pope (New Haven: Yale Univ. Press, 1961), vol. I, p. 274, ll. 311, 315-18.

[8] Matthew Pilkington, *A Dictionary of Painters from the Revival of Art to the Present Period*, rev. ed., ed. Henry Fuseli (London, 1805), p. xviii.

an object *agreeably to its nature and character*, and the use or office it is *intended* to have" (my emphasis). Several of the same associations appear in *The Bee*, an anonymous review of the Royal Academy exhibition of 1788. After giving a scoresheet of qualities desirable in a painting, the author defines expression as

that wondrous power of Painting which conveys the ideas of Characters and Passions of the Person represented: nor is *Expression* confined to the human figure only; it serves equally to mark the peculiar qualities and properties of every other object. . . . *Expression* will sometimes give pleasure, where all other requisites are defective; for *Expression* seems to be the immediate gift of Heaven. . . . for although the skill and learning of the Student may be wanting, the original Genius is displayed in the natural *Expression* of *Truth* and *Beauty*.[9]

Again expression has its strongest associations with the human figure though not with that only, and with characters and passions particularly appropriate to the person represented. The association of expression with "the peculiar qualities and properties of every other object" brings mere appropriateness (of representation to thing represented) closer to Blake's notion of identical form, unique and particular. Finally, the association of expression with original genius instead of skill and learning—the suspicion that education is an external interruption of the directness of expression—found here but not in Pilkington is essential to Blake's purposes.

In his *Lectures on the Art of Engraving* (1807), John Landseer tightens the association of expression with character: "A distinguished artist and critic . . . has said that his [Raphael's] expression is decided by character; and that he adapted form to char-

[9] *The Bee; or, the Exhibition Exhibited in a New Light* . . . (London, 1788), p. 7. Cf. the definition offered by Fuseli in his lecture on composition and expression: "Expression is the vivid image of the passion that affects the mind; its language, and the portrait of its situation. It animates the features, attitudes, and gestures which Invention selected, and Composition arranged; its principles, like theirs, are simplicity, propriety, and energy. . . . Without truth of line no true expression is possible; and the passions, whose inward energy stamped form on feature, equally reside, fluctuate, flash, or lower on it in colour, and give it energy by light and shade. To make a face speak clearly and with propriety, it must not only be well constructed, but have its own exclusive character" (*Lectures on Painting, by the Royal Academicians: Barry, Opie, and Fuseli*, ed. Ralph N. Wornum [London: Bohn, 1848], p. 468).

acter, in a mode, that leaves all attempts at emendation hopeless."[10] In Raphael, character expresses form; since emendation is hopeless, the relation can be put in absolute terms: character is form.

One or another of this group of commonplace associations appears whenever Blake writes about art and expression, and many of them appear as well in Wordsworth, Coleridge, and Shelley. But the transformations that turn the Enlightenment ideas into Blake's are, if natural enough, also radical in effect, so that the differences are great and the possible confusions many.

We can start with an emphatic distinction between expression as a characteristic of something within the work, a relation, usually, between person or thing represented and the representation itself; and as a name for a relation between the artist and the work of art. Expression is also involved in the relation between the artist and the subject of art, but, since I discussed Blake's notion of the proper subject of art at length in the previous chapter, I shall touch on it only occasionally here. In Blake we can trace the basic romantic shift from expression as a characteristic within the work to expression as a name for the relation between the artist and the work of art. When the shift is made completely, as it very nearly is in Blake, the relation of artist to work subsumes all other relations.

In preromantic usage, "expression" is a term applied chiefly to the work of art, as in Pilkington ("a representation of an object agreeably to its nature and character"). Perhaps its simplest use is in describing the appearances of faces in the work, "exhibiting in the face the several passions proper to the figures" (Pilkington), as in Blake's description of the faces of the Roman

[10] *Lectures on the Art of Engraving, Delivered at the Royal Institution of Great Britain* (London, 1807), pp. 274-75. The "distinguished artist and critic" to whom Landseer refers is probably Fuseli, who in his lecture on the art of the moderns says of Raphael, "*His expression*, in strict unison with and *decided by character*, whether calm, animated, agitated, convulsed, or absorbed by the inspiring passion, unmixed and pure, never contradicts its cause, equally remote from tameness and grimace" (my emphasis, *Lectures*, ed. Wornum, p. 384). The standard exemplars of true expression in painting for the eighteenth century are Raphael and Michelangelo. Opie, in his lecture on design, says of Michelangelo, "His peculiar strength . . . was expression. To this all his efforts tended; for this he invented, drew, and composed, and exhausted nature in the choice of subjects to display it: every effect of mind on matter, every affection of the human soul, as exhibited in the countenance, from the gentlest emotion to the utmost fury and whirlwind of contending passions" (*Lectures*, ed. Wornum, p. 267).

soldiers in his lost painting *The Ancient Britons*: "Each shew a different character, and a different expression of fear, or revenge, or envy [etc.]" (*DC*; E 536). Here "expression" has virtually its everyday meaning, facial expression—the way the soldiers looked when they spied the enemy. In this case the people doing the expressing are the people in the painting, their faces show the viewer how they feel, and their feelings show something about their characters. But also present are three associations that have theoretical implications: the association of expression with face, with emotion, and with character. Blake is following a train of metaphorical association from expression to character that has face as its intermediate term: the expression of the face reveals character; face expresses character. Taken by itself there is nothing distinctively romantic about this, of course, and Blake is obviously at one not only with Pilkington's *Dictionary* but also with *The Bee* and Landseer's *Lectures*. In Blake as in the others, expression almost invariably attaches to character: "Expression cannot exist without character as its stamina" (*DC*; E 540), he says.[11]

Here we are moving toward a theory of artistic coherence and unity: the faces of the figures in a work of art express their characters, or, as Pilkington puts it, the faces exhibit "the several passions proper to the figures," the "action suitable" to the "human body," and so on. This is the principle that Landseer's distinguished artist and critic is applying to Raphael, who is said to have adapted form to character. The relationship between character and expression provides more than one standard of artistic coherence, however. One standard is essentially external to the character and may be social; for instance, it may be asked if that expression of that emotion is appropriate to that social situation (festival, funeral). The social situation may be translated into the artistic terms used to define a genre. Thus epic may be conceived as a social situation and the question may be asked, Is that expression of that emotion appropriate to that genre? The other standard is internal: Is the emotion expressed on that figure's face appropriate to her character, that is, her mind? Although in classical formulations the latter tends to be resolved

[11] Although "stamina" has the original Latin sense of "warp" or stationary threads in the weaving of cloth, by Blake's time its usual connotations were organic rather than mechanic, and the word tended to mean something like "basic vital constituent" or "seed."

in the former—the internal in the external—while in romantic formulations the reverse is true, the words used to describe the relationship ("suitability," "propriety," "appropriateness," etc.) may remain the same. The characteristic romantic way of resolving social aspects of expression into individual or private ones is to enlarge its meaning so that it describes something in the work, as always, but also something in the artist that gets into the work, as in Blake's principle that "Character & Expression can only be Expressed by those who Feel Them" (*PA*; E 568). The change is crucial, making all the difference between expression as a mere characteristic of art and expression as the basis for a full-fledged expressive theory of art in the romantic sense.

Broadening the application of the term "expression" to include the artist is the shift that allows expression to be moved from the periphery of Enlightenment classicism to the center of romanticism. As if by a process of natural selection in esthetic theory, the definitions of "expression" that begin to take precedence are those that emphasize the connection between the expressive powers of the artist and the expressive qualities in the work, as the reviewer in *The Bee* writes of expression being "the immediate gift of Heaven" that allows the "original Genius" of the painter to be "displayed in the natural *Expression* of *Truth* and *Beauty*." This is not a new idea but a new emphasis, increasing the significance of an old way of giving the artist a place in the work of art. In the late seventeenth century, John Evelyn's translation of Fréart's *Idea of the Perfection of Painting* makes the expected connection between self and expression: "It is from hence [from expression in painting], a Man is enabl'd to judge of the worth and abilities of a *Painter*; for such an Artist paints *Himselfe* in his *Tables* [canvases], and represents, as in so many *Mirrours* and *Glasses*, the temper of his own *humour* and *Genius*."[12] In his *Theory of Painting* Jonathan Richardson again recites the commonplace, extending it a bit: "(As it has been observed by others before me, and must be true in the main from the nature of things) painters paint themselves. . . . One [painter with an unsound character] will overlook, and debase a fine character [in the painting itself], the other

[12] Roland Fréart, *An Idea of the Perfection of Painting*, trans. John Evelyn (London, 1668), p. 14.

[painter with a sound character] will raise a mean one."[13] The traditional emphasis is heavily moralistic. Both Fréart and Richardson use the idea that painters are present in paintings as the basis for passing moral and technical judgments on "the worth and abilities of a *Painter*." The judgments will be supported by public standards of morality and technique. That is, the traditional interest is in similarities of character rather than in differences—in a supposedly universal ideal of virtuous and artistic human nature rather than in unique human natures. Despite the apparent individualism involved in their principle, neither Fréart nor Richardson seems much interested in witnessing the revelation of the painter's original genius, and in that the painter's individual character, through the agency of a painting.

In his Royal Academy lectures to a later generation, James Barry demonstrates that the stock formula is still usable. In his lecture on design, he cites "the old adage, 'that the painter paints himself, or that the work is always a representation of the author,' " speaks of "the mind of the artist which is visible in what he does," and asserts that "he cannot be original without showing himself." But the connotations have subtly shifted away from morality toward personality. Barry is clearly more comfortable with ideas of originality and the revelation of the artist's mind in the art than, say, Reynolds is. When Barry laments the loss of a work by Leonardo—"Thus perished one of the most justly celebrated monuments of modern art, particularly for that part of design which regards the skilful delineation of the various sentiments of the soul, in all the diversities of character, expression of countenance, and of action"[14]—these souls whose sentiments are expressed in the countenances of characters in the painting might almost be aspects of Leonardo's soul, but are more likely to be the composite soul of universal human nature. Barry's emphasis here and elsewhere falls finally not on identity but on Enlightenment universality. It helps to remember that the old adage he cites is often accompanied by regret: it is unfortunate that "the painter paints himself" but, as Richardson says, "true in the main from the nature of things." The remedy, of course, which I discuss later, is for painters to purge themselves

[13] Jonathan Richardson, *The Theory of Painting* (1725), in *The Works of Jonathan Richardson*, ed. Horace Walpole (London, 1792), p. 92.
[14] *Lectures*, ed. Wornum, pp. 117, 128-29.

of "singularity"—of themselves—and to become universal human natures.

Reynolds creates a special category, the "original or characteristical style" of Discourse v, for painters whose powers reside in the display of their own original genius:

The excellency of every style, but of the subordinate styles more especially, will very much depend on preserving that union and harmony between all the component parts, that they may appear to hang well together, as if the whole proceeded from one mind. It is in the works of art, as in the characters of men. The faults or defects of some men seem to become them, when they appear to be the natural growth, and of a piece with the rest of their character. A faithful picture of a mind, though it be not of the most elevated kind, though it be irregular, wild, and incorrect, yet if it be marked with that spirit and firmness which characterizes works of genius, will claim attention, and be more striking than a combination of excellencies that do not seem to unite well together; or we may say, than a work that possesses even all excellencies, but those in a moderate degree. (v, 131-32; W 85)

Reynolds is like an angel in *The Marriage of Heaven and Hell*, seduced but unnerved by the energy of imagination. The strain that he feels in having to justify a position so distant from his home territory shows up in his rhetoric, where rational qualification softens stark paradox: the faults of some men "seem" to become them, when they "appear" to be a natural growth from their characters; component parts "appear" to hang together, "as if" from one mind, and so forth. Considerable deviance from the logic of his usual positions is required to give the original or characteristical style any credibility, and it is certainly no wonder that he grants it only the status of a subordinate style— subordinate, that is, to the "great style," which is described so as to match his Enlightenment artistic principles.

Nonetheless, Reynolds' description of a style based on the unique character of an artist, whose painting is the faithful picture of a mind, and whose artistic principles are determined by that mind itself, internally instead of externally, anticipates the romantic train of thought about art as an expression of the artist. It may seem curious that Blake reads past the description of the characteristical style in the *Discourses* with no sign that it is in a sense his style—or at least the theory that can be used to justify his style. The reason for his silence is obvious: the artists whom Reynolds cites as exemplars, Rubens, Salvator Rosa, and Pous-

sin. In fact Blake's annotations show that he agrees with much of Reynolds' evaluation of Poussin, but putting him in the company of Rubens and Salvator Rosa would only prove to Blake that Reynolds is blind to the difference between components that appear to hang together, as if from one mind, and those that really do.

The difference between the imitation and the original brings us back again to the principle that "Character & Expression can only be Expressed by those who Feel Them." Blake thus states a condition that ties the artist to the work with emotion. Blake's condition can be distinguished clearly from any condition that calls for separation between the artist's feelings and the feelings in the work, as in scientific naturalism, for example, which has the artist act as an observer for whom feeling is only a form of prejudice that threatens to blur a clear vision of facts. But even within the boundaries of Blake's condition—which is frequently repeated in one form or another by romantic successors—there are a number of distinct artistic possibilities. In the *Biographia*, Coleridge polarizes English literary history by distinguishing the most important two: "While the former [Shakespeare] darts himself forth, and passes into all the forms of human character and passion, the one Proteus of the fire and the flood; the other [Milton] attracts all forms and things to himself, into the unity of his own IDEAL."[15] Neither the way of Shakespeare nor of Milton involves imitation of nature in the classical or neoclassical manner. The romantic version of the way of Shakespeare is romantic empathy of the kind identified by Shelley in the *Defence* as "the great secret of morals . . . love; or a going out

[15] *Biographia Literaria*, ed. Shawcross, vol. II, chap. xv, p. 20. The artists tell the same story, with Michelangelo and Raphael in the place of Milton and Shakespeare: "Michelangelo came to nature, nature came to Raphael—he transmitted her features like a lucid glass, unstained, unmodified. We stand with awe before Michelangelo. . . . we embrace Raphael" (Fuseli, lecture on the art of the moderns, *Lectures*, ed. Wornum, p. 384). Opie concurs: "He [Raphael] saw in nature what every body sees, but nobody ever before so well expressed; . . . Michelangelo saw nature through a medium of his own" (lecture on design, *Lectures*, p. 268). The same formula can be given a negative slant. The "way of Milton" (and Michelangelo) seems to be the formula behind Ralph Wornum's criticism of Fuseli in Wornum's 1848 edition of lectures from the Royal Academy. Wornum pairs Fuseli with Blake: Fuseli "appears to have had somewhat of Blake's constitution of mind; what he saw proceeded from his ideas, rather than his ideas from what he saw: he appropriated [from nature] only general impressions" (*Lectures*, ed. Wornum, p. 50).

of our own nature, and an identification of ourselves with the beautiful which exists in thought, action, or person, not our own. A man, to be greatly good, must imagine intensely and comprehensively; he must put himself in the place of another and of many others; the pains and pleasures of his species must become his own. The great instrument of moral good is the imagination."[16] In the version of Keats, who might shoulder the waves while considering the whale, imaginative empathy is negative capability, as practitioners of which poets surrender their own characters and emotions in order better to imagine the characters in their works. Negative capability is the radical romantic transformation of mimesis: mimetic because it looks outside the artist for the subject matter of art; radical and romantic because it is based on imaginative identification with the external world. Romantic mimesis is engaged mimesis, the artist as the subject versus the artist as disengaged observer of the subject.

With his usual acuity Coleridge proceeds (in chap. xvii) to associate Wordsworth with his second alternative, the way of Milton, showing the irrelevance of Wordsworth's own attempts to justify the vocabulary and subject matter of his poetry on mimetic grounds. While with a sense of the dramatic Keats calls Wordsworth's approach the egotistical sublime, it is more convenient to use the term Keats did not bother to invent, positive capability, art as a picture of the artist's mind. Blake is the most radical English exponent of positive capability, the way of Milton (Milton, that is, in the translation offered by romantic theory): pure expression, in contrast to the various romantic compromises with mimesis. Blake's is the only truly unmediated vision in English romanticism. In Wordsworth and Coleridge it makes eminently good sense to speak of a poetic process, for instance, because the imagination is indeed a kind of processor, doing something essential to material offered to it by the external world, producing, in Coleridge's words, "a reconcilement of the external with the internal" that he calls "the power of humanizing nature": "Now Art . . . is the mediatress between,

[16] *Shelley's Critical Prose*, ed. McElderry, pp. 12-13. For an account of Shelley's ideas about expression and mimesis that is complex enough to do them justice in their own right, see Earl R. Wasserman, "Shelley's Last Poetics: A Reconsideration," *From Sensibility to Romanticism: Essays Presented to Frederick A. Pottle*, ed. Frederick W. Hilles and Harold Bloom (London: Oxford Univ. Press, 1965), pp. 487-511.

and reconciler of, nature and man."[17] Any number of metaphors describe the processing that the imagination does—infusing, stamping, reconciling, unifying, etc. The difference between Coleridge and Blake on the creative process can be measured by the extent to which Blake's arguments overwhelm descriptions of process with identities. Identity and negation, "is" and "is not," are the characteristic syntax of Blake's statements: "Imagination," he says in the margins of Wordsworth's *Poems* of 1815, "*is* the Divine Vision *not* of The World *nor* of Man *nor* from Man as. he is a Natural Man *but only* as he *is* a Spiritual Man Imagination has *nothing* to do with Memory" (my emphasis, E 655). When Wordsworth names observation and description with sensibility as the "powers requisite for the production of poetry," Blake comes back with the "One Power" that "alone makes a Poet.—Imagination The Divine Vision" (anno. Wordsworth; E 654). When Berkeley in his *Siris* describes learning as a process involving "experiments of sense" to allow "a gradual evolution or ascent" from lower faculties of the soul to the highest, and describes fancy as something that "works upon" subjects and reason as something that "considers and judges of the imaginations," Blake responds to him as to Wordsworth: "Knowledge is not by deduction but Immediate by Perception or Sense at once Christ addresses himself to the Man not to his Reason" (anno. Berkeley; E 653). The imagination, which as usual is defined by identifications of the sort that constitute most of Blake's responses to *Siris*, is "the Man" who can know immediately:

[God =] Imagination or the Human Eternal Body in Every Man
[Spirit =] Imagination or the Divine Body in Every Man
The All in Man The Divine Image or Imagination
Jesus considerd Imagination to be the Real Man
. . . the Eye of Imagination The Real Man (E 652-54)

Such identifications are the controlling metaphors of Blake's ideas about art. The relation between the artist and the work of art is finally just such an identification. Put in terms of a theory of expression, the artist expresses the work in the most radical sense: the work is the artist, or rather the "true Man" in the artist. Thus when Blake says that "expression cannot exist with-

[17] "On Poesy or Art," ed. Shawcross, II, 258, 253, 253.

out character as its stamina," he means character as an aspect of the "true Man," and the character of the artist as well as the characters in the work. As a consequence what Blake calls the characters in his works are less mimetic representations of people than mental traits or faculties, and the structure of the works becomes literally psychological, picturing the logic of the psyche, particularly the artist's psyche. Since the only faculty capable of conveying such a unity is imagination, the picture of the whole is a picture of the mind organized under imagination. Blake recognizes that every work of art, every human work of any kind, must to some degree be a picture of the mind itself, since that is all human beings have to think with. But he believes also that art is the cultural paradigm of mental activity: "Art is the First in Intellectuals" (AR; E 626) because, as Los thunders in *Jerusalem*, "God . . . is the intellectual fountain of Humanity" (*J* pl. 91:10; E 248). Or as Blake says "To the Christians," "I know of no other Christianity and of no other Gospel than the liberty both of body & mind to exercise the Divine Arts of Imagination" (*J* pl. 77; E 229).

Blake's insistence that art does not merely have an intellectual component but is the very epitome of intellectual activity raises the traditional problem of the place of ideas in art. Discussions of that issue often focus on allegory, which, since it embodies ideas in fictional characters, has been seen as a way of combining intellect with imagination. This is an important neoclassical theme, as in Winckelmann's complaint that the mind is absent from modern painting, that "the artist is lost in a desert. Tongues the most savage . . . are not more destitute of general signs, than painting in our days. The painter who thinks beyond his palette longs for some learned apparatus, by whose stores he might be enabled to invest abstracted ideas with sensible and meaning images." The painter "wishes for occasions to shew himself a poet, to produce significant images, to paint Allegory." Winckelmann links allegory with the expression of character and claims that "such a representation [of character] owes its possibility only to the allegorical method, whose images convey general ideas."[18] Blake's sympathy with such proposals accounts at least partly for his attraction to neoclassicism (and the idea of London

[18] *Reflections on the Painting and Sculpture of the Greeks: With Instructions for the Connoisseur, and An Essay on Grace in Works of Art*, trans. Henry Fuseli (London, 1765), pp. 58-59.

as a new Athens), and for his definition of "the most Sublime Poetry" as "Allegory address'd to the Intellectual powers." He adds that "it is also somewhat in the same manner defin'd by Plato" (letter to Butts, 6 July 1803, *Letters*, p. 69). But in issuing what sounds like a retraction in 1810, at the beginning of his essay describing one of his paintings of the Last Judgment, he distinguishes allegory and fable sharply from vision: "Fable or Allegory are a totally distinct & inferior kind of Poetry. Vision or Imagination is a Representation of what Eternally Exists. Really & Unchangeably. Fable or Allegory is Formd by the Daughters of Memory" (*VLJ*; E 544). The idea that art is essentially the expression of identity explains the distinction. Both allegory and vision are artistic products of intellect. But allegory is vision censored by memory. In the one, the artist processes or translates an approved social code into the matched correspondences of allegory; thus "Allegories are things that Relate to Moral Virtues" (*VLJ*; E 553). In the other, the uninterrupted individual imagination expresses its own identity in the lineaments of original vision.

A persistent theme of fable and allegory in our culture has been the evil of passion. Fable and allegory have not expressed the intellect in imaginative form because they have denied the passions. At best allegory is a partial expression of the "true Man"—analogous to our social selves. Vision, to be true, must be imaginatively complete: "Men are admitted into Heaven [i.e., into their own imaginations] not because they have curbed & governd their Passions or have No Passions but because they have Cultivated their Understandings. The Treasures of Heaven [of imagination] are not Negations of Passion but Realities of Intellect from which All the Passions Emanate Uncurbed in their Eternal Glory" (*VLJ*; E 553-54). The esthetic term "expression" is useful to Blake and his romantic successors in part because of its strong association with emotion, "every affection of the human soul, as exhibited in the countenance, from the gentlest emotion to the utmost fury and whirlwind of contending passions."[19] Expression is the category under which emotion is traditionally introduced into the discussion of art, especially visual art. When Pilkington tries to explain why "the term Expression" should not be "confounded with that of Pas-

[19] See n. 10 above.

WORKS, PART ONE 59

sion," the explanation only shows how deep the connection runs; and when the anonymous writer of *The Bee* emphasizes the extraordinary power of expression to "give pleasure, where all other requisites are defective," he anticipates Wordsworth's own emphasis in the Preface to *Lyrical Ballads* on pleasure as the great poetic principle. Thus moving expression to the center of an artistic theory means in some sense moving emotion itself to the center: Blake declares that character must be felt to be expressed; in Wordsworth's more famous declaration, "all good poetry"—without exception—"is the spontaneous overflow of powerful feelings" that "takes its origin from emotion recollected in tranquillity."[20]

Of course, the association of expression with emotion is still intact today. A poster that advertises self-expression in some upcoming artistic event is sure to make a reviewer dread a display of the artist's self-indulgent wallowing in private emotions. Closely related is the association between emotion and formlessness: the reviewer will dread an incomprehensible, chaotic display as well. Emotions, like the women whom they are traditionally supposed to characterize, vacillate unpredictably, while masculine reason stays steady on course. The picture of emotion as shapeless is embedded in a number of familiar ideas about art: in the usual eighteenth-century definition of sublimity, for instance, where strong, impetuous emotion is associated with vagueness; in Eliot's objective correlative, a poetic strategy made necessary by the supposedly subjective and formless nature of feelings; or in Robbe-Grillet's idea that, because modern writers are engaged with the world, their writing confuses the outlines of things or makes them incomprehensible[21] (passionate subjective engagement blurs; impassive objective disengagement clarifies). And as we saw earlier, in the visual arts the antithesis of emotion and reason has often been further equated with the antithesis of color and line. Color—itself formless—flows warm and cold like the emotions, while line, representing form and intellect, wins the traditional support of academicians. Thus the

[20] Preface to *Lyrical Ballads* (version of 1800), *The Prose Works of William Wordsworth*, ed. W.J.B. Owen and Jane Worthington Smyser (Oxford: Clarendon, 1974), I, 126, 148.
[21] Paraphrased by Wylie Sypher, *Literature and Technology: The Alien Vision* (New York: Random House, 1968), p. 87.

colorists of Venice and Flanders are the painters of emotion, the linearists of Rome painters of intellect.

This cluster of associations is frequently basic to Enlightenment ideas of artistic expression, of which Rubens becomes a stock exemplar. Reynolds struggles with the paradox of Enlightenment correctness in drawing to give Rubens his place as an exponent of the original or characteristical style, claiming that "one can scarce be brought to believe but that if any one of the qualities that he possessed had been more correct and perfect, his works would not have been so complete as they now appear" (V, 134; W 86). Reynolds' allowance that the incorrect and the imperfect can sometimes create works more complete than correctness and perfection can recalls the statement in *The Bee* that "*expression* will sometimes give pleasure, where all the other requisites are defective. . . . although . . . skill and learning may be wanting, the original Genius is displayed." And it is standard to say of the paintings of Rubens, as Pilkington does, that "the limbs in some parts [are] very inexact in the outline" (p. 481), while at the same time admiring their expressive qualities. Emotion is vague and expression of emotion must be vague accordingly. Expression is, among other things, the artistic privilege of being very inexact in the outline.

Needless to say, Blake's idea of expression, whatever it involves, does not involve inexactness. His running battle with Reynolds about the sublime is instructive. When Reynolds wants to "allow a poet to express his meaning, when his meaning is not well known to himself, with a certain degree of obscurity, as it is one source of the sublime" (VII, 193-94; W 119), Blake issues a flat denial: "Obscurity is Neither the Source of the Sublime nor of any Thing Else"; "All Sublimity is founded on Minute Discrimination" (AR; E 647, 632).[22] In his *Descriptive Catalogue* he similarly corrects the conventional idea of expression: "Such art of losing the outlines is the art of Venice and Flanders; it loses all character, and leaves what some people call, expression: but this is a false notion of expression; expression cannot exist without character as its stamina; and neither character nor expression can exist without firm and determinate outline" (*DC*; E 540). The same correction appears in his attack

[22] Reynolds is relying on Burke's idea that obscurity and privation are basic elements of the sublime.

on Stothard's painting of the Canterbury Pilgrims: "How spots of brown and yellow, smeared about at random, can be either young or old, I cannot see. . . . what connoisseurs call touch, I know by experience, must be the destruction of all character and expression, as it is of every lineament" (*DC*; E 531).

More is involved than meets the eye. Blake's argument with Enlightenment expression is also an argument about the nature of passion and, through it, about the artistic and cultural ideal of beauty. The contrast between Blake's view and Reynolds' is essential. "If you mean to preserve the most perfect beauty *in its most perfect state*," Reynolds says, "you cannot express the passions, all of which produce distortion and deformity, more or less, in the most beautiful faces" (v, 117-18; W 78). Reynolds' conventional point involves the classical ideal of beauty, which is physically static and emotionally cool. Passion introduces an irrational disturbance into an ideal uniformity. Passion is change expressed in motion (what Pilkington calls "the motions" that the passions "impress," "an agitation of soul"). Passion, change, and motion are mutability. Mutability is a distortion of the immutable, and distortion is ugly. Blake responds, "What Nonsense Passion & Expression is Beauty Itself—The Face that is Incapable of Passion & Expression is Deformity Itself Let it be Painted & Patchd & Praised & Advertised for Ever it will only be admired by Fools" (AR; E 642). Implicit in Reynolds' notion of the perfect state of perfect beauty is the attitude that passion itself is wrong; the ideal is passionless beauty, beauty unmoved and unmoving. Blake's metaphor of the painted, patched, and advertised whore is his response: Reynolds' cold Venus is merely the opposite face of the whore of the West.[23] Both are products of a morality of repression. Blake would say— as follows, in the last three stanzas of "Several Questions Answerd"—

The look of love alarms
Because tis filld with fire

[23] Hazard Adams, "Revisiting Reynolds' *Discourses* and Blake's Annotations," *Blake in His Time*, ed. Robert N. Essick and Donald Pearce (Bloomington: Indiana Univ. Press, 1978), p. 133, contrasts Reynolds' and Blake's ideas of beauty: "Reynolds tries to establish a principle of beauty based on generality and really subsumes sublimity under it. Blake . . . holds to a principle of sublimity based on particularity and tends to subsume beauty." I would add that Blake's ideas of beauty and sublimity are subsumed by a principle of imaginative identity.

But the look of soft deceit
Shall Win the lovers hire

Soft deceit & Idleness
These are Beautys sweetest dress

What is it men in women do require
The lineaments of Gratified Desire
What is it women do in men require
The lineaments of Gratified Desire (E 465-66)

Using a jingle about the moralities of repression and gratifica-
tion to illustrate a point about Blake's artistic principles may
seem off the mark, but of course Blake persistently avoids dis-
tinctions between morality and art by putting a mental principle,
the imagination, in charge of both. The lineaments of gratified
desire are the bounding outlines of imagination whether engaged
in art or sex, and soft deceit is a tool of seduction in both:
"There is no Such Thing as Softness in Art" (AR; E 635).
When Blake charges that "Reynolds cannot bear Expression"
(AR; E 642), he means partly that Reynolds cannot bear the
thought of gratification. The sexual relationship between artist
and work of art (and for that matter, audience) implied by these
crossbred metaphors is one that Blake favors repeatedly, not
least in *Jerusalem*, where it is basic.

The opposition between a static ideal of dispassionate beauty
in Reynolds and a dynamic ideal of passionate gratification in
Blake is very likely an episode in the large shift from static to
dynamic values in Western thought at the close of the Enlight-
enment that is sometimes associated with the change from neo-
classical to romantic values in art. The opposition between stasis
and dynamism accompanies an opposition between uniformitar-
ianism and diversitarianism.[24] Reynolds' idea of perfect beauty
values uniformity, Blake's diversity. In turn, the change from
uniformitarianism to diversitarianism parallels the movement of
expression as an artistic ideal from a peripheral to a central
position, because expression is the traditional category in the
visual arts for diversity. Expression covers both diversity within

[24] Morse Peckham has used the concepts of dynamism and diversitarianism,
along with other concepts, in his attempts to catch romanticism in a definition,
beginning with "Toward a Theory of Romanticism" (1951). Peckham borrows
the concepts from Arthur O. Lovejoy's *Great Chain of Being* (1936). Abrams,
The Mirror and the Lamp, pp. 21-22, associates classicism with uniformity, mod-
ernism with diversity.

the work (faces, characters, etc.) and diversity among works; moreover, to support diversity in practice, expression sanctions divergence from the consensus—from the rules, in Reynolds' Enlightenment terminology—about theory. Reynolds wants to take care of diversity with his original or characteristical style. But Blake recognizes the difference between allowing diversity a certain artistic place and making it a fundamental artistic principle. Reynolds reveals his true opinion in a remark such as this: "Peculiarities in the works of art, are like those in the human figure: it is by them that we are cognizable and distinguished one from another, but they are always so many blemishes" (VI, 165; W 102). Understanding the applicability of Reynolds' principle to both the work and the artist, Blake labels the principle an "Infernal Falshood" (AR; E 646), because what Reynolds calls a peculiarity and a blemish Blake calls an identity—the quality that allows us to tell the difference between Michelangelo, Raphael, and Blake. Reynolds and Rubens do not belong in this group because they do not, properly speaking, constitute artistic identities; they are "plagiaries"—composite identities.

Evidence of Blake's position comes as early as his annotations to Lavater's *Aphorisms* (about 1788), where he writes that "Variety does not necessarily suppose deformity. for a rose & a lilly. are various. & both beautiful Beauty is exuberant . . . & if ugliness is adjoind to beauty it is not the exuberance of beauty" (E 585), an idea summed up five years or so later in *The Marriage of Heaven and Hell*: "Exuberance is Beauty" (E 37). For romantics such as Wordsworth and Coleridge exuberance is a property of nature when it is being most itself—nature unrestrained by any principles of order other than those contained within it. Blake looks to imagination rather than nature for exuberance, but the resulting pattern is similar: exuberance is the expressive energy of identity. The metaphor suggests free but organized movement from the inside to the outside. Any movement from the outside to the inside would constitute restraint in the form of interference.

If beauty is a static central form located behind a welter of peculiarities in nature, then, as Reynolds says, "peculiarities . . . are always so many blemishes," and the object of the artist is not to recognize the rose in a rose but the flower in a rose. (The characteristical style builds upon the paradox—to put it

favorably—that blemishes, when they are, or rather seem to be, a natural growth, can be a source of pleasure.) But if beauty is identity, then, as Blake says, "in a Picture its Spots are its beauties" (*PA*; E 564), because (to use Reynolds against himself) "it is by them that we are cognizable and distinguished one from another." Particularity makes identity possible, and if identity is the principle of artistic coherence, the work will be "Organized & minutely delineated & Articulated" with techniques that correspond exactly to identity: lines, Blake says, "Drawn with a firm and decided hand at once with all its Spots & Blemishes which are beauties & not faults" (*PA*; E 565; at some point Blake deleted "with . . . faults"). The expression of identity is the theoretical basis of what has been called his eclectic technique in engraving:[25] "I defy any Man to Cut Cleaner Strokes than I do *or rougher when I please*" (my emphasis, *PA*; E 571). So it is certain that when he describes the style of engraving in his *Canterbury Pilgrims* print as "correct and finished" (E 556), he means something special—an idea of correctness that includes incorrectness, an idea of high finish that includes a lack of finish in the usual eighteenth-century sense of the term, roughness as well as smoothness. "Rougher when I please": not when the subject matter makes a stylistic choice seem appropriate, or when the consensus of artistic tradition favors this style over that in this circumstance, but when I please. In his discussion of the characteristical style, Reynolds verges on a standard of technique that can welcome roughness with smoothness. But Blake's assertion that artistic style expresses individual desire would make Reynolds profoundly uneasy. And of course any authentically characteristical style would violate the most important values in Reynolds' theory as a whole. An esthetic theory that values uniformity, consistency, and generalization so highly cannot value any very firm sense of individuality without contradiction. The source of uniformity for Reynolds (as for Blake) is nature as interpreted by public consensus. The standard is external. The

[25] Raymond Lister, *Infernal Methods: A Study of William Blake's Art Techniques* (London: G. Bell & Sons, 1975), treats Blake's style of engraving as eclectic. This has the disadvantage of suggesting not the form appropriate to identity but the multiple borrowing ("the possibilities of combining techniques," p. 23) that Blake likes to call plagiarism. By far the soundest description of Blake's technical eclecticism is to be found in Robert N. Essick, *William Blake, Printmaker* (Princeton: Princeton Univ. Press, 1980).

source of diversity for Blake, as for Reynolds, is the individual personality, centered in the imagination. For Reynolds performances based on internal standards must be validated, and usually regularized, by external judges. For Blake performances based on external standards must be validated by the individual imagination.

If expression, conventionally the specialized power of "exhibiting in the face the several passions proper to the figures" (in Pilkington's words), is made the center of a theory of art in which artists attempt to exhibit in the face of their work, so to speak, the passions appropriate to their identities, a metaphorical standard for artistic unity and coherence suggests itself: the human face. Thus what Coleridge and the German Romantics would call organic and describe in metaphors of vegetation and nature naturing, Blake calls physiognomic to emphasize its human aspect, its origin in intellectual activity (the head), and its liberation from natural law. And of course it is Blake's idea of nature that distinguishes his view of art from Wordsworth's and Coleridge's, as the annotations to Wordsworth show. As early as *There is No Natural Religion* (a) and *All Religions are One* (ca. 1788) Blake develops a contrast between "natural or organic" and the "form of Man," identifies the "Poetic Genius" as the "true Man," and makes that identification the basis of "the forms of all things," which "are derived from their Genius" (E 1, 2). The human form always seems to have artistic correspondences for Blake, as in one of the Proverbs of Hell: "The head Sublime, the heart Pathos, the genitals Beauty, the hands & feet Proportion" (*MHH*; E 37). "Physiognomy" as an esthetic term takes the face as a metaphor of the human form—the embodied imagination. The physiognomy of the work is the face of the work, as it were, the form of the artist's imagination in it. This is the imaginative form that the narrator of *The Marriage of Heaven and Hell* says he intends to reveal "by printing in the infernal method, by corrosives, . . . melting apparent surfaces away, and displaying the infinite which was hid" (E 38). When revealed, the hidden infinite will have a human form—the form of the imagination itself, which is Jesus. Thus *The Marriage* begins (pl. 3) with the resurrection of the artist/narrator.

The human face is a metaphor of the ideal artistic combination of the particular and the representative, on the principle stated first in *All Religions are One*: "As all men are alike in

outward form, So (and with the same infinite variety) all are alike in the Poetic Genius" (E 2). The same theme is again emphasized two decades later in the commentary on Chaucer that Blake writes for his *Descriptive Catalogue*, as in the remark that "the characters [of *Canterbury Tales*] themselves for ever remain unaltered, and consequently they are the physiognomies or lineaments of universal human life, beyond which Nature never steps" (*DC*; E 523-24; repeated E 558); or, translated into the terms of this discussion, Chaucer's characters express the imaginative form—the human face—of life. The use of "Nature" here, like a number of other apparently conventional features of Blake's Chaucer criticism, may be more characteristically Blakean than is at first evident. "Physiognomy" serves Blake's purposes well, because of the traditional use of the term to mean not merely face (as in "phiz") but also to suggest the face as a visual metaphor for the rest of the person, including mind, character, and body. This synecdoche, arousing the urge to systemize, supports the formal analysis of individual faces and their classification as to universal type.[26]

Drawing can be called "Physiognomic Strength & Power" (*PA*; E 560) because it is the power of defining the "true Man" of imagination. Since as far as Blake is concerned "definition" virtually means "line," "physiognomy" is virtually synonymous with line—"physiognomies or lineaments"—but with the added connotation of "human": "*Characters* . . . are the physiognomies or lineaments." Nature is the blurry approximation of human form, while physiognomic strength resides in the self-expression of the poetic genius. Self-expression for Blake necessarily means self-definition. Definition can be nothing if not definite, and thus physiognomic strength resides in the strength of the minute particular, on the "discrimination" of which "All Art is founded," because "General Masses are as Much Art as a Pasteboard Man is Human. . . . I intreat then that the Spectator will attend to

[26] Physiognomy was popular in Blake's time. He knew Lavater's *Essays on Physiognomy* (1788-89), for which he engraved some illustrations; his sympathy with Lavater in other respects is obvious from his annotations to Lavater's *Aphorisms on Man* (1788). The "visionary heads" that Blake drew for Varley late in life are a species of imaginative physiognomy, and Blake's life mask was itself intended as a physiognomical specimen for display in the shop of Deville the astrologer. See also Anne K. Mellor, "Physiognomy, Phrenology, and Blake's Visionary Heads," in *Blake in His Time*, ed. Essick and Pearce, pp. 53-74.

the Hands & Feet to the Lineaments of the Countenances they are all descriptive of Character & not a line is drawn without intention" (*VLJ*; E 550).

"Intention" here falls into the category of critical terms that define the relationship between the artist and the work: the artist intends it. Blake gives "intention"—"intend" from Latin *intendere*, to stretch toward, direct one's mind to—a number of connotations. It has the moral force of the expression of character: "He who stands doubting of what he intends whether it is Virtuous or Vicious knows not what Virtue means" (anno. Watson; E 603). Intention suggests to Blake the direct expression of feeling: "No man can think write or speak from his heart, but he must intend truth" (*All Religions are One*; E 2). A heart that intends truth is a heart that thinks, a heart that is also mind, and thus intention can be intellectually significant. Blake's assertion that "not a line is drawn without intention" is tautologous, because for Blake the firm line is the visual sign of firm intention.

INTEGRITY AND ORIGINALITY

Thus Blake widens the range of the traditional critical term "expression" considerably beyond its conventional association with emotion to mean the expression of the whole identity of the person. Since the imagination is that identity, art is indeed the expression of imagination. Expression in this full sense is part of the romantic artistic strategy that would restore integrity to personal identity. When he reads a dissociation of sensibility into European history, T. S. Eliot reads with the romantics, who offer repeatedly an ideal of wholeness in opposition, as they think, to a culture flying to pieces under the specialized pressures of industrialization.

Earlier in this century a common criticism of romanticism was its overreliance on individual emotion at the expense of something like rational thought. Shelley's self-dramatization in *Ode to the West Wind*, where he falls sensitively on the thorns of life and bleeds profuse feeling, was a favorite example. The romantics have since been restored to critical favor, and romanticism is at the center of a major reinterpretation of the history of the modern arts. Even so, the romantic poets are still often seen as ineffectual mythopoeists, extraordinarily sensitive to rev-

olutionary changes in modern life and to the deplorable social conditions around them, but better at crying out emotionally at the sight of such conditions than at thinking their way rationally toward solutions.

The argument against such objections turns partly on questions about the nature of art that are not particularly relevant here, especially the enduring suspicion that idle inventions of imagination are distractions from the proper business of real life. But one aspect of the argument involves expressive theories of art, which at every essential point, as we have seen, emphasize feeling rather than reasoning. Mimetic theories seem to do the opposite; the question is not what artists feel but what they see. Is expression then the emotive (or affective) theory of art that provides a foundation for romantic emotionalism in practice? Or, to state the question another way, is the romantic hero a sublime extension of the man of feeling from the previous age of sensibility?

One problem is the meaning of "feeling," which the romantics tend to use in one way, many of their critics in another. For critics of romanticism, emotion is a specialized reaction likely to mislead. It is literally thoughtless and is often opposed to thought: this problem is too important to be approached emotionally; we must approach it rationally. Suspicion of emotion involves a suspicion of immediate knowledge, of individual instincts as opposed to impersonal processes and methods, and of personal involvement as opposed to detachment.

In fact, such doubts about emotion correspond to doubts about imagination and, as Blake notices, doubts about sex. He also notices that some of the deepest divisions in his culture correspond to ambivalence about sex, emotion, and imagination, and further, that an ambivalence about one of the three often parallels an ambivalence about another: love at first sight is as suspiciously regarded as immediate knowledge, and both are regarded as cultural myths, fictions invented by the imagination. Metaphors themselves are forms of immediate knowledge, of connection without process, and are often said to hide errors in reasoning, or to be seductive, and so on.

But the expressive theories of art that romanticism historically favors use emotion not as a specialized reaction but as a synthetic reaction, and not as a reaction only, but as an action too. An important goal of the romantic program, as it has been titled

recently, is not emotion but wholeness, and emotion is often employed as a sign of wholeness, as reason is employed in the Renaissance. Right reason for the Renaissance largely corresponds to right feeling in the intellectual scheme of the romantics, though the significance of the two is different. Feeling in this sense does not oppose rational thought but uses the individual human being as a measure of the correctness of rational thought. As Blake would say, it is the human form of thought, romantic humanism, in which reason is subsumed not by religion, as in the Renaissance, but by its spiritual guide, imagination, which replaces the God of the Renaissance as the spiritual shape of human purposes. As feeling is not a specialized response, imagination is not a specialized faculty but a synthesis of all faculties. Mental disintegration and reintegration are a favorite romantic theme. When Wordsworth in *The Prelude* and elsewhere makes a plot out of the loss and restoration of imagination, he is writing not about the specialized skill or talent that makes a poet the way muscular coordination makes an athlete but about the reintegration of a fragmented identity at war with itself. One important sign of the loss of identiy is the loss of feeling, because feeling emanates from the whole personality. Specialized reason, on the contrary, is by Wordsworth's time disembodied technique, a system or method that can be taught, learned, and even mechanized.

Art, the product of imagination, is the natural embodiment of the synthesis of sensation, emotion, and thought. In *A Vision of the Last Judgment* (1810), Blake corrects the usual view: "Men are admitted into Heaven [the imagination] not because they have curbed & governd their Passions or have No Passions but because they have Cultivated their Understandings. . . . Those who are cast out Are All Those who having no Passions of their own because No Intellect. Have spent their lives in Curbing & Governing other Peoples by the Various arts of Poverty & Cruelty of all kinds" (*VLJ*; E 553-54). Intellect for Blake is mental integrity as expressed in art, not a specialized rational faculty. Intellect incorporates the entirely free emanation of all the feelings in imaginative form, that is, a form appropriate to the individual. Shelley, prime exemplar of the feeling romantic, describes the human wholeness of art, which "compels us to feel that which we perceive, and to imagine that which we know." This integration makes it possible to claim that imagination is

the "great instrument of moral good."[27] In a famous sentence in the Preface to *Lyrical Ballads*, Wordsworth calls poetry "the breath and finer spirit of all knowledge; it is the impassioned expression which is in the countenance of all Science."[28] Wordsworth's metaphor takes feeling about knowing to be more complete than just knowing. Poetry is the completion of knowledge; it is the behavior that results from how we feel ("impassioned expression . . . in the countenance") about what we know ("all knowledge . . . all Science"). Coleridge similarly describes the leading features of Wordsworth's poetry that he noticed the first time he read it: "It was the union of deep feeling with profound thought." Poetry, he says, has a striking power to reveal "the mind that *feels* the *riddle* of the world," and "to carry on the *feelings* of childhood into the [intellectual] *powers* of manhood" (my emphasis).[29] Coleridge is drafting the romantic version of the commonplace that poetry makes old things seem new: poetry completes thought with feeling. He adds that "this is the character and privilege of genius," for the unstated reason that genius is more nearly complete than other personalities and aspects of personalities. In fact, "the poet, described in *ideal* perfection, brings the whole soul of man into activity, with the subordination of its faculties to each other, according to their relative worth and dignity. He diffuses a tone and spirit of unity, that blends, and (as it were) *fuses*, each into each, by that synthetic and magical power, to which we have exclusively appropriated the name of imagination."[30]

One effect of this idea on artistic forms is to promote a multimedia ideal of completeness. If the work of art is going to strive to become the expression of the whole soul of man, then it must be commodious enough to accommodate such a comprehensive ideal. The natural tendency of the argument is to favor plenitude over specialization, diversity over uniformity, mixture over purity, and the like, with the recognition that plenitude, diversity, and mixture are human or organic whereas specialization, uniformity, and purity are mechanical. Wagner's musical drama is a late product of this romantic ideal, as is

[27] *Defence of Poetry*, ed. McElderry, pp. 32, 13.

[28] Preface to *Lyrical Ballads* (version of 1850), *Prose Works*, ed. Owen and Smyser, I, 141.

[29] *Biographia Literaria*, ed. Shawcross, vol. I, chap. iv, p. 59.

[30] *Biographia Literaria*, ed. Shawcross, vol. II, chap. xiv, p. 12.

program music of the sort that Berlioz's *Symphonie Fantastique* represents, or Turner's combinations of words and images. But Shelley, who was himself an artist in words only, complains in his *Defence* that specialization is a product of "the decay of social life," one symptom of which is "tragedy . . . divested of all harmonious accompaniment of the kindred arts." He characterizes the drama approvingly as "that form under which a greater number of modes of expression in poetry are susceptible of being combined than any other," but goes on to complain that "on the modern stage a few only of the elements capable of expressing the image of the poet's conception are employed at once. We have tragedy without music and dancing; and music and dancing without the highest impersonations of which they are the fit accompaniment, and both without religion and solemnity," although the "modern practice of blending comedy with tragedy . . . is undoubtedly an extension of the dramatic circle."[31]

Blake's illuminated books are an effort to restore completeness and coherence in those "elements," as Shelley calls them, "capable of expressing the image of the poet's conception." In *The Marriage of Heaven and Hell*, probably Blake's first statement on the subject, the metaphor for the restoration of artistic integrity is the reunion of body and soul, which the narrator says he will accomplish "by printing in the infernal method, by corrosives" (*MHH* pl. 14; E 38), a description of the relief-etching process used to make the illuminated books. In *The Marriage* body and soul are not only pictures and words but also energy and reason, sex and morality, devils and angels, hell and heaven. Many commentators have noticed that, although the title joins heaven and hell on equal terms, the work itself gives hell most of the space. It does that for the same reason that theories of expression give such prominence to feeling. Angels and reason have been dominant for so long that the argument in their favor is built into our acculturated brains. Energy, in *The Marriage*, covers the territory of expression, emotion, and imagination, and an expressive theory of art is part of it. The Proverbs of Hell show the associations of energy with the expression of desire, emotion, sex, self, imagination, and art. Energy, like its product art, is expressive; reason is repressive. Energy issues from the inside out, reason from the outside in. The satirical

[31] *Defence of Poetry*, ed. McElderry, pp. 16, 17, 14.

strategy of *The Marriage* is to subsume reason under energy by asserting devilishly that "Energy is the only life. . . . Reason is the bound or outward circumference of Energy" (*MHH* pl. 4; E 34). Reason is only the name for the (present) limit of energy.

The restoration of wholeness to the personality restores identity, and in doing so restores the possibility of originality to art. When Blake calls for originality we must understand that he means the complete self-expression of a complete self in imagination. Imagination is less the name of a specialized faculty that processes thoughts or images than a synonym for identity. Considered as a process, its work is restoring thoughts and images to identity, that is, to wholeness.

In the classical and neoclassical tradition originality usually means novelty, a change of angle (conception) or style (execution) more or less imposed upon nature, which comprises the ideas and objects of imitation that really matter. The admixture of novelty in a superior artistic work would imitate the (moderate) proportion of novelty in nature, where novelty provides the variety that serves chiefly to call attention to the sameness. The second "principle" in Blake's *All Religions are One*, one of his earliest works in illuminated printing (ca. 1788), pretends to offer a version of this idea: "As all men are alike in outward form, So (and with the same infinite variety) all are alike in the Poetic Genius" (E 2). The clichés, the reasonable tone, and the syllogistic diction in *All Religions* are only rhetorical bait. By the sixth principle the reader has been cornered into believing that "The Jewish & Christian Testaments are An original derivation from the Poetic Genius," and by the seventh that "As all men are alike (tho' infinitely various) So all Religions & as all similars have one source." The last principle inexorably moves in: "The true Man is the source he being the Poetic Genius" (E 3). Reading this mock syllogism for its bearing on originality, we notice that the emphasis is not on the work of art, or the aspect of nature being imitated by the work, but on the character of the poet, from whom works of art are derivations. The ultimate artist is God, apparently, and the ultimate original derivation is the "Jewish & Christian Testaments"; and God is "true Man," and poetic genius.

In the context of artistic originality, this sort of romantic internalization is one way of reestablishing the original integrity

and centrality of the human being by reinterpreting the historical origins of the external world. Two metaphors are fundamental: a balance of power between internal and external worlds, and wholeness. In a middle or golden phase classicism strives for balance between private and public need, but there is an important Enlightenment shift in favor of the external that is coincident with the growth of technique—systematic procedures with measurable and predictable results—in almost all areas of English culture, but especially in the familiar triad of science, technology, and commerce. Romantics like Blake do not strive to restore a balance between public and private but to restore personal wholeness. The difference in metaphors is essential: balance avoids both extremes of imbalance, while wholeness is itself an extreme, its opposite being fragmentation. Blake exploits the satirical possibilities of this contrast in *The Marriage*, where moderation is the butt of the satire ("Prudence is a rich ugly old maid courted by Incapacity") and is associated with the external ("Bring out number weight & measure in a year of dearth"), while the satirical norm is wholeness ("Man has no Body distinct from his Soul," and "the notion that man has a body distinct from his soul, is to be expunged"), which is associated with the internal ("Thus men forgot that All deities reside in the human breast," and "God only Acts & Is, in existing beings or Men," as well as "Jesus was all virtue, and acted from impulse, not from rules" [E 35-42]). Appropriately, the strongest criticism of Swedenborg in *The Marriage* (pls. 21-22) is that he is not original.

During this same period in Germany Friedrich Schiller uses similar metaphors to describe the modern split between sense and intellect: "With us . . . the image of the human species is projected in magnified form into separate individuals—but as fragments . . . with the result that one has to go the rounds from one individual to another in order to be able to piece together a complete image of the species. With us, one might almost be tempted to assert, the various faculties appear as separate in practice as they are distinguished by the psychologist in theory, and we see not merely individuals, but whole classes of men, developing but one part of their potentialities, while of the rest, as in stunted growths, only vestigial traces remain." And, like Shelley and Blake, Schiller tells a golden-age myth of original wholeness. When Blake was telling how "The ancient Poets animated all

sensible objects with Gods or Geniuses" (*MHH* pl. 11; E 37), Schiller was telling how "at that first fair awakening of the powers of the mind, sense and intellect did not as yet rule over strictly separate domains; for no dissension had as yet provoked them into hostile partition and mutual demarcation of their frontiers. . . . However high the mind might soar, it always drew matter lovingly along with it."[32]

The primary goal of originality as one of Blake's artistic principles is personal realization rather than historical recognition. The personal generates and also controls interpretation of the historical, even in a mock: "Columbus discoverd America but Americus Vesputius finishd & smoothd it over like an English Engraver or Corregio or Titian" (*PA*; E 567). Enlightenment originality is, however, primarily a public matter, and thus favorable judgments tend to be based on its historical meaning: the original artist discovers how to do something that no successor can afford not to do. Supremely original artists are thus supremely imitable. Personal originality tends to be either a peripheral source of pleasing variety in an otherwise public work, or, if central, then negative, just as the judgment of originals or eccentrics tends to be negative. The proper place for fictional originals in Enlightenment literature is satire, where they are usually self-deceived characters whose originality turns out to be foolishness when put under public scrutiny.

Reaching for social consensus here, as usual, Enlightenment principles treat deviant works of art like social deviants. Personal originality in romanticism is thus singularity in classicism, and artistic singularity is dismissed by questioning the motives of the artist. Gersaint, one of Rembrandt's Enlightenment cataloguers, frequently criticizes Rembrandt's work as if it were the behavior of an unruly adolescent straining to make an impression at a party of polite adults. Of course, the Rembrandt who too often "Affected a Singularity" and who was "sometimes reduced to Absurdity by his Desire of Singularity"[33] created the

[32] Friedrich von Schiller, from the sixth letter, *On the Aesthetic Education of Man, in a Series of Letters*, trans. and ed. E. M. Wilkinson and L. A. Willoughby (Oxford: Clarendon, 1967), p. 31.

[33] M. Gersaint, et les Sieurs Helle and Glomy, *A Catalogue and Description of the Etchings of Rembrandt Van-Rhyn, With some Account of his Life*, . . . translated from the French [with many changes and additions] (London, 1752), pp. 3, 32. The French edition was published in 1751.

very work that a twentieth-century critic such as William Ivins, employing romantic principles, can turn around and call "his most remarkable accomplishments," and "highly autographic and idiosyncratic."[34]

Since the Enlightenment skepticism toward unique artistry is based on a positive faith in consensus, negative judgments of nonconformity are made from the point of view of the conforming group, interpreting uniqueness as a threat to solidarity. Singularity is thus interpreted as false or affected rather than authentic. The view assumes that the authentic personality of the artist will conform to the group. When Reynolds tries to account for Gainsborough's style, for instance, he is driven to compare the painter to someone who does not use language in the customary way, "speaking a language, which they can scarce be said to understand; and who, without knowing the appropriate [i.e., correct] expression of almost any one idea, contrive to communicate the lively and forcible impressions of an energetick mind" (xiv; W 258). Reynolds' suspicion of any style that appears characteristic makes it no surprise to find Gainsborough's style compared to the language of a person who doesn't know what he is saying as he tries to communicate the impressions of an energetic mind. But the most remarkable feature of the description lies in the implication that Gainsborough cannot know the language he speaks because others do not know it. This is of course an extreme and unconscious Enlightenment parody of the oracular knowledge that the oracle may deliver but cannot understand. The resulting vision of one who speaks, then steps outside oneself to learn one's own language with a group, then presumably translates oneself for oneself into the language of the community, is a stunning indicator of one of the limits of Enlightenment comprehension. Blake can doubtless see that if Reynolds' principles cannot contain Gainsborough—a mild case of the characteristic indeed—there is little hope for himself, even if he would settle for a corner of that cautious category.

During his lifetime, Blake seems always vulnerable to negative evaluations of his originality by a conforming community: "Those who have been told that my Works are but an unscien-

[34] Ivins, *Prints and Visual Communication* (1953; Cambridge, Mass.: MIT Press, 1969), p. 80.

tific and irregular Eccentricity, a Madman's Scrawls, I demand of them to do me the justice to examine before they decide." The occasion of the remark, which occurs in the advertisement for his exhibition of 1809, could stand as an epitome. He has been excluded from the group that represents the consensus: "The execution of my Designs, being all in Water-colours, (that is in Fresco) are regularly refused to be exhibited by the *Royal Academy*, and the *British Institution* has, this year, followed its example, and has effectually excluded me by this Resolution." He consequently organizes an exhibition of his work, and his work only, in his own brother's residence: "I therefore invite those Noblemen and Gentlemen, who are its [the resolution's] Subscribers, to inspect what they have excluded" (E 518). The *Descriptive Catalogue* of the exhibition is described in suitable terms as "Original Conceptions on Art, by an Original Artist" (E 519). With his residential exhibition of original works of art and his descriptive catalogue of original ideas, Blake is not trying to win admission to the group from which he is excluded but to generate a group with his own imagination at the center.

This behavior of course illustrates one phase of romantic individualism, which is easily misinterpreted along Enlightenment lines to mean something like a maverick mentality. Wylie Sypher, for instance, asserts that the six great romantics are linked by feeling rather than method or "any agreement about execution. The English romantics had no accepted theory of their métier, although there was a consistent emphasis upon the sanction of feeling. The romantics validated their poetry by their personality, not by their method, about which they were sadly at odds."[35] It is true enough—to take only one representative instance—that Blake and the institutions that represent artistic consensus are sadly at odds. But they would seriously differ on the nature of their differences. Blake wants to be accepted, of course, but he does not want agreement. He wants inclusion on his own terms. The only thing that is sad about being at odds is the exclusion—from a community requiring uniformity—that results. Sypher misses the point about the romantics' lack of a consensus about execution, and the implication that they reached a consensus about feeling is misleading as well, if he means a consensus about artistic conception. Although they criticized each

[35] Sypher, *Literature and Technology*, p. 41.

others' execution severely on occasion, I am not aware of any serious attempt to reach a consensus, and in fact the absence of consensus is almost programmatic. The essential romantic idea of organic unity, including Blake's version of it, virtually precludes any such consensus about execution, which in Blake's vocabulary would be only a "machine" of art anyway. And of course he would certainly not assent to the "sanction of feeling" by which Sypher characterizes the English romantics. It is hardly accurate to oppose feeling or personality to theory or method as Sypher would have it. Feeling is not equal to conception in romantic art as his opposition implies; execution is not equal to method; and of course personality is not equal to feeling. The only sense in which the "romantics validated their poetry by their personality" is that in which personality is the creation of imagination (the poetic genius), which is not feeling but a unity of feeling and thought.

Adherence to an expressive theory of art and a concept of individual identity eliminates the possibility of a standard idea of beauty or hero, a standard definition of poem or painting, and thus any standard public basis on which to judge works of art. There is no possibility of a romantic consensus on execution or on conception, despite the contention that feeling somehow represents one. The consensus was rather against consensus.

Criticized on Enlightenment principles, romantic art would seem to be obsessed with trying to find new things to say and new ways of saying them, at the expense of abiding truths and what Reynolds calls "the world's opinion" (II, 38; W 32). But a debate based on such a superficial conception of originality could lead only to superficial conclusions, with the side favoring originality represented by, say, Edward Young's essay on original composition, where originality seems to be chiefly a tactic in a game played by living writers competing for a reputation with dead writers whose reputations are secure. Blake may seem to be at this level when he says that his execution is unique and that "none but Blockheads copy one another" (PA; E 571). But Blake's idea of originality is the deep originality of human personality expressed in works of art that perfectly unite conception and execution. Originality of personality is perfect integrity of personality, not feeling but wholeness. Artistic execution is "Physiognomic Strength & Power," the strength of identity, in

contrast to "Imbecillity" (*PA*; E 560), the weakness of nonentity, an empty container where personality should be. Original art is an act of imagination in a community where any one expression of individuality complements or coexists with many other expressions of other individualities.

III.

Works, Part Two

CONTENT BECOMING FORM IN SIX SCENES

In all the works of art there is to be considered, the thought, and
the workmanship, or manner of expressing, or executing that
thought. What ideas the artist had we can only guess at by what we
see, and consequently cannot tell how far he has fallen short, or per-
haps by accident exceeded them, but the work like the corporeal,
and material part of man is apparent, and to be seen to the utmost.
Thus in the art I am discoursing upon, every thing that is done is in
pursuance of some ideas the master has, whether he can reach with
his hand, what his mind has conceived, or no. —Jonathan
Richardson, *The Theory of Painting*

CLOSING FORM AND CONTENT

Some Integrative Rhetoric

> There is a Moment in each Day that Satan cannot find
> Nor can his Watch Fiends find it, but the Industrious find
> This Moment & it multiply. & when it once is found
> It renovates every Moment of the Day if rightly placed[.]
> In this Moment Ololon descended to Los & Enitharmon
>
> > (*Milton* pl. 35:42-46; E 135)

The moment in each day that Satan and his Watch Fiends try
to find is the moment when the artist's conception expresses itself
in the execution; the moment when the conception is "in" the
execution; or "is" the execution. If mental things are alone real,
then all objects, including art objects, are absorbed into the sub-
ject. If the subject is the artist and the mental faculty the artist's
imagination, then the idea behind the work of art is, finally, the
work itself.

While relation of content to form is a significant issue in every artistic theory known to me, it is central in romantic expressive theories.[1] Virtually every idea fundamental to expressive theories can be translated into the idea of form and content. If expressive theories tend to erase distinctions between artists and art—in fact to search for artists in their art, and in later extensions of the theory to study artists' lives as their most important works, and so on[2]—then there is a parallel tendency to eliminate distinctions between the idea for the work of art and the work itself. Coleridge remarks that, measured against this standard, nature, which seems to be God's magnum opus, displays "co-instantaneity of the plan and the execution" in which "the thought and the product are one." When carried to the limit of artistic possibility, human works, however, are similarly able to "make the external internal, the internal external, to make nature thought, and thought nature,—this is the mystery of genius in the Fine Arts. Dare I add that the genius must act on the feeling, that body is but a striving to become mind,—that it is mind in its essence!" If all theories of art have their

[1] Abrams discusses the romantic need "to heal the cleavage between thought and expression, language and figure, by substituting an integrative for the separative analogues most frequent in earlier rhetoric." He emphasizes Wordsworth, who opposes "the body-and-soul of traditional philosophy to the body-and-garment, garment-and-ornament of traditional rhetoric" (*The Mirror and the Lamp: Romantic Theory and the Critical Tradition* [New York: Oxford Univ. Press, 1953], pp. 290-91). Abrams sees this integrative rhetoric developing out of an eighteenth-century association of style (in our terms, execution) with the artist, content with cultural traditions. Abrams does not mention Blake. We shall come at the same idea in another way, better suited to Blake's own formulation of the problem.

A number of sections in Lawrence Lipking's *The Ordering of the Arts in Eighteenth-Century England* (Princeton: Princeton Univ. Press, 1970) are relevant to the ideas in the present chapter, especially perhaps part 2, "The Ordering of Painting," and within that the chapter on Reynolds' *Discourses*, pp. 164-207.

[2] In his *Romantic Image* (New York: Random House, 1957), Frank Kermode discusses the postromantic idea of the "inextricable" relation between "form" and "matter" in artistic "vision." He quotes from Pater's essay on Winckelmann: "The mind begins and ends with the first image, yet loses no part of the spiritual motive. That motive is not loosely or lightly attached to the sensuous form, but saturates and is identical with it." Kermode rightly concludes, "This, of course, is what gives music its status as the art to which all the others aspire; it resists the separation of matter and form," and goes on to quote Graham Hough from *The Last Romantics*: "His [Pater's] ideal is the kind of art where thought and its sensible embodiment are completely fused" (p. 21).

obsessions, the leading obsession of expressive theories is probably artistic unity, "the thought which is present at once in the whole and in every part,"[3] according to Coleridge. Shelley is measuring poetry on this scale even when he divides idea from execution in his famous metaphor of the poet whose fiery imagination is cooling off by the time the poem is being written down. The standard is the same: the best poem is the one closest to the original conception, the poem whose conception seems to contain its own execution.

While it is impossible to forget the romantic concern with unity, it is easier to forget the grounds on which the idea of unity rests: not primarily on the formal properties of the work but the expressive relation of artist to work. Of course the work will display formal unity, but that unity will depend upon its success in expressing the unity of the artist's imagination. Shelley can thus say that "a great statue or picture grows under the power of the artist as a child in the mother's womb" in one sentence and in the next say that "poetry is the record of the best and happiest moments of the happiest and best minds."[4] To put it crudely, the organically organized poem clones the true self of the poet.

Blake's pointed remarks about the relation of form to content make it impossible to mistake his position, though one may easily mistake its significance. This chapter and in a broader sense this book provide what I take to be the context of the following passage:

I have heard many People say Give me the Ideas. It is no matter what Words you put them into & others say Give me the Design it is no matter for the Execution. These People know Enough of Artifice but Nothing Of Art. Ideas cannot be Given but in their minutely Appropriate Words nor Can a Design be made without its minutely Appropriate Execution[.] The unorganized Blots & Blurs of Rubens & Titian are not Art nor can their Method ever express Ideas or Imaginations any more than Popes Metaphysical Jargon of Rhyming[.] Unappropriate Execution is the Most nauseous of all affectation & foppery He who copies does not Execute he only Imitates what is

[3] "On Poesy or Art," *Biographia Literaria* (and Coleridge's "Aesthetical Essays"), ed. John Shawcross, rev. ed. (London: Oxford Univ. Press, 1954), II, 257, 258, 255.

[4] *A Defence of Poetry*, in *Shelley's Critical Prose*, ed. Bruce R. McElderry, Jr. (Lincoln: Univ. of Nebraska Press, 1967), p. 31.

already Executed Execution is only the result of Invention[.] (*PA*; E 565)

Here content is "ideas" and "design" and form is "words" and "execution," in poetry and painting, respectively. To name the relationship Blake chooses the term "appropriate," contrasted to "unappropriate." The vocabulary is conservative Enlightenment, the position radical romantic. On a scale that slides from complete separation of form and content at one end to complete identity at the other, Blake belongs as far from the center as any other artist in England at the time, inclining very nearly to the position that conception and execution are not divisible, that each must necessarily be perfectly appropriate to the other or the result is absolute artistic incoherence. Thus the emphasis in the passage quoted: "Ideas *cannot* be Given but in their *minutely* Appropriate Words nor *Can* a Design be made without its minutely Appropriate Execution." A radical formulation emerges: "Execution is only the result of Invention." And because form and content are interdependent, the formulation is reversible: "Invention depends Altogether upon Execution or Organization. as that is right or wrong so is the Invention perfect or imperfect" (*AR*; E 626). Though "appropriate" in Blake's criticism may sometimes seem to have eighteenth-century force, as when he insists that "every Horse [in his Chaucer fresco] is appropriate to his Rider" (E 557), the authentic thrust is expressive: "colouring appropriate" that "Imagination only, can furnish us" (*DC*; E 536). Form is answerable to content, color to line, and all to the imagination. Blake uses appropriateness stripped of its usual public connotations of decent behavior according to communal norms (the issue behind Reynolds' discussion of Gainsborough) and converts it from an external to an internal standard that is an extension of the personal imaginative standard of identity. The question *appropriate to what?* brings the artist's answer, *to my vision of it.*

Appropriateness so internalized internalizes ideas of artistic significance. When Blake declares that, "as Poetry admits not a Letter that is Insignificant so Painting admits not a Grain of Sand or a Blade of Grass Insignificant much less an Insignificant Blur or Mark" (*VLJ*; E 550), the criterion of significance is identity. Thus the synonym for "significant" in this case is "characteristic"—of the imagination of the artist. This meaning

needs to be distinguished from at least two others. The signifi-
cance to be found in the identity of the artist is not external and
public significance of the kind that makes us think of interna-
tional wars fought in the public interest as more significant than
some mere private affair of the heart. By asserting that lines are
significant, Blake is asserting that the imagination is significant,
contrary to the usual notion that significance is a characteristic
of ideas and actions. Traditionally, the role of the insignificant
imagination is to increase the attractiveness of significance, or
truth, by ornamenting it. The work of imagination is nonethe-
less insignificant because it is separable and dispensable; someone
really serious about a truthful idea will know how to disregard
the imaginative particulars that decorate it. Moreover, as a crit-
ical theory Blake's assertion of significance in every letter and
mark differs fundamentally from similar assertions associated
with various critical schools of this century that want to empha-
size the formal and internal properties of the work apart from
any notion of the artist's intention. Blake's notion of significance
identifies rather than distinguishes the artist and art. As Blake
intends it, the idea of artistic significance is like his idea of
beauty. Both are essentially appropriateness, which is the true—
direct, exuberant, various—expression of the artist's intentions
in character: the perfect relationship of conception to execution.

Blake with his strong statements on the appropriate relation
of execution to conception is not writing a systematic theoretical
treatise but joining—some might even say starting—an argu-
ment. The argument is with the prevailing critical assumption,
adapted from classical esthetics to Enlightenment needs, that
conception and execution are divisible. Of course Enlighten-
ment observers did not fail to recognize a relation between the
two: "We are all sensible," as Reynolds says, "how differently
the imagination is affected by the same sentiment expressed in
different words, and how mean or how grand the same object
is when presented to us by different Painters" (XI; W 196). But
in assuming the existence of a sentiment apart from the words
used by different poets to express it and an object apart from its
representations by different painters, he rests his apparent tol-
erance on a separation of content from form. Of course conven-
ience and ordinary language make such separations seem almost
inevitable, but the separation implicit in Reynolds' simple state-
ment is part of a consistent and profound assumption, far be-

yond convenience, in his own esthetics and the esthetics of his age.

The existence of a separation is so unquestioned that tests of quality can be derived comfortably from it, as when Reynolds explains that in order to separate local customs from universal artistic principles, "we may have recourse to the same proof by which some hold that wit ought to be tried; whether it preserves itself when translated. That wit is false, which can subsist only in one language" (VII, 226; W 134). Proof-by-translation is the natural extension of the belief in sentiments apart from the words used to express them, and one fascinating if bizarre solution to the problem of Enlightenment universalism that searches for truth behind local appearances. The test reported by Reynolds associates execution with the local, and conception rugged enough to survive any execution with the universal. Any work that fails to generate such a conception fails the test and is labeled, with a circular flourish of Enlightenment confidence, false. True wit is not to be found in a poem or painting but abstracted from a series of particular executions by different hands in different times and places. Analogous judgments can be extracted at all levels, though with a general tendency—true to the principle— to associate general conception with public truth liberated from the individual and execution with falsehoods stubbornly lodged in individual character.

In Discourse IV, Reynolds compares the painter's process of artistic invention to what happens in a group of people "whenever a story is related": "Every man forms a picture in his mind of the action and expression of the persons employed. The power of representing this mental picture on canvass is what we call invention in a Painter. And as in the conception of this ideal picture, the mind does not enter into the minute particularities of the dress, furniture, or scene of action; so when the Painter comes to represent it, he contrives those little necessary concomitant circumstances in such a manner, that they shall strike the spectator no more than they did himself in his first conception of the story" (IV, 81-82; W 58). Painters play a strenuous version of the Gossip game. Instead of being auditors who become speakers and pass on what they remember to other auditors, they are auditors who translate what they remember into pictures. In Gossip the tenthhand account of the message is measured against the firsthand account. Reynolds returns neither to the original

nor to an eyewitness account but to the image of the account that forms in the auditor's mind while listening. He calls such an image an ideal picture.

Of course this fable of Reynolds' is a painter's version of the Enlightenment commonplace offered by Johnson as praise of Shakespeare: "A poet overlooks the casual distinction of country and condition, as a painter, satisfied with the figure, neglects the drapery."[5] Reynolds and Johnson seem to be using Enlightenment generalization in the service of a doctrine of intellectual focus, of first things first. In Reynolds' fable, what is first is what is remembered and visualized—the figure, in Johnson's comparison, not the drapery. This is finally Imlac's doctrine: as the drapery to the figure, so the streaks to the tulip. By comparison there is Blake's Chaucer painting, which from the Enlightenment angle is a work without focus, or rather, focused all over: "Every Character & every Expression, every Lineament of Head Hand & Foot. every particular of Dress or Costume . . . minutely labourd . . . by the Original Artist himself even to the Stuffs & Embroidery of the Garments. the hair upon the Horses the Leaves upon the Trees. & the Stones & Gravel upon the road" (Chaucer prospectus; E 557). Blake's minute particulars are present here with a vengeance, commanding direct contrast with Reynolds' and Johnson's formulas for generalization. But when the comparison is left at that level, Reynolds and Johnson seem to be critics acting upon sound principle, Blake a rebellious crank whose only principle is stubborn reaction—if they'll have generalization, he'll have particulars. But the positions rest upon important assumptions that help explain the opposition. For now, the essential element in Blake's position is his emphasis upon the connection between minute particulars and the "Original Artist himself." Artists acting in their own identities conceive precisely, that is, in minute particulars, and execute likewise. Minute particulars are therefore minutely labored. Execution is the labor of conception.

Reynolds' reasoning is quite different. The object of his fable is to explain why, "as it is required that the subject selected [for a painting] should be a general one" (IV, 81; W 58), so the representation of the subject must also be general. While he may

<hr/>

[5] Preface to Shakespeare, *Johnson on Shakespeare*, ed. Arthur Sherbo, Yale Ed. of the Works of Samuel Johnson (New Haven: Yale Univ. Press, 1968), VII, 66.

seem to be matching (general) form to (general) content, he is
actually establishing their separation on principle. In fact the
relation of form to content is an essential, but usually omitted,
ingredient in the formula for Enlightenment generalization. The
relation is, in a word, general. Separation between conception
and execution furthers generalization by acting as needed secu-
rity against idiosyncrasy. Thus in Reynolds' fable the question
is not what was in the original story, but what can the auditors
remember of it. Their visual memories operate as safeguards
against overparticularization, an undesirable product of singu-
larity. And there is the further danger that, as the story may
have been corrupted by particulars, the memories of the artists
will themselves be corrupted by the intrusive idiosyncrasies of
personality, which the artists must therefore try to filter out of
their executions, again by generalization. Thus Reynolds advises
students that "instead of copying the touches of those great mas-
ters," they should "copy only their conceptions" (II, 35; W 30).
Touches are part of the execution of the painting itself, in real
paint by a real person afflicted by singularity. "Conception" here,
like "invention" in Reynolds' memory-fable, means something
like "treatment," an intermediate category between the idea for
a painting and the painting itself. In Reynolds' formulation, the
general conceptions of great masters are things that can be seen
behind the individual particulars of the execution. The execution
by painters acting as themselves is the collection of technical
touches that lie superficially on their conceptions. Their concep-
tions resemble what remains of a painting when the art history
teacher throws a slide out of focus: generalized forms with names
that vary according to the level of generalization. The subject
Troy at one level becomes War at another, as the costume be-
comes heroic and the composition triangular. In Enlightenment
terms, the superficial touches on a painting are like individual
idiosyncrasies on the authentic Human Nature. One very im-
portant kind of artistic failure is thus the intrusion of the artist,
whose presence in the execution is bad craftsmanship. By im-
plication, the best craftsmanship is an impersonal external ideal,
a collection of skills. Other lesser forms of craft require special
pleading. The search for the conceptions of Michelangelo be-
hind his touches is part of the search for the good artist in
Michelangelo, in turn part of the wider eighteenth-century search

for the species in the singular, and the consequent degradation of individual identity.

Compare Reynolds' advice to his students with Blake's assertion to Thomas Butts: "Be assured, My dear Friend, that there is *not one touch* in those Drawings & Pictures but what came from *my* Head & *my* Heart in *Unison*" (my emphasis, *Letters*, p. 58). From this vantage point it is easy to see what Blake meant when he accused his age of preferring translations, imitations, and copies to originals. Reynolds' fable reveals that the content of works of art comes from the world outside the minds of the artists, as a "story . . . related." Artists imitate the story as they would imitate nature or Homer, by putting it to the simple test of memory. What the visual memory can retain is, in a very important sense, the true story, which proves itself by passing two tests: the test of translation (from words into images) and the test of memory. The parts of a story that pass the test of memory are, like the parts of wit that pass the test of translation, survivors of the filter of other minds and other media. Getting through these rites of passage qualifies a story for the stamp of authenticity as general or universal and for admission to the heaven of true stories, much as getting past the inquisition at the gates of St. Peter certifies true believers for admission into that other heaven. Reynolds' argument applies to works of visual and verbal art as to stories related: the true work is not the work of art itself, with its irregularities, defects of proportion, and idiosyncrasies, but the work remembered; that is, the work generalized by the memory and thereby freed of defect; the translation. Of course, because memories belong to individual brains, works of art are vulnerable to a new set of idiosyncrasies at each processing, but the basic line of argument remains: the true work is the work translated by the memory. At its best, memory, unlike imagination, can be the property of the culture, or even, in the best minds, of the wide world, and only hired for life by the individual. This pattern yields the Enlightenment analogue to the neo-Platonism plot of souls circulating into bodies. Capturing that elusive image of the general mired in the particulars of personality is one of the great goals set by Enlightenment esthetics. Reynolds' *Discourses* well represents the many forays into the territory, and stands as one of many attempts, perhaps the greatest, to map it for others.

Blake depicts the same territory as seen by another explorer

in painting no. 6 of his 1809 exhibition. *A Spirit Vaulting from a Cloud to Turn and Wind a Fiery Pegasus* shows "the Horse of Intellect . . . leaping from the cliffs of Memory and Reasoning; it is a barren Rock: it is also called the Barren Waste of Locke and Newton" (*DC*; E 536). As far as Blake is concerned, Reynolds' fable of conception in the *Discourses* merely reveals how the poor vision and inadequate memory that we usually regard as handicaps can be elevated to artistic standards. Blake's painter chooses between two clear alternatives, "Portrait Painting" and its "direct contrary . . . Historical Painting." In neither does good work depend upon memory. "If you have not Nature before you for Every Touch, you cannot Paint Portrait; & if you have Nature before you at all, you cannot Paint History; it was Michael Angelo's opinion & is Mine" (*Letters*, p. 59). Memory is only secondhand nature: "All likenesses from memory being necessarily very very defective" (*Letters*, p. 69). Bad portrait painters and bad history painters rely on their memories; good portrait painters rely on nature. Good history painters draw on a different sort of storehouse that Blake describes to Flaxman: "In my Brain are studies & Chambers fill'd with books & pictures of old, which I wrote & painted in ages of Eternity before my mortal life; & those works are the delight & Study of Archangels" (*Letters*, p. 42). In an expressive theory the radical relation between tradition and the individual talent originates with the talent. Inspired original artists eat tradition, which, incorporated, ends up in their brains. Blake's anecdotes of nighttime conversations with Milton and Shakespeare fall into the same category. Blake is able to see those poets because they are in him; their works are ones he wrote before his mortal life; studying them he gains, not knowledge of their conceptions, but self-knowledge.

Substance, Accident, & Identity

The prominence of sense impression, memory, and generalization by categorization in Reynolds' fable of the process of artistic invention helps locate his esthetics in the history of ideas as a subcategory of post-Renaissance empiricism, probably a northern province of the Barren Waste of Locke and Newton, as Blake has it. In that context the division of conception from execution in art is a central instance of the alienation of subject from object that many romantic intellectual remedies attempt to

heal. Lockean empiricism did not come from nowhere, and Blake traces its heritage to Greece and Rome, which has at least the advantage of aligning his antagonisms with the Bible's, "Greece & Rome as Babylon & Egypt." When he calls "Greece & Rome . . . destroyers of all Art" in his sharp little attack "On Virgil," he is not beating two of the dead horses of Western intellectual history but updating Milton's opposition to the corrupt line of thought that connects ancient Athens to modern Europe through the fundamental assumptions symbolized in "Grecian . . . Mathematic Form . . . Eternal in the Reasoning Memory" (E 267).

Blake's epistemological myth in *The Marriage of Heaven and Hell* about the abstraction of mental deities from sensible objects would seem to suggest a parallel historical myth beginning in ancient Greece with the distinction between the idea of the thing and the (inferior) thing itself. History has proved such a distinction extremely useful. It comes in handy for Reynolds when he wants to complain about students, "boys" as he says, who, in making "the mechanical felicity the chief excellence of the art, which is only an ornament," are blamed for taking "the shadow for the substance" (I, 14; W 18). Mechanical felicity is the thing itself, the shadow, while the substance is of course the idea. Substance and shadow are conception and execution, and the substance-shadow distinction reflects the traditional distinction between body, or idea, and garment, or ornament, techniques of representation. In this respect Reynolds exemplifies the Enlightenment artistic trend that William Ivins describes: "The eighteenth century talked about harmony, proportion, dignity, nobility, grandeur, sublimity, and many other commonsense abstract verbal notions based upon the gross generalities of the subject matter." As an early example Ivins cites the statement of purpose in Bosse's handbook on engraving: "I speak only of the neatness of his etched lines, leaving aside the invention and the composition, it not being my intention to talk of such things," a disclaimer that Ivins describes as "proceeding along the lines of the old Aristotelian-Scholastic distinction between substance and attributable qualities."[6]

[6] Ivins, *Prints and Visual Communication* (1953; Cambridge, Mass.: MIT Press, 1969), pp. 173-74, 75. Ivins proposes that the division of objects into categories has more to do with the nature of "exactly repeatable verbal descriptions and definitions"—and the absence, until fairly recently, of exactly repeatable visual

Actually, while the old Aristotelian-Scholastic distinction may be the distant lineage of Reynolds' metaphor of shadow and substance, he is putting the old distinction to new uses that are part of the larger Enlightenment adjustment of classical ideas to modern empiricism. To Blake Reynolds' division of art into substance and shadow is only one more sure sign that Reynolds is the figurehead of the artistic division of this movement, whose major aim is to harmonize classical esthetics with the new philosophy. An art that divides into substance and shadow, content and form, is an esthetic allegory of a natural world said to divide into subjects and objects, primary and secondary qualities, essence and accident.

Reynolds' antithetical characterization, for instance, of Raphael's "dry, Gothick, and even insipid manner" as one "which attends to the minute accidental discriminations of particular and individual objects" versus the "grand style of painting, which improves partial representation [i.e., representation of parts] by the general and invariable ideas of nature" (I, 9; W 15-16) employs the philosophical language of substance and accident to authorize the distinction between conception and execution and the generalization of each. Blake, understanding that the argument is really about the integrity of the artistic process, responds firmly that "Minute Discrimination is Not Accidental" (AR; E 632). He counters with a concentration upon identity as the expression of essence: "From Essence proceeds Identity" (anno. Swedenborg's *Divine Love*; E 593; see also anno. Lavater). As the Barren Waste attempts territorial expansion, Blake finds himself trying to protect a human world in which the reality of "Every Thing" is "Its Imaginative Form" (anno. Berkeley's *Siris*; E 653) rather than an abstract collection of phantom qualities and properties: "Deduct from a rose its redness, from a lilly its

descriptions—than with the nature of the objects: "Plato's Ideas and Aristotle's forms, essences, and definitions, are specimens of this transference of reality from the object to the exactly repeatable and therefore seemingly permanent verbal formula. An essence, in fact, is not part of the object but part of its definition. Also, I believe, the well-known notions of substance and attributable qualities can be derived from this operational dependence. . . . In a funny way words and their necessary linear syntactical order forbid us to describe objects and compel us to use very poor and inadequate lists of theoretical ingredients in the manner exemplified more concretely by ordinary cook book recipes" (p. 63).

Ivins' conclusion agrees with Blake's: that such logical verbal analyses strongly influenced visual representations in the eighteenth century.

whiteness from a diamond its hardness from a spunge its soft-
ness from an oak its heighth from a daisy its lowness & rectify
every thing in Nature as the Philosophers do. & then we shall
return to Chaos & God [like the artist] will be compelld to be
Excentric if he Creates O happy Philosopher." Imagination re-
verses this process on the principle that "substance gives tincture
to the accident & makes it physiognomic" (anno. Lavater; E
584-85). If "the Philosophy of Causes & Consequences" had
not "misled Lavater as it has all his cotemporaries," he would
have understood the philosophy of imaginative form that makes
substance eat accident: "Each thing is its own cause & its own
effect" (anno. Lavater; E 590) means, in artistic terms, that
every authentic work is physiognomic because it is its own con-
ception and its own execution.

ARTISTIC PEDAGOGY AND CULTURAL PROGRESS

Although an attempt was made in 1784, by a Mr Hawkins of whom
little is known, to raise a subscription to send him to Rome, Blake
never in fact travelled; nor did he have an entrée, since he lacked
social graces and was not even a practitioner of "the Polite Arts", to
most of those places where fine pictures could be seen. Had Blake
gone to Rome in his twenties and had his artistic spirit tempered by
the real Michelangelo and the real Raphael, whom he only knew from
engravings (and even perhaps from engravings of engravings), he
might have sloughed off, helped by the experience of travel itself,
many of those prejudices which later grew into mentally diminishing
fixations. —Tom Phillips, *Times Literary Supplement*, 24 March 1978

No work of genius dares want its appropriate form, neither indeed is
there any danger of this. As it must not, so genius cannot, be lawless;
for it is even this that constitutes it genius—the power of acting cre-
atively under laws of its own origination. —Coleridge

Genius has no Error. —Blake (AR; E 641)

My earlier comparison between Reynolds' fable of invention
and the art history teacher's pedagogical methods is more than
illustrative. Enlightenment empiricism pictures the human being
as a collector and processor of the external world through
impressions of it delivered to the senses and thence to the brain.
Significant lines of force run from the outside to the inside.
Enlightenment esthetic theory envisions an artist similarly re-
ceiving, storing, processing, and transmitting. The parallels be-

tween epistemological categories and esthetic categories are an important reminder that their divisions—between primary and secondary qualities, between content and form, and the like— are, as much as anything, especially useful analytical techniques. Historically, the discovery of their usefulness opens the way to a variety of Enlightenment optimisms, among them the view that art is teachable. It can be taught because it can be analyzed into categories that become the basis of a system of communicable norms that in turn serve as the theoretical basis of a practical pedagogy. For good reason the eighteenth century is the age of the academy in art as in science.

The basis of esthetic pedagogy is the belief, or at least the faith, that art is fundamentally a public matter, a matter of informed consensus, in Lockean terms a matter of common sense. In classical esthetics, the idea of art as a sector of the larger society, playing its proper role in teaching delightfully (and therefore effectively) what is already public knowledge in the form of the knowledge of ages, makes art an agent in the socialization of members of society. The artist is charged with the responsibility for taking what the public (in the grander sense) knows and delivering it to the members of the public who for one reason or another do not yet know it. For members of the public who already have the knowledge, art then becomes entertainment or what professionals call a refresher course. The classical scheme may appear more traditional and conservative than it is. It easily adjusts, for example, to take in science, an agent of discovery, because science discovers public facts.

The significance of such esthetics depends upon the significance of public knowledge. Locke's psychology strengthens considerably the idea that individuals are not merely superficially adaptable to the world outside them but fundamentally products of that world. The individualism of eighteenth-century American theories of government with roots in Locke is distinct from romantic concepts of identity such as Blake's. American republicanism gets a large measure of the confidence to gamble on a new form of government from the soothing effect of the Lockean psychology that makes differences among people extraneous, similarities (through common sense) fundamental. What may appear, then, to be a terrifying collection of individuals is really a collection of repeatable images, many versions of the same thing, "all Intermeasurable One by Another" (*Letters*, p. 162),

as Blake says, like the English since the French Revolution.
Blake's contemporary Thomas Jefferson can argue for the free-
dom of the individual with faith that individual behavior is the
result of a composite of experiences shared in varying mechan-
ical and intermeasurable combinations with other individuals.
Lockean psychology makes possible a new optimistic picture of
the human being: the core of the personality that, especially in
radical Protestant theologies, seems private and inaccessible to
the community, now appears accessible and explainable. The
significantly private is really public in origin, and the rest, the
singular, is spurious. Blake's romantic individualism starts in-
side, with the character, based in imagination, that makes an
identity identifiable. Imaginative identity, left to itself, produces
authentic behavior, which is essentially singular—or as Blake
prefers to call it, original.

From the Horatian side of classical esthetics Reynolds takes
the idea of an artist as entertaining teacher responsible for trans-
mitting a body of public knowledge and adapts it to the new
science of Locke: "The mind is but a barren soil; a soil which
is soon exhausted, and will produce no crop, or only one, unless
it be continually fertilized and enriched with foreign matter"
(VI, 157-58; W 99). Even Reynolds' barren-soil metaphor of
mind is misleading, for in his formulation the "foreign matter"
is not additive but basic, while the individual's additive contri-
bution is bound to be superficial: "The greatest natural genius
cannot subsist on its own stock: he who resolves never to ransack
any mind but his own, will be soon reduced . . . to the poorest
of all imitations . . . himself" (VI, 158; W 99). This is the
position required by the rest of Reynolds' argument, not to be
altered by a sprinkling of reverences for the power of individual
imagination. As Blake saw, Reynolds repeatedly degrades the
individual in favor of the community and, insisting that the
artist "take the world's opinion rather than your own" (II, 38;
W 32), mocks inspiration: "Reynoldss Opinion was that Genius
May be Taught & that all Pretence to Inspiration is a Lie & a
Deceit to say the least of it" (AR; E 632). And of course, Blake
was not the only one to see the implications of Reynolds' ideas
about genius. In his essay on "The Royal Academicians" written
in the 1790s, scurrilous "Anthony Pasquin" (John Williams)
points out that the "principle . . . chiefly inculcated" in the
Discourses "is erroneous, as they tend to maintain an idea that a

Disciple in Painting can do as well without genius as with it."[7] Blake was more severe: "When a Man talks of Acquiring Invention & of learning how to produce Original Conception he must expect to be calld a Fool by Men of Understanding" (AR; E 645).

But Reynolds' premises lay the foundation for a pedagogy. The arts come to seem teachable because the unstatable values traditionally associated with unteachable faculties like the imagination are altogether secondary in the theory as a whole. The oracular aspect of genius is feared traditionally as wily foe (instincts are not trustworthy), wild horse (imagination will run away with you), and dangerous woman (imagination will seduce you). Reynolds' strategy for controlling such a dark and private threat is to bring it out into the open by systemizing it. It may be true, he admits, that "invention is one of the great marks of genius; but if we consult experience, we shall find, that it is by being conversant with the inventions of others, that we learn to invent; as by reading the thoughts of others we learn to think" (VI, 156; W 98). So "it must of necessity be, that even works of Genius, like every other effect, as they must have their cause, must likewise have their rules" (VI, 155; W 97).

That is to say, Enlightenment esthetics is fundamentally pedagogical as a natural result of a firm belief that what is primary can be stated and agreed upon, while everything uncommunicable and irreproducible is secondary or delusive. The pedagogical nature of Enlightenment artistic theories has often been the basis of misplaced attempts to reconstruct Reynolds' *Discourses* for the modern reader: "When inconsistencies are detected in Reynolds's remarks on reason and genius, rules and inspiration, the solution often lies in the level of student to which the various remarks, occurring as they do over more than twenty years, are addressed. Sometimes he is talking to beginners, who should not worry their heads about inspiration, but just do what they are told and accept the rules provided. On other occasions he is clearly talking to more advanced students." The critic's histori-

[7] Pasquin [Williams], *An Authentic History of the Professors of Painting, Sculpture, and Architecture, Who Have Practised in Ireland; Involving Original Letters from Sir Joshua Reynolds, Which Prove Him to Have Been Illiterate. To Which Are Added, Memoirs of the Royal Academicians; Being an Attempt to Improve the Taste of the Realm* (London, n.d. [?1796]), p. 66 (of the second pagination, which begins after 64 pp.).

cism in this case is adjusted to give Reynolds the benefit of the doubt whenever there is any hint of inconsistency: "Before we jump to conclusions about what he *meant* we must be clear about what he *could* have meant." Within those limits the apparent dilemma of rules versus inspiration and genius can be resolved by formulating the issue pedagogically: "It is not that inspiration plays no part in artistic creation; of course where great art is concerned it is vital, but it cannot be *taught*, and can never form a basis for art education."[8] But there is really no need for special historical or biographical pleading in Reynolds' case. It is further from the truth to say that his esthetic principles are peda-

[8] David Mannings, "An Art-Historical Approach to Reynolds's Discourses," *British Journal of Aesthetics*, 16 (Autumn 1976), 362, 361, 361. David Bindman picks up the theme in *Blake as an Artist* (Oxford: Phaidon, 1977), noting that Hazlitt and Blake, in emphasizing Reynolds' inconsistencies, "failed to do justice to the fact that the *Discourses* were delivered over twenty years, and were subject to the specific demands of the time" (p. 151). Bindman also believes that Reynolds and Blake are much closer in their theories of art than Blake is willing to admit. The ground they share Bindman calls "idealism," sometimes "Platonic idealism" (pp. 150-54). Morton D. Paley's view seems close to Bindman's; see *William Blake* (Oxford: Phaidon, 1978), pp. 49-54. But cf. Hoyt Trowbridge, "Platonism and Sir Joshua Reynolds," *English Studies*, 21 (1939), 1-7, which carefully weighs the Lockean and Platonic contributions to Reynolds' esthetics, as does Adams, below. My opinion is that pairing Blake and Reynolds under headings such as "idealism" or "Platonism" trades peripheral similarities for central differences, much as would pairing Plato and Jesus under those headings. Citing Robert Wark and Walter J. Hipple as predecessors, Hazard Adams is the latest commentator to align himself with this tradition of apology, calling Blake's failure to take Reynolds' pedagogical purposes into account ("adjusting his discourse to a certain audience") "part of the problem" in Blake's annotations; "Revisiting Reynolds' *Discourses* and Blake's Annotations," *Blake in His Time*, ed. Robert N. Essick and Donald Pearce (Bloomington: Indiana Univ. Press, 1978), p. 138. However, Adams sees clearly that Blake's annotations are sensitive to the fundamental assumptions and important implications of Reynolds' theory, and Adams carefully establishes the differences between Reynolds' Platonizing and Blake's. But he returns at the end of his essay to the theme of Blake's willful mistreatment of Reynolds, even accusing Blake of having "lost sight of charity" (p. 100). I think Blake would have felt that he had done his duty to the charitable aspects of truth when he sprinkled his annotations with warnings to future readers. Though two hundred years of a changing market in art stocks may give us reason to imagine Blake in a kind of art heaven in a position to exercise charity, even pity, toward Reynolds, it is important not to forget that Reynolds, after all, wrote and delivered the *Discourses* from the podium as President of the Royal Academy, wealthy artist, distinguished friend of Johnson and Burke. Blake, poor engraver, author of a "public address" never delivered and organizer of an exhibition hardly noticed, wrote annotations.

gogical because he addresses students than to say that he becomes
a pedagogue on these occasions because his principles lend them-
selves to pedagogy. His ideas about art not only can be taught
but must be taught, or the student's tabula rasa will, to put it
literally, get the wrong impression. In one way the academies
that spread over Europe are only special-interest groups that
take the place left by the medieval guilds. But the urgency with
which the young Royal Academy in London tries to carry out
its educational mission is remarkable. Reynolds' principles do
not have to be adjusted to the pedagogical occasion; indeed, one
might say that they are invented—or at least assembled—for the
occasion, but properly so, because Enlightenment principles are
intended to teach.

In this context the historicism of modern apologists has been
both too narrow and too cautious to do justice either to Reynolds'
ideas or to Blake's objections. We must not forget that in Blake—
born in the failing heart of the Enlightenment, trained in the
Academy among artists whose ideas were in line with Reynolds'
—the *Discourses* have a contemporary antagonist who thinks that
Reynolds has it all wrong. Translating Reynolds' contradictions
into pedagogical rules of thumb may produce bits of conven-
tional advice as respectable as that which puts inspiration into
the category with sex as dangerous or distracting knowledge that
ought to be reserved for consenting adults—thus let beginners
stick to rules. Though such formulations might interest Blake,
they are scarcely hardy enough to survive exposure at the depths
where any serious arguments are registered. To Blake's way of
thinking, once Reynolds' ideal students are old enough to start
looking for inspiration, they will no longer recognize it. Reyn-
olds is living proof, ignoring inspiration in practice all his life,
vaunting its importance, or pretending to, when time has run
out. He uses his famous last discourse as the occasion to declare
that, if he had it to do over again, he would take the high road
of Michelangelo. Instead, he laments, he had taken "another
course, one more suited to my abilities, and to the taste of the
times in which I live" (xv; W 282), two respectable common-
sense excuses that would, however, prove to Blake what he al-
ready knows: that Reynolds has not the faintest idea where Mi-
chelangelo's course lies. If the St. Peter who keeps the gates of
the heaven of art bothers to ask Reynolds why he failed to follow
the strait way of imagination, Reynolds apparently plans to an-

swer that his talents and the times were insufficient to support a Christian vocation, so he squandered the one on the other. Blake imagines a speech from the gallows:

The Villain at the Gallows tree
When he is doomd to die
To assuage his misery
In Virtues praise does cry

So Reynolds when he came to die
To assuage his bitter woe:
Thus aloud did howl & cry
Michael Angelo Michael Angelo ("A Pitiful Case"; E 504)

Unlike Reynolds, Michelangelo did not wait, and Blake prefers to learn from Michelangelo. But if works of genius are not effects with causes whose rules can be determined like Newton's mechanics, what is to be learned? Education is a profoundly ambiguous notion in romantic formulations, often incorporated in a paradox. If "Reynolds Thinks that Man Learns all that he Knows" while "I say on the Contrary That Man Brings All that he has or Can have Into the World with him," then Blake's garden of the mind is self-sufficient: "Man is Born Like a Garden ready Planted & Sown This World is too poor to produce one Seed" (AR; E 645-46). That is, the world doesn't grow the garden, the garden grows the world—and poor gardens grow poor worlds ("This World"). The only educational strategy worth having cultivates the individual mind and protects it against intrusion. The only thing that can be learned from an identity is the identity. Thus the importance of empathy in romantic education: the only thing that Michelangelo can teach is Michelangelo, and the only thing Blake can learn from Michelangelo is to be Blake.

Film director Lina Wertmuller's characterization of her experience as Fellini's assistant director is a model of romantic education: "I was totally enlightened by Fellini's personality," she says, "but you really can't *learn* anything from Fellini. Because Fellini is an *artist*, and you can't *learn art*. What you *can* learn is the *freedom* of art."[9] Teaching and learning are not ways

[9] In an interview with Gene Shalit, *Ladies' Home Journal*, April 1976, p. 24. Cf. George Eliot's effort to explain what Rousseau had taught her: "The writers who have most profoundly influenced me . . . are not in the least oracles to me." Even if someone were to prove that Rousseau's ideas are "miserably erroneous

of communicating information but of being enlightened by someone's personality about the freedom of art, which is obviously the freedom *from* other artists' skills and principles. Wertmuller restates the position outlined by Blake in the margins of his Reynolds: "I do not believe that Rafael taught Mich. Angelo or that Mich. Ang: taught Rafael., any more than I believe that the Rose teaches the Lilly how to grow or the Apple tree teaches the Pear tree how to bear Fruit. I do not believe the tales of Anecdote writers when they militate against Individual Character" (AR; E 632). Advising young artists to be themselves—to learn to unlearn, to free their imaginations, release their creativity, and be more original and spontaneous—is obviously a long way from advising them to go to the Royal Academy school and learn correct drawing; to go to Reynolds' presidential addresses at the Academy and learn good taste and sound principles; or even to go to Rome, where the sight of fine pictures causes young artists to accept the world's opinion, not their own, and to shed the personal prejudices that inevitably turn into mentally diminishing fixations. All these counsels have been offered to Blake as a species of career-planning-with-hindsight; predicting the possible advantages for Blake's art and career of an extended Roman vacation is in fact one of the great old games of Blake criticism, expressing at once in a nice mixture the cosmopolitan spirit of Enlightenment art pedagogy, class prejudice, English cultural insecurity, and a touching faith in education abroad.

The Royal Academy is an institutional hierarchy of masters and students. Fellini and Wertmuller, like Michelangelo and Blake or Milton and Keats, are eternal identities in a world of equal individual characters the goal of whose artistic education is self-discovery facilitating self-expression. From the Enlightenment angle this is anti-education, as we can see by comparing Blake and Wertmuller with Reynolds: "There are two different

. . . it would be not the less true that Rousseau's genius has sent that electric thrill through my intellectual and moral frame. . . . the rushing mighty wind of his inspiration has so quickened my faculties that I have been able to shape more definitely for myself ideas" (1849); quoted by Hugh Witemeyer, "George Eliot and Jean-Jacques Rousseau," *Comparative Literature Studies*, 16 (June 1979), 122. In a comparable position Blake would say that in an earlier age, before his mortal life, he wrote Rousseau's works, which are now stored in the chambers of his brain.

modes, either of which a Student may adopt without degrading
the dignity of his art. The object of the first is, to combine the
higher excellencies and embellish them to the greatest advantage;
of the other, to carry one of these excellencies to the highest
degree" (v, 140-41; W 89). The excellencies are known; stu-
dents may choose to combine them or to specialize. The peda-
gogy is conventionally curricular and goal oriented: divide, choose,
pursue.

If the rudimentary principles of art can be known and system-
ized, they can be systematically taught, learned, and applied to
produce predictable "excellencies." The successful application of
such knowledge produces great confidence in the principles be-
hind it, and the confidence is bolstered by the elite collegiality
that forms around knowledge shared. "We are very sure," says
Reynolds, "that the beauty of form, the expression of the pas-
sions, the art of composition, even the power of giving a general
air of grandeur to a work, is at present very much under the
dominion of rules. These excellencies were, heretofore, consid-
ered merely as the effects of genius; and justly, if genius is not
taken [as it should not be] for inspiration, but as the effect of
close observation and experience" (vi, 153; W 97), to which
Blake characteristically replies, "Damnd Fool" (AR; E 645).
The idea that a scientific analysis of evidence can yield theories
that can in turn be applied in practice as rules encourages the
feedback that is characteristic of efficient systemizing; and a cycle
of fact gathering, theorizing, application, and refinement be-
gins. The resulting pattern is often called progress or improve-
ment. I say "called" advisedly, because what is called improve-
ment in the Enlightenment arts might just as well be called an
extension of the original principles or something of the sort,
without connotations of better and better. There are at least two
major problems. Most important, the strict pragmatic test of
successful application that makes experiment (based on "close
observation and experience") and demonstration the dependable
keystones of an efficient scientific method is missing in the arts.
Though they may be used as evidence in the forming of theo-
ries, paintings are not easily used as experiments capable of test-
ing the adequacy of esthetic theories. Treating them as tests tends
to produce not a theory tested but a theory projected into prac-
tice. Moreover, misplaced confidence in a defective method brings
on the plague of ghosts that always haunt such endeavors. Tra-

ditional esthetic values, for instance, slip into the system to be confused both with the values tied to empirical methods and with the values discovered naturally in the subject when empirical methods are applied to it. Eighteenth-century science, despite its avowed reverence for the sacred relation of religious values to Newtonian mechanics, as a rule allows the former to assume whatever shape the latter dictates. While eighteenth-century esthetic theorists for a variety of reasons are unable to proceed with such efficiency, in their confusion they make titanic efforts that influence artistic theory and practice for decades.

A culture beginning to receive the vast benefits of the methods of science is almost irresistibly tempted to interpret any demonstrable pattern of consistent change as improvement. The usual—and the logically consistent—assumption in Enlightenment esthetics is that the arts follow an upward curve of improvement from a primitive to a perfected state. And of course it is a commonplace of intellectual history that words like "progress" begin to take on such an overwhelmingly positive connotation that even monarchs can no longer progress in a pompous circle through the countryside without suggesting that they and the nation are perhaps somehow the better for it. Reynolds follows the rest of his century in discussing art in terms of improvement and progress. Such statements as this one are repeated with many variations in the *Discourses*: "It is apparent, if we were forbid to make use of the advantages which our predecessors afford us, the art would be always to begin, and consequently remain always in its infant state; and it is a common observation, that no art was ever invented and carried to perfection at the same time" (VI, 150; W 95). Reynolds' criticism is a good example of the neoclassical adjustment of classical principles to include progress (improvement, refinement) as a basic theme. Classicism tends toward stasis: it provides for rational knowledge of art, but education takes place largely on the assumption that the necessary knowledge is already known by the culture at large, and needs to be passed on. Reynolds makes the characteristic Enlightenment adjustment by adding the notion that, while past artistic practice is a true source of knowledge, it is often unrefined, and the job of modern artists is to analyze the practice of the past in order to improve the art of the future.

It is no surprise to find, then, that in Blake's time the histories of engraving, like histories of the other arts, are based largely on metaphors of improvement or some variation. In the Preface

to his *Lectures on the Art of Engraving* (1807), for instance, John
Landseer says that his aim is to write a "regular history" of the
"Art of Engraving" on the model of Dr. Charles Burney's *History of Music*[10]—that is, a comprehensive survey that would test
the history of the art against the standard of progress. And the
guiding historical principle of Landseer's attempt is clearly "improvement" and "advancement."[11] More than two decades earlier Joseph Strutt had introduced his *Biographical Dictionary
Containing an Historical Account of All the Engravers from the
Earliest Period of the Art of Engraving to the Present Time* (1785-
86) with the same principle: "The improvement of the Arts has
ever been considered as an object of great importance, by the
enlightened part of mankind; and there is no nation in the world,
where the art of engraving is held in higher esteem, or more
generously encouraged, than in England."[12] And, indeed, wherever one opens Strutt's *Dictionary*, the talk is apt to be of improvement. Certain German engravers, he says, "certainly possessed sufficient genius to have made very considerable
improvements in the art of engraving."[13] In this case genius is
responsible for making improvements; but the formula was also
frequently reversed, as in the title of a handbook published in
Birmingham in 1773: *The Artist's Assistant, in the Study and
Practice of Mechanical Sciences. Calculated for the Improvement of
Genius*.

Employing improvement as a guiding principle of historical

[10] John Landseer, *Lectures on the Art of Engraving, Delivered at the Royal Institution of Great Britain* (London, 1807), I, vii. For ideas of progress in Burney, see Lipking, *The Ordering of the Arts in Eighteenth-Century England*, pp. 276, 303-12.

[11] *Lectures*, I, ix.

[12] Joseph Strutt, *A Biographical Dictionary Containing an Historical Account of All the Engravers from the Earliest Period of the Art of Engraving to the Present Time*, 2 vols. (London, 1785-86), I, 1. The library of the British Museum Department of Prints and Drawings contains an enlarged revision of Strutt's *Biographical Dictionary*, written ca. 1820; this manuscript in three volumes, *A Chronological Account of the Most Eminent Engravers from the Invention of the Art by Finiguerra to the Present Time*, was never published. The manuscript is not mentioned in Howard Levis's *Bibliography of Engraving* (the standard reference). Ideas of improvement dominate the revision as they do the original. Strutt's participation in intellectual circles that included Erasmus Darwin and the novelist and factory-owner Robert Bage, among other technically minded progressive thinkers and writers in the provinces, would certainly reinforce his inclination to believe that an art such as engraving improves.

[13] Strutt, *Dictionary*, II, 7.

interpretation naturally emphasizes those aspects of the subject in which patterns of improvement are easiest to demonstrate. The history of cinema, for instance, can be successfully described with metaphors of improvement if confined to the aspects that can be demonstrably improved: the technologies of film making, the mechanical equipment, and the systems for using it. An actual rather than hypothetical example would be Suzi Gablik's *Progress in Art*,[14] which argues that the visual arts show a pattern of evolution in perceptual integration. This pattern deserves to be called progress because of the claim that the pattern parallels the evolution of human intelligence as described by Piaget and others. That is, the author abstracts from the visual arts a component that in other (scientific) contexts is regarded as showing a pattern of positive development and identifies the development of that component with the development of the visual arts as a whole.

Enlightenment histories of the arts work along comparable lines. Histories of engraving, for instance, tend to split their subject into two parts, the mechanical and the mental, and then, using the curve of mechanical improvement as the standard, to decide that everything but the mechanical aspects of engraving has failed to improve sufficiently. Thus Joseph Strutt notices that as long as painters, who thought of etching as amusement, had also been the main etchers, "no great improvement could be supposed to take place. . . . They were, therefore, content with the state of the art, as they found it; but seldom attempted to go to any great lengths towards the improvement of it; especially, with respect to the mechanical part." But in modern times, he says, after the specialization of the arts that has put the painters in one class and the etchers in another, the advancement has been prodigious: "Certainly when we speak of the mechanical part of engraving, the taste and beauty of finishing, the judicious distributions of light and shadow, the works of the old masters will bear no comparison with those of the modern ones. But perhaps it may be added, that the mechanical part of engraving is too much the object in view of the present day; while the more essential parts, namely, correctness and purity of drawing, in which the ancients [note: not Dürer and the "Gothic"

[14] (New York: Rizzoli, 1977).

engravers, however] excelled, are too often hastily over-looked."[15]

It is easy to hear in such judgments a version of Blake's complaint that modern engravers are nigglers who spend all their time thinking about dots and lozenges while the more essential parts of their art languish, but the comparison is misleading for several reasons. Blake also mentions the old painter-engravers, and the difference from Strutt is instructive: "The Designer [Blake] proposes to Engrave, in a . . . manner . . . similar to . . . the old original Engravers, who were great Masters in Painting and Designing, whose method, alone, can delineate Character as it is in this Picture, where all the Lineaments are distinct" (*Canterbury Pilgrims* prospectus; E 556). Strutt's criticism of modern engravers is actually a version of the criticism that irks Blake most: modern engravings are well executed but poorly conceived. Strutt clearly means to say that, to bring their art to perfection, modern engravers need only to correct their drawing. He is using improvement as a standard against which to measure both conception and execution and discovering that his mechanical standard measures the mechanical aspects of engraving better than other aspects. Instead of drawing that conclusion, however, he arrives at its solipsistic negation: what fails to measure up is not beyond his ability to measure but a failure.

Strutt's method of drawing conclusions about the state of engraving in his time is only a minor instance of what was becoming a paradigm of thought. In *The Burden of the Past and the English Poet*, W. J. Bate notes the fear, expressed many times in the eighteenth century, that civilization and art are opposed, that a well-ordered, cultivated society cannot produce the best art.[16] By the nineteenth century this doubt is ready to be incorporated into generalizations about the course of history, as in the thesis of Macaulay's 1825 essay on Milton, that "as civilization advances, poetry almost necessarily declines."[17] The premises that Strutt applies to the history of engraving Macaulay applies to the history of civilization. His "civilization" parallels Strutt's "mechanical parts" of engraving; his "poetry," Strutt's "more essential parts." Both mistake the limits of their

[15] Strutt, *Dictionary*, II, 11, 4-5.
[16] Bate, *The Burden of the Past and the English Poet* (New York: Norton, 1972), pp. 49, 50.
[17] Quoted in Bate, *The Burden of the Past*, p. 64.

assumptions for limits in the object of their study. Blake would ask, in what sense can civilization be said to advance if poetry has declined?

The answer, of course, is the sense in which civilization is the sum of its technologies, civilization as technique. Proof lies in such documents as *The Four Ages of Poetry*, Thomas Love Peacock's essay that not only anticipates Macaulay by half a decade but also states baldly the assumptions that are only latent in Macaulay. Since Peacock's satirical hyperbole becomes the plain talk of decades to come, it matters little that he may be exaggerating to bait his friend Shelley. Though his argument is contradictory at important points, usually to accommodate some comic exaggeration, its main outline is clear enough. For the ancients, poetry was the repository of knowledge and therefore rose as civilization rose. But in the modern world, "while the historian and the philosopher are advancing in, and accelerating, the progress of knowledge, the poet is wallowing in the rubbish of departed ignorance, and raking up the ashes of dead savages to find gewgaws and rattles for the grown babies of the age." We recognize the metaphors of infancy (versus adulthood), ignorance (versus education), and progress (versus arrested development, or, for the sake of the satire, regression) as a familiar combination, present in more dignified form in Reynolds. Peacock, like Macaulay, is following an eighteenth-century argument to its nineteenth-century conclusion. While Reynolds' century prefers to believe that the arts are improvable and thus to analyze their histories into the components that have improved and those that have not, the nineteenth century uses the metaphor of improvement to make the more radical assertion that the arts are a waste of time. The key term is "useful," as in this description by Peacock of the philosophic frame of mind versus the poetic:

The philosophic mental tranquillity which looks round with an equal eye on all external things, collects a store of ideas, discriminates their relative value, assigns to all their proper place, and from the materials of useful knowledge thus collected, appreciated, and arranged, forms new combinations that impress the stamp of their power and utility on the real business of life, is diametrically the reverse of that frame of mind which poetry inspires, or from which poetry can emanate. . . . It cannot claim the slightest share in any one of the comforts and

utilities of life of which we have witnessed so many and so rapid advances.

Peacock asks why readers should bother with modern poetry when "there are more good poems already existing than are sufficient to employ that portion of life which any mere reader . . . should devote to them," but of course the deeper question is why readers should bother with poetry at all, considering that "in whatever degree poetry is cultivated, it must necessarily be to the neglect of some branch of useful study." Poems are "playthings" for an infant culture. The arts have no significant future. As civilization matures,

the great and permanent interests of human society become more and more the main-spring of intellectual pursuit; . . . in proportion as they become so, the subordinacy of the ornamental to the useful will be more and more seen and acknowledged, and . . . therefore the progress of useful art [i.e., mechanics] and science, and of moral and political knowledge, will continue more and more to withdraw attention from frivolous and unconducive, to solid and conducive studies. . . . intellectual power and intellectual acquisition have [already] turned themselves into other and better channels, and have abandoned the cultivation and fate of poetry.[18]

Macaulay and Peacock are projecting into history, from the point of view of men of letters, the assumptions of a world in which Gradgrind and Bounderby can be the leading citizens: "A world in which whatever seems obscure and inward, whatever cannot be reduced to a quantity, is thereby treated as unreal . . . [in favor of a] very limited kind of objectivity, which treats as nonexistent the subjective fish that cannot be caught in its coarse conceptual net."[19] Blake knows that the arguments in the margins of his Reynolds over the education of genius and the improvement of art are not quarrels with the old-fashioned artistic ideas of a dead generation. And by the end of the second decade of the new century, the future of those arguments has arrived. It is at least fortuitous coincidence that as Peacock, in 1820 a man in his thirties, scribbles *The Four Ages of Poetry*, Blake, a man in his sixties still playing with his gewgaws and

[18] *The Four Ages of Poetry* in *Shelley's Critical Prose*, ed. McElderry, all quotations from pp. 169-72.
[19] Lewis Mumford, *Art and Technics* (New York: Columbia Univ. Press, 1952), p. 34.

rattles, assembles tools and materials to etch the aphorisms around
his Laocoön: "Empire against Art" (E 272).

Strutt's pattern of improvement is the Enlightenment division
of conception from execution projected into the history of en-
graving. As such it is a specialized version of the "common
observation" repeated with approval in Reynolds' *Discourses*: "that
no art was ever invented and carried to perfection at the same
time." In Johnson's *Rasselas*, Imlac sees the history of literature
from this perspective: "It is commonly observed that the early
writers are in possession of nature, and their followers of art:
that the first excel in strength and invention, and the latter in
elegance and refinement" (chap. x). The division of the mental
and mechanical aspects of art is being reinforced historically, so
that the moderns may be said to have improved the execution at
the cost of the conception, which is associated with imagination
and hence with some more primitive, less inhibited conceptual
power. Goldsmith's argument that an age of great art is followed
by an age of philosophy and analysis, followed in turn by an
age of refinement through commentary, reflects similar assump-
tions.[20] The metaphors of Imlac and Goldsmith can be employed
at any level. Dropping from history to society—from the succes-
sion of ages to a cross section of one age—we find a culture of
young people with ideas, maybe even inspired ideas, and old
people who know what to do with them, or—relying now more
on the association of youth with nature and age with art—a
peasantry feeding raw ideas to the educated classes for process-
ing. At the level of biography, Goldsmith's pattern suggests an
adolescence of natural and strong but crude inspirations giving
way to a discriminating middle age capable of refinement, fol-
lowed by an old age that explicates its own earlier performances.
The pattern can be applied at more than one level to get sym-
metrical complications. The obituary notice of Grignion the en-
graver, for instance, laments that "as Mr. Grignion advanced
in life, his pure, old-fashioned style was superseded by one more
imposing, more finished, but less intellectual. This revolution
in engraving threw him into obscurity and reduced him to pov-
erty."[21] Imlac fails to mention that his history can so impose
upon an engraver as to reduce him to obscurity, poverty, and,

[20] See Bate, *The Burden of the Past*, p. 62.
[21] Pye, *Patronage of British Art, An Historical Sketch* (London: Longman, 1845),
p. 317, n. 5.

I suppose, death—though Blake would certainly not be sur-
prised. In poor Grignion a stable biographical pattern fails to
synchronize with a changing historical pattern. Though the fail-
ure is measured by the standard of style, the contrasting adjec-
tives "intellectual" and "imposing" make it evident that the same
division is at work: ideas (the intellectual) versus form (the im-
posing).

At an episodic level beneath the biographical the pattern brings
us back once again to the stages in the creation of an individual
work of art: first the conception—a crude but strong idea from
nature—followed by the execution—refinement by learned tech-
nique. Neither stage belongs to the identity of the individual
artist, who simply exchanges allegiances—allegiance to nature
in youth for allegiance to art in old age.

"If Art Was Progressive": Heroes and Hero-Worship in Romantic History

Since Blake begins inventing assertions against the doctrine
of artistic improvement at least as early as the proverb in *The
Marriage* that "Improve[me]nt makes strait roads, but the crooked
roads without Improvement, are roads of Genius" (E 37), we
expect him to contradict Reynolds thus: "If Art was Progressive
We should have had Mich Angelo's & Rafaels to Succeed & to
Improve upon each other But it is not so. Genius dies with its
Possessor & comes not again till Another is Born with It" (AR;
E 645). This rejects artistic improvement in its historical aspect.
Blake extends the rejection to all time and all art history in the
Descriptive Catalogue: "[The Artist] knows that what he does is
not inferior to the grandest Antiques. Superior they cannot be,
for human power cannot go beyond either what he does, or what
they have done, it is the gift of God, it is inspiration and vision.
He had resolved to emulate those precious remains of antiquity,
he has done so and the result you behold" (*DC*; E 534-35).
This is Blake's contribution to the anxious debate over the bur-
den of the past. The significant characteristics of art are not
affected by its historical occurrence in movements and schools.
The times may be worse for art, or better, but the confidence
of Enlightenment artists in their knowledge of art is as irrele-
vant as the insecurity with which it alternates. Artists do not
improve upon the work of other artists; they "emulate" their

achievements directly, across time. Blake refuses to consent to
the idea that art improves, or declines, with the same logic that
he refuses to believe that the age of prophecy is behind us, or
in front:

Poetry as it exists now on earth, in the various remains of ancient
authors, Music as it exists in old tunes or melodies, Painting and
Sculpture as it exists in the remains of Antiquity and in the works of
more modern genius, is Inspiration, and cannot be surpassed; it is
perfect and eternal. Milton, Shakspeare, Michael Angelo, Rafael, the
finest specimens of Ancient Sculpture and Painting, and Architecture,
Gothic, Grecian, Hindoo and Egyptian, are the extent of the human
mind. The human mind cannot go beyond the gift of God, the Holy
Ghost. To suppose that Art can go beyond the finest specimens of Art
that are now in the world, is not knowing what Art is; it is being
blind to the gifts of the spirit. (*DC*; E 535)

The radical grammatical identifications here are characteristic
of the radical view they embody: each of the four arts "is Inspi-
ration" and the great works "are the extent of the human mind."
The orientation is radically and typically romantic as well,
grounding history in the unique individual identity rather than
in ideas or techniques that can be communicated in such a way
as to comprise a cultural tradition in which the individual par-
ticipates. The view does not make a cultural tradition impossi-
ble, as some later commentators have tried to claim, but it does
turn the classical idea of tradition upside down. Even a nodding
acquaintance with the Carlylean strain in romanticism reveals
the historical pattern that develops from the claim that the unit
of genius is the individual artist who is born with it and dies
with it: not a history in which individuals inherit, serve, and
advance a cultural tradition but a history of heroes. In *The Mar-
riage*, the devil states the view with such firm persuasion that
he converts the angel: "The worship of God is. Honouring his
gifts in other men each according to his genius. and loving the
greatest men best, those who enjoy or calumniate great men hate
God, for there is no other God" (E 42).

If history does not demonstrate a pattern of improvement, in
a certain sense neither do individuals. Any reader gathering evi-
dence against Blake's smug titanism will stock up on his claims
of once right, always right: "I read [Burke, Locke, and Bacon]
when very Young. . . . I wrote my Opinions & on looking

them over find that my Notes on Reynolds in this Book are exactly Similar. I felt the Same Contempt & Abhorrence then; that I do now. They mock Inspiration & Vision Inspiration & Vision was then & now is & I hope will always Remain my Element my Eternal Dwelling place" (AR; E 650). Blake feels the same about his artistic practice, so much so that he makes it the issue on which to end his *Descriptive Catalogue*: "This Drawing [*The Penance of Jane Shore in St. Paul's Church*] was done above Thirty Years ago, and proves to the Author, and he thinks will prove to any discerning eye, that the productions of our youth and of our maturer age are equal in all essential points" (*DC*; E 541). Blake of course demonstrates his belief in this principle repeatedly by his continued reworking of, and new versions of, his engravings and paintings, and, in his poetry, by the persistent mining of one work for another, shuttling whole passages back and forth between poems.

He seems to want to claim that, as "A Man who Pretends to Improve Fine Art does not know what Fine Art is" (*PA*; E 562), so a man who pretends that his own work improves—or his own opinions, for that matter—does not know his own work. But where in all this certainty and stability do we find the Blake who revises "The Tyger" and *The Four Zoas* and invents proverbs about people who breed reptiles of the mind because their opinions never change? In this instance, at least, we have not located a titanic identity rent in dramatic contradiction between Enlightenment stasis and romantic dynamism. Blake does not mean that people learn nothing from other people, nor that people never change. Not only do they change but they also improve; furthermore, "What is the Joy of Heaven but Improvement in the things of the Spirit?" (*J* pl. 77; E 229). The first principle of such improvement must be the coherence of individual identity, which is where the spirit lives. Thus when Reynolds fusses at the arrogant geniuses who claim to learn nothing from others, Blake once again scornfully replies with identity: "How ridiculous it would be to see the Sheep Endeavouring to walk like the Dog. or the Ox striving to trot like the Horse just as Ridiculous it is to see One Man Striving to Imitate Another Man varies from Man more than Animal from Animal of Different Species" (AR; E 645). Because all knowledge of the ordinary kind—the kind proposed as the basis of artistic education by Reynolds—is from the outside in, education

is merely "Thieving from Others" (AR; E 635). The best that can happen when an ox thieves from a horse is a ridiculous ox. The purpose of all authentic education must be self-knowledge, in its romantic version. As "States are not Improved at the Expense of Foreigners," so "The Increase of a State as of a Man is from Internal Improvement or Intellectual Acquirement" (anno. Bacon; E 614). If art is self-expression, then it can only be interrupted, not improved, by foreign intervention.

Artists and writers who take such a view of their work are laying landmines for critics who come to study their intellectual or artistic development, usually armed with latent doctrines of corruption and/or improvement by influences, Enlightenment patterns of decline and fall, and some romantic notions of originality. There may be some profit, almost anyone will admit, in examining Blake's ideas or work on Enlightenment grounds, as there may be in examining Reynolds' on romantic grounds. But the critic of Blake faces an artist who deliberately shapes, or at least interprets, his own development in romantic patterns on romantic principles, and the critic who wants to drive against the traffic had better map the intersections. Blake's principles envision a career in some version of the shape proposed by Frye in *Fearful Symmetry*, which treats the illuminated books as Blake's major canon with an integrity of its own. Beneath Frye's idea of Blake's illuminated canon is an idea of Blake's intellectual consistency: "His principles he held with bulldog tenacity all his life. The lyrics of his adolescence, the prophecies of his middle period, the comments which blister the margins of books he read on a sickbed at seventy, are almost identical in outlook."[22] The Blakean extension, or rather foundation, of such a proposal is the integrity of Blake's personality that generates a body of work with integrity. The picture that finally emerges, however, is a picture of personality that subsumes not only its own history but also the history of its times and the significant history of all times.

Reynolds may speak of the time "when the Arts were in their infancy" (VI, 152; W 96), but the point of the organic historical metaphor of infancy is to provide an occasion for contrasting the ignorance of infancy with the knowledge of maturity, which on the level of the individual becomes the contrast between native ability (ignorance) and educated taste and skill (knowledge).

[22] *Fearful Symmetry* (Princeton: Princeton Univ. Press, 1947), p. 13.

Blake's romantic tendency is to turn the metaphor around, using it as an occasion for contrasting internal knowledge (infancy) with external pseudoknowledge acquired by acculturation (old age), the emphasis in Blake usually being on the swiftness with which the culture tries to bind the infant's innate knowledge in order to populate its vineyard with another docile laborer. The first step is provided by Locke's epistemology; the child must be regarded as having no knowledge of its own. "The world's opinion"—the vision of This World impressed upon the senses of the child from without—is everything, the child's opinion only an obstacle that Lockean pedagogical strategies are designed not to honor but to slyly circumvent.

From Lockean premises emerges an educational pattern of radical socialization, from unimproved child to improved adult. From the Blakean conflict between identity and threats to its coherence emerges a characteristically romantic three-part pattern of identity, loss of identity, and recovery of identity. It has been noted frequently in recent years that such a pattern, as exemplified in central romantic poems such as *The Prelude* and *Jerusalem*, may be seen as the psychological or internal version of the Christian myth found in major preromantic works such as *Paradise Lost*. If we want to take the romantic view, it will be truer to call *Paradise Lost* the historical or external version of the romantic myths found in *The Prelude* and *Jerusalem*. Schematically, at any rate, and perhaps historically, the elements required for the romantic internalization of the Christian myth are provided by Christianity itself, in the branches of radical Protestant thought that shifted the focus of Christian religion from the institutional church to the individual believer: "Hence," as Frye concludes, "the English Romantic tradition has close affinities with the individualism of the Protestant and radical traditions. In all three the tendency is to take the individual as the primary field or area of operations instead of the interests of society, a tendency which is not necessarily egocentric, any more than its opposite is necessarily altruistic."[23] We can extend the last sentence into the present argument: while romanticism shifts the basic area of operations from the society to the individual, the shift does not necessarily make a view of society, culture, and history impossible (as has been claimed), any more than

[23] "Blake after Two Centuries," *Fables of Identity: Studies in Poetic Mythology* (New York: Harcourt, 1963), p. 149.

Enlightenment classicism makes a view of the individual impossible.

As for the relation of Protestant religious tendencies to romantic artistic tendencies, the familiar rudimentary pattern is as follows: when radical Protestantism emphasizes the individual believer instead of the institutional church, it then focuses on a quasipersonal relationship between the believer and God, and a pattern of individual salvation in three stages comprising a fall from some better state and a subsequent recovery. This pattern may be secularized in at least two ways: by denying the existence of God or by identifying the believer with God. Shelley prefers the former method, Blake the latter. The secularized pattern of salvation becomes the romantic formula for the recovery of identities lost to experience and the external world. Though the pattern is weighted at the individual end, it may be applied, as it is in Christian tradition, at all levels from the salvation of the individual to the salvation of the community and of cosmic history.

In its Protestant and related romantic forms, the pattern itself suggests that the logical place to begin applying it is at the level of the individual identity. The foundation of identity is the intersection of the smallest unit of time with the smallest unit of space in which the identity acts as a whole and wholly as itself: the "Moment" that "equals a pulsation of the artery" and the "Space" determined by "a red Globule of Mans blood": "For in this Period the Poets Work is Done: and all the Great / Events of Time start forth & are concievd in such a Period / Within a Moment: a Pulsation of the Artery" (*M* pls. 28-29; E 125-26). The time and space of this creative moment are ruled by identity, in contrast to the universal time and space by which the culture rules every part of human life except the imaginative part.

At this episodic level, the pattern of lapse and return governs romantic stories of the creation of single poems and paintings. Blake works such stories frequently into his *Descriptive Catalogue*, especially to explain his "experiment Pictures," which are treated as fables of identity:

I was myself ("This Picture was done many years ago, and was one of the first Mr. B. ever did in Fresco; fortunately or rather providentially he left it unblotted and unblurred");

I lost myself to others (I was possessed by "Venetian and Flemish Demons" in the form of "memory of nature and of Pictures of the various Schools . . . instead of appropriate execution, resulting from the inventions; like walking in another man's style . . . tormenting the true Artist");

I found myself again (the picture "was with difficulty brought back again to a certain effect, which it had at first, when all the lineaments were perfect"). (*DC*; E 536-38)

Blake's experiment pictures (Numbers 7, 8, and 9 in *A Descriptive Catalogue*; E 536-39) are parody experiments against experiments—"Note. These experiment Pictures have been bruized and knocked about, without mercy, to try all experiments" (E 539)—and educational exercises against education. The result is a hilarious parody of the academic mentality in art by an artist who, setting himself up as an academy-of-one-in-exile, exhibiting his own work under his own family's roof, outlines in a series of discourses some fundamental principles. While one side of this painter commits himself entirely to the positive defense of his principles, the other side sees that the principles are counterprinciples, even antiprinciples. This is the side that seldom misses a chance for parody, though I am aware that some readers make it a matter of principle to miss Blake's jokes. As Reynolds in his *Discourses* shows a fondness for using his artistic education to demonstrate how the inexperience of the young usually leads them astray until experience teaches them that the world's taste is based on solid experience, so Blake in his *Descriptive Catalogue* includes his three experiment pictures to concoct by experiment the antidote to the poisonous thesis of Reynolds' seventh discourse (as summarized by Blake): "That Taste & Genius are not of Heavenly Origin & that all who have Supposed that they Are so. Are to be Considerd as Weak headed Fanatics" (AR; E 647).

The parody is constructed out of the clash between the plot of scientific demonstration by experiment and the plot of romantic identity, the latter reminiscent of a quest, with Blake as the knight in lonely battle against a representative variety of the dragons of art history. But the plot of romance externalizes spiritual autobiography in knights confronting dragons who occupy the castles of weak rulers and tyrannize over distressed damsels. Blake, again favoring New Testament metaphors for their internalizing tendencies, calls his opponents "demons" and tells a

story of "possession," which must be followed, of course, by exorcism. Blake reports how the "vile tricks" of the "Venetian and Flemish Demons" "cause that every thing in art shall become a Machine":

They cause that the execution shall be all blocked up with brown shadows. They put the original Artist in fear and doubt of his own original conception. The spirit of Titian was particularly active, in raising doubts concerning the possibility of executing without a model, and when once he had raised the doubt, it became easy for him to snatch away the vision time after time, for when the Artist took his pencil, to execute his ideas, his power of imagination weakened so much, and darkened, that memory of nature and of Pictures of the various Schools possessed his mind, instead of appropriate execution resulting from the inventions; like walking in another man's style, or speaking or looking in another man's style or manner, unappropriate and repugnant to your own individual character. (*DC*; E 537-38)

Personal integrity here expresses artistic integrity. The original artist with his own individual character expresses his own ideas and vision with his power of imagination. The artist's mind encompasses both an original conception or invention and an execution. The personal integrity that molds this two-part image into one produces artistic integrity characterized by "execution *resulting from* the inventions."

In the counterplot, which controls the action of the middle phase or crisis of identity, the original integrity is interrupted by "fear and doubt." Doubt, from the vocabulary of Protestant salvation, maintains the Christian pattern of internal action that supports the experiment-picture parody:

Doubt Doubt & dont believe without experiment
That is the very thing that Jesus meant
When he said Only Believe Believe & try
Try Try & never mind the Reason why

("You dont believe"; E 492)

Doubt is self-doubt, fear is fear of being wrong. Systematic self-doubt as a Christian virtue is called humility. Since "Humility is only doubt" and Jesus insists on its opposite, faith, Blake later devotes a section of *The Everlasting Gospel* to proving that humility is a political instrument, not a true Christian virtue: "Was Jesus Humble?" (E 510). In the program for art and society that Milton announces in *Milton*, doubt is associated with the

idiot Questioner "Who publishes doubt & calls it knowledge; whose Science is Despair" (*M* pl. 41:15; E 141). Despair is the feeling that one knows nothing worth knowing, that others know everything worthwhile already and know it better. Doubt leads to despair, despair extinguishes the self: "If the Sun & Moon should doubt / Theyd immediately Go out" ("Auguries of Innocence"; E 485).

In Blake's romantic pattern of self-development, as in the Christian pattern of salvation, despair is the lowest point of the middle phase, alienation from self, alienation from God. As the self vacates the self—as imagination weakens and memory is stimulated—others arrive to fill the vacuum. These are the demons of the *Descriptive Catalogue* who, "by entering into disease and excrement, drunkenness and concupiscence, . . . possess themselves of the bodies of mortal men, and shut the doors of mind and of thought, by placing Learning above Inspiration" (E 537). The demons of doubting Titian, "outrageous" Rubens, and "soft and effeminate and . . . most cruel" Correggio enter the fatigued mind of the painter as rum and whores enter the lives of journeymen overworked in their mindless occupations: "poor wretch" (E 538). This of course is the parody version of the point that Blake makes seriously in the seventh Night of *The Four Zoas* when the sons of Urizen (Reynolds would be one) take over the tools of the "arts of life" and change them into tools of "the arts of death":

> And in their stead intricate wheels invented Wheel without wheel
> To perplex youth in their outgoings & to bind to labours
> Of day & night the myriads of Eternity. that they might file
> And polish brass & iron hour after hour laborious workmanship
> Kept ignorant of the use that they might spend the days of wisdom
> In sorrowful drudgery to obtain a scanty pittance of bread
> In ignorance to view a small portion & think that All
> And call it Demonstration blind to all the simple rules of life
>
> (E 396)

The sons of Urizen did not all grow up to be factory-owners, though the customary citation of this passage as evidence of reactions to the Industrial Revolution might lead one to think so. The best way of perplexing youth and binding them to their labors is by putting the taskmasters in their brains. The task-

master may be Bounderby and his den may be the factory, but he may just as well be Correggio and his den the artist's mind. The imagery of "Journeymen . . . manufacturing" by "manual labor" the products "that go under his name" (*DC*; E 538) is appropriate to both kinds of mechanization. The belief that makes both kinds possible is voiced by the "perturbed Man" to the "Phantom of the over heated brain" (his friendly imagination) in *Jerusalem*: "By demonstration, man alone can live, and not by faith" (*J* pl. 4:28; E 145). Demonstration is life by the ideas of others, life from the outside in; faith is faith in oneself, life from the inside out.

The self at this phase is robotic, no real self organized by imagination but a composite of others organized by "memory of nature and of Pictures of the various Schools" (nature and Homer are the same). The self possessed by others Blake calls the Selfhood. The Selfhood is "Reasoning & doubting" (*VLJ*; E 553) because it is the result of self-contradiction. The doubts of the Selfhood in action lead to "self accusation" (*FZ* VII[a]; E 354). Doubt, then, is a wedge driven between parts of a single Human Form, as Blake would say, and the consequence is the multiplication of divisions, self from self, self from work, self from others, subject from object, societies from societies, worlds from worlds, until at last the image of the universe is the externally projected picture of cosmic alienation that Newton imagines, which is the negation of the vortical artistic universe that Blake imagines, worlds within one world, societies within one society, self expressed in others, subject expressed in object, self expressed in work, self unified in variety, the universe of "All Human Forms identified" that we hear of at the end of *Jerusalem*.

A kind of schizophrenic art characterizes the middle phase. The conception may belong to the artist, but the conception, strain as it might, cannot push past the crowd of demons to the artist's own execution. First Titian's spirit takes over, then Correggio's, then Rubens', until the artist is thinking in one style, walking in another, speaking in another. Blake records that the more labor he spent on his experiment pictures, the worse they got, until finally he, or rather his demons, had labored them "to a superabundant blackness" (E 537). When the sun and moon of the self have doubted themselves out of existence, the external world, including the paintings in it, go dark. Blake's experi-

ment pictures are thus all artistic disasters which demonstrate by experiment that romantic experiment, like romantic education, is paradoxical. The experiment of the pictures, like the education of the child in Wordsworth's "Immortality" Ode, leads away from the light, not toward it. The only labor that can restore a painting thus darkened by labor is antilabor, labor eradicating labor the way true education eradicates false, to bring the painting "back again to a certain effect, which it had at first, when all the lineaments were perfect" (E 537), and the self with it.

Blake emphasizes that his experiment pictures were "painted at intervals" (E 536-37). The span of space and time that governs the pattern of lapse and return is an extension of the "pulsation of the artery" that Blake names, in his *Canterbury Pilgrims* prospectus, the "Artist's Year": "No Work of Art, can take longer than a Year: it may be worked backwards and forwards without end, and last a Man's whole Life; but he will, at length, only be forced to bring it back to what it was, and it will be worse than it was at the end of the first Twelve Months. The Value of this Artist's Year is the Criterion of Society: and as it is valued, so does Society flourish or decay" (E 556). The history of art in Blake's time is full of stories about paintings so highly finished that a decade is insufficient to complete them, and of engravers who go to their graves working, working, and still working on the highly finished fancy prints-to-be of history paintings long since exhibited and faded from the public memory. The artist's year is of course no natural year of 365 days but an imaginative year that may begin "September next" (E 556) or any other time and end, similarly, when the imagination has done its work and mechanical frittering begins. A society that uses the latter as its criterion sees the making of a painting as a pattern of steady, linear improvement, and accordingly values paintings in hours lapsed, turning painters into day-laborers.

The idea of an artist's year probably explains Blake's habit of dating his works occasionally by the time of original invention. Scholars have known for a long time that the date of 1804 on the title pages of both *Milton* and *Jerusalem* is too early to be the conventional date of completion or publication that we expect on title pages. But most of the hypotheses that have been proposed to account for the discrepancies—for example, the sug-

gestion that an early year appears on an etched title page because
Blake etches the title page that year but continues to etch other
plates for years to come—are probably wrong, or at least incom-
plete. The year on the title page is just as likely to be the artist's
year, the chronological home of the pulsation of an artery, the
creative moment in which all the poet's work and all the great
events of time start forth and are conceived. Thus the discovery
that a copy of *Newton* is signed by Blake 1795 but color printed
on paper watermarked 1804 should come as no surprise.[24] Many
other surprises may be waiting among the watermarks. How
can one fail to sympathize with responsible scholars who have
to swim against the current of an esthetic theory that encourages
an artist painting in the year 1804 to sign the work "WB
1795"?—doubtless a lie in clock time but, in Blake's terms,
truth in eternity.

The warning to which the pattern of lapse and return leads—
"I say again, O Artist, you may disbelieve all this, but it shall
be at your own peril" (*DC*; E 538)—is true to the fundamental
place of the biographical anecdote in romantic pedagogy. The
intent of the fable here as elsewhere is not to draw students
outward toward the information and skills of the teacher but to
turn students inward toward themselves. Blake's "disbelieve me
at your peril" is an exhortation to students to believe in them-
selves.

At the full biographical level the pattern of romantic educa-
tion assumes its more familiar Wordsworthian forms. Blake's
own loss and recovery of identity cover the stages of his life
from the mid-1790s, through the period with Hayley in Felp-
ham at the turn of the century, to a renewed vision with literary
inspiration from Milton and visual inspiration from the Truch-
sessian exhibition in London.[25] The characteristic statement to
emanate from such a view of one's own life is Blake's description

[24] See Martin Butlin, "A Newly Discovered Watermark and a Visionary's Way
with His Dates," *Blake/An Illustrated Quarterly*, 15 (1981), 101-03. Significant
advances have been made recently in the dating of Blake's work. See especially
Robert N. Essick, *William Blake, Printmaker* (Princeton: Princeton Univ. Press,
1980), and Martin Butlin, *The Paintings and Drawings of William Blake* (New
Haven and London: Yale Univ. Press, 1981), a catalogue in two volumes.

[25] The first full and accurate reconstruction of this crucial period in Blake's
life, worked into a plausible if speculative view of Blake's changing artistic theory
and practice, is Morton D. Paley's "The Truchsessian Gallery Revisited," *Studies
in Romanticism*, 16 (1977), 165-77.

of his engraving style for the *Canterbury Pilgrims*: "In this Plate M^r B has resumed the style with which he set out in life" (*PA*; E 561).[26]

The romantic pattern is easily confused with the pattern of Imlac and Goldsmith, which, adjusted to sound vaguely romantic, may suggest the Wordsworth of "Tintern Abbey" and the "Immortality" Ode and the Coleridge of "Dejection": the natural youth of enthusiastic inspiration declining in experience to the cold philosophical refinement of age. The distinction most important to my argument lies less in the pattern than in the association of the pattern with personal identity. Imlac's is a scheme in which neither idea nor technique, invention nor refinement, nature nor art is necessarily associated with personality. All may be in a sense public property, and the individual a cultural vehicle. Wordsworth's conflict, however, grows out of the desire to make both sides, the imagination of youth and the philosophy of maturity, his. He fears growing away from his true self toward philosphy, the impersonal truth. That is, he fears the betrayal of self and poetic self-expression to a conceptual pattern that he adapts to himself rather than expresses as himself. We might compare the autobiographical pattern that Wordsworth applies with the pattern applied to Grignion. The distinction made in his obituary between the fashionable engraving style of his youth and the change in fashion that left him stranded does not depend upon the romantic distinction between a style that is his and one that is imposed. The obituary writer does not imply that the more "intellectual" style of Grignion's youth had anything to do with *his* intellect, merely that the age

[26] It is at the biographical level that scholars tend to confirm or deny the romantic pattern. Some recent accounts of Blake's visual art, for instance, adopt a three-part pattern of development, based on a combination of evidence from Blake's work, his statements, and apparent stylistic influences. Paley, for instance, describes three basic stages, including a "transitional phase which ends with the utter condemnation of Flemish and Venetian painting," and "an eclectic middle period [in theory and practice], during which he was willing to absorb lessons in colourism and chiaroscuro from sources which he later rejected as inimical to true art" (*William Blake*, pp. 51, 52); see also my Chapter I, notes 10, 18, 33 and 36, above. Blake's experiments in practice seem to me less profound evidence than the essential consistency of his theory, his reasons for doing what he does. Blake saw his end as a return to his beginning, with a brief middle stage that is aberrant; in his terms, an error. I would be reluctant to call that a stage of development in the usual sense.

had gone from serious and intellectual to empty-headed and technical, in the manner of Reynolds' warnings to the Royal Academy about the false attractions of virtuoso technique. Romanticism of the phase favored by Blake distinguishes sharply between any old nostalgia for the loss of youth and romantic nostalgia for the loss of *my* youth.

Projected into the social order, the pattern of romantic education may divide society into an innocent class of, say, children or peasants whose identities are intact, an experienced class of adults in the worst sense, and a class of those who have recovered innocence from the ashes of experience. The child in such a society may be especially valued, not as a resource but as a model. "The proper result of intellectual cultivation," writes George Eliot, "is to restore the mind to that state of wonder and interest with which it looks on everything in childhood."[27] Such visions of the social order may humanize and secularize the Protestant class divisions—Elect, Redeemed, Reprobate—that Blake works into *Milton*. Blake's own choice, of course, is to project the three-part pattern not into any system of social classes but into a system of psychological "states" that all may "enter" and "leave" in a society without classes.

Romantic education sees history as a pattern of interrupted integrity headed, naturally, toward a recovery, which, honoring religious parallels, may suspiciously resemble biblical apocalypse.[28] Thus the basic historical idea in the Argument of *The Marriage*, in the Preface to *Milton*, the *Descriptive Catalogue*, and the *Public Address*—to name only obvious examples—is that the time has come for English artists to find again the true path that has been lost; or as Frye says it, "like the Romantics, Blake thought of the 'Augustan' period from 1660 to 1760 as an interruption of the normal native tradition."[29] Applying metaphors from sacred history, Blake imagines a ratio in which the Augustans are to true art what pagans are to true religion. The story that results is either an external battle of false with true, as in the battle of Roland, or an internal battle in which the true threatens to turn into the false, "falling away," as Christians

[27] Quoted in Witemeyer, "George Eliot and Jean-Jacques Rousseau," p. 121.
[28] Abrams studies the congruence of these two patterns in *Natural Supernaturalism: Tradition and Revolution in Romantic Literature* (New York: Norton, 1971).
[29] "Blake after Two Centuries," *Fables of Identity*, p. 148.

have been known to say, from the truth. In any case, the larger historical pattern is again the one represented in the Bible.

Blake, we should note, complicates the mythical parallels considerably by incorporating the history of the Christian religion into his history of art, as Shelley also does (in his *Defence of Poetry*), though starting with ancient Athens instead of Eden. The history proposed by Blake makes the history of Western institutional religion a tragic antiartistic detour of which Augustanism and the Enlightenment generally are a final stage, leading, fortunately (providentially), to recovery through a process, familiar to anyone who reads the illuminated books, of the gradual consolidation of error. The use of the Judeo-Christian pattern of sacred history against itself recalls the parallels between radical Protestantism in religion and romanticism in the arts and suggests a caveat. The historical sequence that puts the former before the latter does not necessarily translate into the facile causal sequence that would have the romantics and their successors "compensating" for the loss of religion by exalting art to the level of religion and themselves to priests. The religious parallels do indeed suggest that the fanatical believer becomes the artist, the inner light the imagination, and artistic theory and sometimes art itself the scriptures. But Blake for one sees the so-called religion of imagination as the only true religion, while what usually passes for religion is in fact the worship of an allegory of imagination—that is, an allegory of individual accomplishment. Thus his sacred history puts so-called sacred history in its proper place as one more allegory through which some individuals enslave others by telling them scary stories about their own minds.

Blake employs the historical version of the three-part pattern of loss and recovery of identity when he asserts that "Engraving as an Art is Lost in England" since "the Enterance of Vandyke & Rubens into this Country" and claims for himself that "to recover Art has been the business of my life" (*PA*; E 560-61, 569). From this perspective it becomes clear that the *Descriptive Catalogue* is thematically circular. It begins with a historical vision of the true art that predominated before the present "corrupt state of Society" and ends with what must be the basis of any return to true art, the integrity of the artist's imagination that allows early work to be "identical in all essential points" with later. "*My* life" is the individualism on which the recovery

is founded. It is possible by missing this emphasis to confuse Blake's with any golden age view of history that urges a return to the values of an earlier age. Even when he issues a call to a community of artists, as in the Preface to *Milton*, the basis of communal effort is to be a rejection of "Greek or Roman Models" in favor of being "just & true to our own Imaginations"—a Christian belief, Blake says (E 94). Likewise, when he urges a return to an earlier style of engraving—"the style of Alb Durers Histries & the old Engravers which cannot be imitated by any one who does not understand drawing" (*PA*; E 561)—and claims to have resumed that style in his own work, commentators have sometimes mistakenly thought him to mean literally that engravers should revert to some old-fashioned mode of representation abstracted from Dürer and "the old English Portraits." The error comes about honestly enough; such notions of style are a part of conventional art historical methodology, inherited from the Enlightenment tradition and improved. But Blake means not "I adhere to the manner of Dürer" but "I adhere to myself, as Dürer himself did." Thus he states, "To Imitate I abhore I obstinately adhere to the true Style of Art such as Michael Angelo Rafael Jul Rom Alb Durer left it"; and at that point he deletes, apparently as superfluous, "the Art of Invention not of Imitation. Imagination is My World" (*PA*; E 569).

Blake's urging artists to return to the true style of art is also distinct from Pound's urging the study and practice of complex old metrical techniques and verse forms or Eliot's urging a "discipline of prose" to which the talented young poet must first submit. The implied pattern of development can be contrasted most directly with Blake's in a passage from a letter to Butts from Hayley's estate in Felpham: "I have recollected all my scatter'd thoughts on Art & resumed my primitive & original ways of Execution in both painting & engraving, which in the confusion of London I had very much lost & obliterated from my mind" (10 January 1803; *Letters*, p. 55). For Blake, getting his thoughts back together is recovering his primitive and original identity, which expresses itself in his execution. "Primitive" carries the force of "primary." When Blake puts himself in the vanguard of the movement to recover the lost tradition of true art—for all artists a style of their own—in the context of Enlightenment esthetics he is calling for a return to no-style and thus making no sense. In romantic terms, at the individual level

artists recover their own primitive and original ways; at the historical level they recover the primitive and original ways of the art. But Blake interprets the historical in terms of the individual; Dürer is not the historical representative of a historical style but an individual artist with his own style. The history of art, like all history, is a history of heroes whose message to posterity is "be just & true to your own Imaginations."

"This Absurd Assertion"

The assumption that makes content and form separable, and may ultimately make separability a test of authenticity (as in the proof-of-wit-by-translation reported by Reynolds), extends Enlightenment critical practice in certain characteristic ways. Blake has good reason to take special note of how the assumption encourages a typical Enlightenment mode of evaluation. By the time he drafts his *Public Address* in 1810, a veritable tradition in the evaluation of his work seems firmly established. He describes it bitterly toward the end of the *Address*: "The Lavish praise I have recieved from all Quarters for Invention & Drawing has Generally been accompanied by this he can concieve but he cannot Execute this Absurd assertion has done me & may still do me the greatest mischief I call for Public protection against these Villains I am like others Just Equal in Invention & in Execution as my works shew" (*PA*; E 571). After practicing his art professionally for three decades, Blake finds his work tamed by a dismissive formula so effective that later critics have had only to repeat it. A brief examination of the context will document Blake's fears and add needed perspective.

In the mid-1790s "Anthony Pasquin" writes that the painter James Barry "appears to me . . . to conceive too powerfully for the ordinary methods of deliverance"; it seems that "his thought is too ponderous for his mechanism."[30] By the time he offers it, Pasquin's judgment is already a commonplace at least a decade old. Perhaps Dr. Johnson himself started it. In the entry for 26 May 1783 Boswell's *Life* quotes Johnson as saying of Barry's paintings in the Great Room of the Society of Arts at the Adelphi, "Whatever the hand may have done, the mind has done its

[30] Pasquin [Williams], "A Critical Guide to the Exhibition of the Royal Academy, for 1796. . . " (London, 1796), p. 126.

part. There is a grasp of mind there which you find no where else."[31] By the time of the compilation of the eleventh edition of the *Encyclopaedia Britannica* in 1910, the author of the entry on Barry can muster the heavy confidence of tradition itself to pronounce that "as an artist, Barry was more distinguished for the strength of his conceptions, and for his resolute and persistent determination to apply himself only to great subjects, than for his skill in designing or for beauty in colouring. His drawing is rarely good, his colouring frequently wretched." Mona Wilson, writing her biography of Blake a few years later, brings us curiously full circle back to Johnson via Blake: "Barry may have inspired Blake to see what he [Barry] had meant to do and what he declared in his descriptive pamphlet [*An Account of a Series of Pictures in the Great Room of the Society of Arts*] that he had sublimely accomplished, rather than the muddled and somewhat ridiculous performance he actually achieved."[32]

To some of his contemporaries, Fuseli seems to share Barry's problems. In a review of a Royal Academy exhibition, Charles Westmacott writes off Fuseli's *Thunder-Storm* in a sentence: "Well conceived, but not well painted."[33] A quarter-century later we find Ralph Wornum elaborating Westmacott's dismissal in his edition of lectures by the Royal Academicians. Fuseli's most famous painting, *The Nightmare*, "owed its celebrity purely to its idea." Fuseli "appears to have totally failed . . . to acquire a mastery over the material or technical department of the art."[34]

Any teacher will recognize in these evaluations the method and language of paper-grading pedagogy, where a combination of convenience and public standards creates conditions similar to those favored by Enlightenment esthetics. Grading student essays involves the teacher in a pedagogical version of the intentional fallacy (claiming to perceive the student's intention, the teacher declares that the work fails to communicate the intention adequately) and in the assumptions of a consensus esthetic

[31] *Boswell's Life of Johnson*, ed. G. B. Hill, rev. L. F. Powell, IV (Oxford: Clarendon, 1934), 224.

[32] Wilson, *The Life of William Blake*, 3rd ed., ed. Geoffrey Keynes (London: Oxford Univ. Press, 1971), p. 17.

[33] *A Descriptive and Critical Catalogue to the Exhibition of the Royal Academy* (London, 1823), p. 14.

[34] James Barry, John Opie, and Henry Fuseli, *Lectures on Painting, by the Royal Academicians: Barry, Opie, and Fuseli*, ed. Ralph N. Wornum (London: Bohn, 1848), p. 49.

(claiming to perceive that the content of a paper is appropriate to a journalistic feature story, as defined by a set of rules, the teacher declares that student execution is inappropriately matched to content). In the pedagogy of Enlightenment criticism, such assumptions support formulas for correctly choosing a medium of execution (watercolor or the heroic couplet), correctly mixing comedy in tragedy, or correctly drawing the human figure. The intentional fallacy and consensus esthetics are closely related: intentional fallacies lose their sinful aura as artistic intentions become public matters, standardized by consensus. And both are based on a separation of form from content.[35] A teacher of writing acts toward student papers as Wornum acts toward Fuseli's *Nightmare* by telling students that their ideas are sound but their style does not convey them properly, meaning that the teacher can see that the style does not conform to certain public standards (rules) of usage, usually a combination of the rational and the conventional, and meaning also that the teacher presumes to be able to see what students intended but failed to accomplish. Coleridge is schoolmastering in this way when he says that certain of the *Lyrical Ballads* "would have been more delightful to me in prose, told and managed . . . in a moral essay, or pedestrian tour."[36] Very often the problems can be resolved in consensus, since the teacher's idea of writers' intentions will be based on other performances by other writers on other occasions, and represents a kind of guess at what writers might intend if they too have some notion of these performances (or if their minds are predictably like the minds of other writers). That is, the teacher obviously cannot know what is in the students' minds except by the behavior of the students—a spoken description after the fact, for instance, by students of what they intended to say. We are riding the edge of the difficult philosophical prob-

[35] Intentionalism has been associated with a rather narrow school of critical thought. But every kind of critical theory produces its own characteristic intentional "fallacy." In a radical phase of Enlightenment classicism, a successful search for an artist's intentions discovers that they are identical to public expectations (of genre, technique, sentiment, etc.). Romanticism at an equally radical phase discovers intentions by means of empathy. The one finds out what an artist means to do by finding out what an epic is; the other by finding out who the author is. For reasons to be discussed later, in the section on the romantic audience, romantic empathy does not show the Enlightenment tendency to separate intention from performance, at least not in the same way nor to the same degree.

[36] *Biographia Literaria*, ed. Shawcross, vol. II, chap. xviii, p. 53.

lem of other minds. Clearly, Enlightenment esthetics can offer
confident solutions to its share of such problems. Just as clearly,
painters who do not fit the expectations of the method and its
assumptions will not be comfortably accommodated by it. As
for the division of conception and execution, perhaps a pattern
of evidence is emerging in the fact that Barry and Fuseli, two
near contemporaries whose work Blake associated with his own,
are summed up in the same formula and found lacking in the
same way. If so, the pattern is certainly revealing more about
the limits of the formula than about the value of the works to
which it is being applied.

No less a figure than Reynolds himself seems to be the inven-
tor of the Blakean branch of the tradition when he admonishes
the stubborn youth whose student work he examines to correct
a drawing.[37] Reynolds speaks as a teacher; his opposite number
in prose may urge students to correct their syntax. The differ-
ence between the two is in the breadth of application. Not only
students are told to correct their drawing: Rubens is told to
correct his, Rembrandt his, Reynolds his. In correctness, as in
other related Enlightenment standards, pedagogical convenience
and ultimate critical value are seldom distinguished. It is easily
forgotten that the approximate modern equivalent to writing a
poem or painting a history in the eighteenth century is writing
a prose essay for a respectable magazine, whose editors apply
public standards of good thinking and good writing with some
confidence to subject matter, organization, syntax, diction, and
punctuation. The basis of the confidence is consensus, largely as
a result of training. The eighteenth-century consensus that al-
lows Reynolds to dictate correctness is a broad agreement in
principle that the community, properly trained, can perceive the
conception behind the execution and can consequently judge the
artist's success in matching the one to the other, or can legiti-
mately judge the success of the artist in either conception or
execution without reference to the other, as in adjusting the ex-
ecution to certain norms that the audience can agree upon before
seeing the particular work of art to be judged. The definition of
"correctness" in Pilkington's *Dictionary* as "a term which im-
plies a design that is without defect in its measures and

[37] Alexander Gilchrist, *Life of William Blake, "Pictor Ignotus,"* 2nd ed. (Lon-
don, 1880), I, 314. Gilchrist cites a letter from an unnamed acquaintance of
Blake.

proportions"[38] begs every question it raises unless "defect," "measures," and "proportions" are previously defined. The absence of such definitions in Pilkington suggests prior definition by consensus. We do not usefully advise correctness without a norm to give "correct" some kind of rational meaning. We do not complain of a lack of finish (or execution) without first agreeing upon what is there to be finished (the conception), as we must agree upon what is being refined before judging how refined the product finally is.

By the time Blake enters his final decade the critical formula has become so familiar that he can probably hum the refrain before his critics begin to sing, though Dr. Thornton's comment on Blake's Virgil illustrations may be the first appearance of the formula in print: "They display less of art than genius, and are much admired by some eminent painters."[39] Thornton's embarrassed compliment parallels Johnson's on Barry's "grasp of mind," with the emphasis shifted from mind generally to imagination in particular. Thornton is implicitly relegating Blake to the category of expressive artist reserved for those suffering an imbalance of genius; as we recall from *The Bee*, "For although the skill . . . may be wanting, the original Genius is displayed in the natural *Expression*." Thornton no doubt hopes that the category, suggested to him by some experts, will help make the best of a bad thing: make some illustrations that have been bought and paid for appear, if not competent, then at least exciting.[40]

[38] Matthew Pilkington, *A Dictionary of Painters from the Revival of Art to the Present Period*, rev. ed., ed. Henry Fuseli (London, 1805), p. xvii.

[39] Thornton edited the *Pastorals of Virgil*. His comment on Blake appears in vol. 1 (1821), frontispiece, facing p. 13. Blake illustrated Ambrose Philips' imitation of Virgil's *First Eclogue*.

[40] The Virgil wood engravings have a curious critical history. They had a powerful influence on the group of younger artists who gathered around Blake in his last years. Gilchrist gave them a special place of importance among Blake's works, admiring them in certain ways most of all. Alternating with admiration is the dismissive technical formula, as in Raymond Lister's *Infernal Methods: A Study of William Blake's Art Techniques* (London: G. Bell, 1975). Lister begins his book by pointing out "how intimate to Blake was his technique," lauding his "tremendous versatility" that produces "equal facility" in several media, including "wood engraving" (p. 2). But Blake's only wood engravings are the Virgil series, and of those Lister later boasts on the one hand of "their minute, jewel-like conception" containing "the concentrated essence of Blake's visual Romanticism," while on the other hand complaining of their "coarse and amateurish" technique,

Not long after Blake's death the tradition proves its hardiness when Bernard Barton writes to John Linnell in 1830 concerning a failed attempt to sell a set of Blake's *Job* engravings: "A dryness and hardness in Blake's manner of engraving . . . is very apt to be repulsive to print-collectors in general." He fears there will be few with "taste enough to appreciate the force and originality of his conceptions, in spite of the manner in which he has embodied them." Blake's "style," he says, combines "old Albert Durer with Bolswert" and is "little calculated to take with admirers of modern engraving." Barton "cannot but wish he [Blake] could have clothed his imaginative creations in a garb more attractive to ordinary mortals."[41]

Thornton wants to be sure to float his project despite the handicap he suspects Blake of being. Barton wishes Blake could have displayed somewhat more of art with his genius. But by the end of the nineteenth century Blake's stock has risen considerably, giving someone like William Bell Scott a chance to employ Thornton's and Barton's formula to make a place, not for Blake, but for himself alongside Blake. We shall discuss the practical side of Scott's Blake project in a later section and concentrate for the time being on his rationale. Expression has by Scott's time come to be identified as poetic, and poetry to be associated with the feelings of the artist that may be present in a work without skills of execution. Scott describes Blake, for instance, as "essentially . . . a poet" whose "egotistic fancies"— that is, those conceptions whose execution does not use publicly sanctioned signs of skill—have the following quality: "The intensity of expression that presents intellectual passion, so to speak, is always present with Blake. We cannot pass his works by coldly and without being roused or moved by them." Scott contrasts Blake with the artists of the 1870s, who are all execution and no conception; in short, they have no feeling, no "poetic insight." He complains of the monotony of art in his time, when "a purely aesthetic [i.e., the equivalent of mechanical in Blake's time] motive furnishes, properly speaking, the *raison d'être* for all modern art; but beauty that affects the feelings is the rarest of productions." He boasts that the English artist has learned to

of "clumsiness in handling—a surprising clumsiness for a professional engraver" (pp. 32-33). In the presence of such contradiction, Blake's favorite tactic is to conclude that the book is the work of more than one person.

[41] G. E. Bentley, Jr., *Blake Records* (Oxford: Clarendon, 1969), p. 397.

appreciate characteristically English sights along with the tex-
tures of sheep, rocks, and dogs, "but there he stops short, and
on the next canvas you find the same excellence, of execution
only."

Scott is saucing an Enlightenment dish with late Victorian
lavender. In the eighteenth century, Winckelmann's cure for
the sterile skills of the modern artist is a strong dose of intellect,
which he associates with poetry and thus with the poet in the
painter. He and Scott both believe that modern painting is tech-
nique-rich but significance-poor. For Winckelmann the missing
significance that would rescue painting from slavery to technique
is conceptual; for Scott, emotional: for both, poetry, whatever
it is, is the ingredient whose absence is much lamented. Another
version of this pattern is found in Reynolds' repeated warnings
to immature Academy students learning to worship Mammon
(the "material" aspects of art) in the guise of "a facility in com-
posing,—a lively, and what is called a masterly, handling of the
chalk or pencil," with "dazzling excellencies," in "frivolous
pursuits" that so seduce the intellect that it can never understand
true art again after being "debauched and deceived by this fal-
lacious mastery" (I, 13; W 17-18). "The wish of the genuine
painter," he says, "must be more extensive" than the direct me-
chanical imitation of "individual nature": "Instead of endea-
vouring to amuse mankind with the minute neatness of his im-
itations, he must endeavour to improve them by the grandeur
of his ideas" (III, 52-53; W 42). Scott turns the "grandeur" of
Enlightenment "ideas" into the "intensity" of post-romantic
"expression," "intellectual passion," and "loveliness"—all sig-
nificant alterations, of course—while maintaining despite every-
thing the formula of lament that Enlightenment assumptions
make possible: "[Blake] was what we call a genius, but he was
entirely without the executive and expletive powers of hand and
mind we call talent; and this want made him in one point of
view the most imperfect of artists, but in another the most un-
approachable. He worked simply 'according to the idea'
He is thus entirely unlike other modern artists, especially those
of our own time, since photography showed them the miracles
of unselected detail."[42] Reynolds might have reminded Scott that

[42] All of Scott's remarks are drawn from William Bell Scott, *William Blake:
Etchings from His Works with Descriptive Text* (London: Chatto and Windus,
1878), pp. 3-5.

"minute neatness" in imitations of individual nature was not invented by painters swept away by the "miracles of unselected detail" supposedly discovered by that bugbear photography; and that Scott's implicit history of nineteenth-century art, while true to his assumptions, is nothing new: Scott's poetic Blake represents the past age of romantic invention that has been supplanted by an age of refinement in the 1870s. (This historical myth persists from Blake's time until the period of World War I, when poets and artists such as Pound reverse it in their call for a new concentration on old technical skills after a "romantic" period of sloppy sentiment and fat ideas without technique.) Otherwise Reynolds and Scott have little to disagree about, certainly not about Blake's need to correct his drawing. Even after an esthetic revolution, old assumptions die hard.

In the twentieth century the evaluative formula, by now a domesticated and virtually universal cliché, has flourished with Blake's reputation. It has become a sign of his presence, like cans tied to a cat's tail, following him from the surface of newspaper reviews into the deep interiors of scholarly books.

We must not forget how difficult it is to do without the convenience of a division between form and content, and to draw the bounding line between convenience and principle. As astute an interpreter of the history of engraving as William Ivins seems to fall almost unconsciously into contradiction on the subject, with Blake once more on the losing end. A major aim of Ivins' *Prints and Visual Communication* is to show how in the history of engraving "form and content were separated, and both got lost." He quotes approvingly a remark about Pascal, "that he had no style, he merely had important ideas which he expressed in such form that there was no difference between his words and his thought." Ivins identifies the eighteenth-century "emphasis on etching as such" as an error: "When a man asks do you not think this is a good etching, his words relate to the craft and not to the picture—an inversion of interest and importances that has fooled a great many innocent people. It is a hang over from the eighteenth century's interest in the moiré of engraved lines and its forgetfulness of the picture." But the distinction between the craft and the picture cannot be maintained. The etching as such is the picture as such. When Ivins goes on to say that "it is perilously easy to forget that after all an etching or engraving is a drawing and that the most important thing in a drawing is

draughtmanship," he may seem to echo Blake's declaration that "Painting is Drawing on Canvas & Engraving is Drawing on Copper & nothing Else" (*PA*; E 571), but Ivins is himself forgetting that an etching is "after all" an etching. Draftsmanship is not a known quantity separate from conception, somehow visible through the etching, or the paint, or whatever. Blake seems conscious of the difference: "Drawing is Execution & nothing Else" (*PA*; E 571). It is only mildly surprising that Ivins, in the chapter reporting the Pascal anecdote and on the page correcting the obsession with etching as such, judges Blake "a very incompetent technician and draughtsman."[43]

A long feature review in the *Times Literary Supplement* of the 1978 Blake exhibition at the Tate Gallery and of recent books on Blake's art is built around the Enlightenment theme (offered by the reviewer as his original insight) that Blake cannot draw— "every part of the picture is clumsily or feebly drawn"—but that, somehow, sometimes, "it works," which is presumably the colloquial equivalent of Thornton's "less of art than genius." The reviewer, British artist Tom Phillips, is irritated by his difficulty in figuring out what Blake's "unforgettable" images mean and calls the difficulty "Blake's frequent failure to communicate what he has in mind." This in turn he attributes to a contradiction between Blake's conception—a radical and unconventional "system of thought"—and his execution—a "conventional" "visual vehicle" labeled "Gothicized Neoclassicism." Thus Phillips describes his tour of the exhibition as a series of doubletakes: "Blake is, as he was in life, his own worst enemy: one is continually brought to a halt by a piece of seeming self-parody or by a vulgarization of his own vision." Phillips finds himself in a classic corner: claiming not to understand Blake's meaning ("one comes away with the picture but the message stays on the wall"), lamenting Blake's "failure to communicate," while claiming simultaneously to perceive Blake's ideas and intentions, separate from his techniques of execution pegged in neat historical categories. Furthermore, Phillips claims to perceive—most audaciously—that the two contradict each other.[44]

The conception/execution split and the Enlightenment formula based on it find their way into the innermost circle of

[43] *Prints and Visual Communication*, pp. 169, 112, 100, 101, 100.
[44] Tom Phillips, "The Heraldry of Heaven and Hell," *Times Literary Supplement*, 24 March 1978, all quotations drawn from pp. 349-50.

knowledgeable Blake criticism. In a recent study of Blake's art, Morton Paley evaluates one of Blake's series of designs to *Paradise Regained* as follows: "In *Angels Ministering to Christ*, one can see that Blake's intention is to create a sublimely serene Christ figure, and it may be that had he attempted this in the more uncompromisingly linear style of a few years earlier the result would have been more interesting." Paley approves of Blake's conception, which he perceives through the execution, and suggests an alternative technical recipe that might have produced a more interesting picture. Paley is one of Blake's most sophisticated critics, however, and, sensing Blake's reaction to such judgments, Paley justifies his procedure: "Unfortunately, Blake did not consistently take such painstaking care in his early drawings [as he did with one academic nude drawing, perhaps of his younger brother], thus giving rise to an accusation that was forever to dog him: that his execution was not equal to his conception. However unfair this may be to the Blake of, say, *A Vision of the Last Judgment*, we must not be misled by the vehemence of his denial of this charge, at least not as far as these early works are concerned, especially when we remember that the works of the mid-1780's were produced by a man in his late twenties, not by an adolescent prodigy."[45] The statement does not distinguish Paley's position from Blake's, which is, however, different. Paley accuses Blake of urging his critics to be-

[45] Paley, *William Blake*, pp. 64, 20. A further minor objection may be made. I know of no evidence to show that Blake's carelessness with his early drawings is to blame for the accusation that he cannot execute ("*thus* giving rise to the accusation"), unless Paley is thinking of Reynolds' advice for Blake to correct his drawing. Surely Paley is not suggesting that Blake *should* have "corrected" it, with all that "correct" implies in Blake's time, opposed to his basic artistic principles. On the other hand, if the suggestion is rather that the accusation against Blake's powers of execution has been *limited* to certain of Blake's early drawings, that is not the case. Blake's work as a whole has frequently been characterized as well conceived, inadequately executed. Furthermore, Paley seems to suggest that Blake's motive in taking his position on the equality of form and content is self-defense. While indeed he defends himself with it, Blake's claim cannot be called merely defensive, because—as far as I can see—it is consistent with, not to say fundamental to, the rest of his artistic theory and with significant aspects of romantic theory generally. As I point out in the text, the same Enlightenment assumptions that catch Blake catch Barry, Fuseli, and Friedrich too, and they have also been used to compare romantic poets such as Wordsworth unfavorably with poets from other periods that prize the kind of virtuosity that the assumptions promote.

lieve that his execution is equal to his conception even when it is not. But Blake's response to his critics is that the two are necessarily equal: "I know that The Mans [i.e., any artist's] Execution is as his Conception & No better [and no worse]" (AR; E 639). As for himself, "I am like others Just Equal in Invention & in Execution" (PA; E 571).

Paley's critical practice is based, I presume, on a principle similar to the one stated by Arnold Hauser: "Form and content are two completely different things—the most conceivably different—although they can also only be conceived in relation to one another." Hauser's synonyms for content and form are thus the familiar ones: "What he has to say" versus "The way in which an artist says something."[46] Blake's position, however, is closer to the one stated for him in Frye's *Fearful Symmetry*: " 'Every Poem must necessarily be a perfect Unity,' said Blake: the identity of content and form is the axiom of all sound criticism."[47] Since the opposition between the two positions is one of the themes of this book, we can leave the positions here at the level of assertion. The important point is the opposition itself, and the likely conflict when a critical methodology based on one theory is employed on works of art produced by an opposing theory.

Insofar as quality can be used as a measure of authenticity, the Enlightenment formula can be used in connoisseurship. Martin Butlin, a sharp-eyed, judicious Blake connoisseur of great experience, announces what is indeed "a rather strange criterion in assessing the authenticity of works by Blake": "that quality of execution is relatively immaterial. Blake was a very uneven artist and many of his earlier works and scrappier drawings are almost totally lacking in technical merit. With the great draughtsmen of the Renaissance, Michaelangelo and Raphael, quality is the final touchstone. With Blake, one can justifiably argue that a drawing too bad to be by, say, Flaxman or Stothard can nevertheless, other things being equal, be by Blake."[48] The encounter of Blake with his connoisseur is fascinating, as the

[46] Hauser, "The *l'art pour l'art* Problem," *Critical Inquiry*, 5 (1979), 431. Hauser's essay is a translation by Kenneth Northcott of a section from *Sociology of Art* (1974, trans. forthcoming).

[47] *Fearful Symmetry*, p. 10.

[48] Martin Butlin, "Cataloguing William Blake," in *Blake in His Time*, ed. Essick and Pearce, pp. 80-81.

authentic Blake is being determined according to a principle that can only be called anti-Blake. Since Butlin is concerned not with theories but with truth in fact and pragmatic efficiency, the dilemma may not strike him as worth considering. But the collision helps to define Blake's own position more accurately. As part of his procedure, the connoisseur assumes that there are standards of quality of execution that can be separated entirely from conception and treated on their own. The mark of an authentic Blake in certain cases is not something characteristic of Blake but a level of quality that he fails to reach. The quality of execution can be measured, Butlin implicitly claims, with sufficient separateness and objectivity to allow points of direct comparison with Renaissance artists and Blake's contemporaries. Butlin does not specify the standards by which he measures technical merit. I suspect he would not judge Flaxman and Stothard better artists than Blake, just better draftsmen. The existence of such standards is frequently taken for granted in art history and connoisseurship, but the standards are seldom examined and systematic definitions of technical merit are seldom offered.

Employed as critical standards, such ideas often reveal a drastically uneven (and unexplained) historical pattern of technical merit. The tide of history appears to turn mysteriously in favor of the Renaissance, leaving it afloat on a sea of great draftsmen while dooming the romantic era to navigate the shallows with vast incompetence. Familiar curves of distribution that tend to emerge when objective standards are applied objectively and universally are conspicuously absent. Usually the standards that produce this boom-and-bust history of draftsmanship are applied to individual paintings, or, as in Tom Phillips' review of the Blake exhibition, to the work of an individual painter. Occasionally, however, bold critics will carry the assumptions behind their standards of judgment all the way to fascinating condemnations. John Gage, for instance, has identified "the problem of the inadequacy of form to content in the romantic period," a thesis that with sufficient foresight we might have anticipated on 26 May 1783, the day Dr. Johnson passed judgment on Barry. Gage selects as his exemplar not Barry, Fuseli, or even Blake: "The problem . . . is presented perhaps most strikingly in the work of Caspar David Friedrich. . . . Friedrich's symbolism has been the keynote of recent criticism; with some it has become something of an hermetic cult of the sort that has also been the

fate of Blake in recent years. Every object, every brushstroke, is pregnant with meaning, accessible only to the student thoroughly in tune with the artist's frame of mind. Such approaches tend to solipsism."[49] Gage, like Phillips, is annoyed by the difficulty in determining the meaning of his painter's symbolism, though it is hard to tell whether he blames Friedrich or modern students—presumably the former for encouraging the latter. By "inadequacy" of form to content I believe Gage means that he wants public standards of conception and execution, as both his irritation at the idea of a critic having to be in tune with the artist's frame of mind and his identification of that requirement with solipsism—a typical charge against certain forms of romanticism that we shall discuss—seem to indicate. Furthermore, he assumes that the audience for art is properly something like a general public—not a hermetic cult—according to the Enlightenment ideal of the well-educated person of common sense whose views are understood in relation to a public consensus. In short, Gage assumes that the artist ought to be tuned to the audience instead of the other way around, and that both should be tuned to the culture at large and to the larger traditions in which the culture participates. Of course, Gage could not even speak of the inadequacy of form to content without assuming that he knows what form the content should have. Like most modern critics engaged with such subjects, he accuses Friedrich and romantic painting in general of inadequacy but stops short of offering the formal remedy to their problems. His remarks seem to imply that, while it is none of his critical business to recommend specific forms to painters, he believes he recognizes adequate forms when they present themselves. Traditionally the knowledge of formal adequacy is carried not in the heads of individual critics but in schemes of decorum whose business it is to stipulate desirable relations between the separate categories of content and form. (I discuss decorum below.)

Blake does not invent the notion of being "like others Just Equal" to ward off criticism but to hold himself together. His fundamental defense against the Enlightenment critical formula is his concept of his own imaginative identity, which, if a defense mechanism, must rank with the most elaborate ever de-

[49] Gage, in a review of *Kunst am 1800*, a series of exhibition catalogues, in *Studies in Romanticism*, 15 (1976), 487.

vised, comprehending virtually the whole of his life's work. Like other romantic artists, Blake guards, not his faith, or his soul, or his virtue, but his identity from the divisive powers of the world.

Blake's responses to Reynolds suggest what response he would make to William Bell Scott and others in Scott's vein. When Reynolds warns his students not to fall for the "fallacious mastery" of a "facility in composing," we might expect Blake to agree as one who himself bitterly complains of the attention given to pictures that have been "smoothd up & Niggled & Poco Piud" (*PA*; E 565). Instead he goes on the attack, claiming that "Mechanical Excellence is the Only Vehicle of Genius" and that "Execution is the Chariot of Genius": "A Facility in Composing is the Greatest Power of Art & Belongs to None but the Greatest Artists i.e. the Most Minutely Discriminating & Determinate." Blake accuses Reynolds of casting "a stigma upon Real facility in Composition by Assimilating it with a Pretence to & Imitation of Facility in Execution" (*AR*; E 632). Real mechanical excellence extends the artist's identity. A "Pretence to & Imitation of Facility in Execution" is disembodied technique, an amalgamation of the executions of other artists abstracted from their conceptions, and therefore from their identities, and learned as a collection of skills. Reynolds' memory fable, as we saw earlier, shows how these imitations of facility in execution are then presumably matched to imitations of facility in conception to achieve an imitation of nature. Blake's personal diction here, his use of "pretence" and "imitation," is an index to his argument for personal identity against impersonal systems that imitate identities. Similar diction appears in his charge, quoted earlier, that "Unappropriate Execution is the Most nauseous of all affectation & foppery He who copies does not Execute he only Imitates what is already Executed" (*PA*; E 565). Blake criticizes disembodied mechanical excellence in personal terms: artists wear a collection of mechanical skills the way fops affect other persons' mannerisms. The skills do not express identity but substitute for it. "Foppery," "affectation," and "pretence" are counterterms against Enlightenment "singularity."

Let us contrast the two views further. The Enlightenment train of thought that Gersaint, for instance, follows to find Rembrandt sometimes "affecting" a "singularity" expresses a fear of

anarchic individualism conforming to no known principles, consensus lost in self. Wary of the personal knowledge that appears to be incomprehensible idiosyncrasy, Enlightenment classicism in its nightmares imagines a bestial criminal terrorizing the citizenry with its unpredictable behavior. The romantic train of thought that Blake follows to find "Unappropriate execution" as "affectation & foppery" expresses a fear of personal disintegration, self lost in consensus. Wary of public intrusions that might stretch the personality on a Procrustean bed of consensus, romanticism in its nightmares imagines outraged mobs dismembering the individual who dares to stick by private convictions. At the very phase of development where Blake thinks that artists have lost their true selves in inappropriate executions, the Enlightenment argument would suggest that at last these artists have ceased to affect singularity. The romantic pattern of artistic development thus requires a third phase in which artists shed their foppery and affectation by unlearning the styles of others and then restoring appropriate style to their own work.

Dividing Barry's thought from his mechanism or his mind from his hand, as Pasquin and Johnson do, anticipates the more ruthless division of Blake promoted by Scott, of Blake as "essentially . . . a poet" from Blake as "the most imperfect of artists." Among the variety of potent critical traditions that this helps to explain are two of the most familiar, that Blake is a fine poet but no painter, and of course the reverse, that his late works show his pictorial talents coming to the fore while his poetic skills are washed up in muddy prophecy. Ultimately, when critics press their case to the extreme suggested in the *Times Literary Supplement*, the procrusted Blake is not merely a torn identity with its separate pieces going their separate ways but a self-divided monstrosity at war with itself. Though readers will recognize "self-divided" as a prominent item from Blake's own lexicon of self-analysis, it cannot be an excuse for the casual but dramatic flourishes of judgment that turn weak criticism into strong reading. Blake's utter devotion to locating and maintaining his own coherent imagination against the tremendous divisive forces of his and our culture should win him, not charity or sainthood, but the justice of a justly formed critical position. Blake's staunch refusal to accept the artistic assumptions of his culture on faith, without profound consideration, should get him equal consideration in turn. Critics who mournfully de-

plore the facile romantic criticisms directed against Reynolds are
not often equally alert to the facile Enlightenment criticisms
directed against Blake. By contrast, Blake's criticism of Reyn-
olds is neither facile nor irrelevant but committed and pro-
found. While Blake may win no prizes for his charity to Reyn-
olds, critics who understand Blake's principles will find little
cause to fault his justice—and even for that he warns them:
"Having spent the Vigour of my Youth & Genius under the
Opression of Sʳ Joshua & his Gang of Cunning Hired Knaves
Without Employment & as much as could possibly be Without
Bread, The Reader must Expect to Read in all my Remarks on
these Books Nothing but Indignation & Resentment" (AR; E
625). But if Blake's critics are as sure of their ground as he is
of his, he will have little to fear from them.

DECORUM

Formulas of Augmentation

If conception and execution are separate in theory, then they
are likely to become separate in pedagogy. And they are not
likely to be found combined in the same artist or same teacher.
In his lecture on design, Opie quotes with approval the special-
ist motto appropriate to this notion of art—"one science only
will one genius fit"—and applies it to Leonardo for trying to do
too many things well.[50] We remember Reynolds offering one
science as one of a student's two choices, the other being to select
a range of excellences and combine them. Those choices, which
are actually halves of one whole, are the themes of this chapter.

In Opie's motto an efficient convenience is being moralized
and then reimposed upon the evidence. Not only may skills be
separated, but they should be separated, and people like Leo-
nardo who fail to separate them are culpable. Blake criticizes
the prevailing view as early as 1795 in a letter to George Cum-
berland: "I know that the Genius that produces these Designs
can execute them in any manner, notwithstanding the pretended
Philosophy which teaches that Execution is the power of One &
Invention of Another—Locke says it [is the] same faculty that
Invents Judges, & I say he who [can] Invent can Execute"
(*Letters*, pp. 25-26).

[50] *Lectures on Painting*, ed. Wornum, p. 259; also Fuseli, p. 381.

The pattern of critical analysis resulting from the separation of skills appears in one of its moderate forms in Reynolds' fifth discourse, where he plays off the "excellencies" and "defects" of Raphael against those of Michelangelo (v, 124-31; W 81-84). Blake, recognizing that from Reynolds' point of view Michelangelo and Raphael are not so much persons painting as skills collected in two human containers, responds "What Nonsense" (AR; E 643). Opie's catalogue of kinds of inventiveness in his lecture on that bottomless subject extends the pattern from Reynolds' moderation toward an extreme: "Michelangelo shows it [invention] more particularly in the unrivalled breadth, simplicity, greatness, and energetic character of his forms, and style of design, as well as in the epic grandeur of his conception; Giorgione, and Titian, in . . . their colouring; Correggio and Rembrandt, in chiaroscuro; and Rubens in composition."[51] Such catalogues become the staples of art criticism and pedagogy. James Elmes outdoes himself in sorting out the popular idols of excellence for the entry on "drawing" in his *General and Bibliographical Dictionary of the Fine Arts* (1826): "Of the leading elements of painting Raffaelle has excelled in drawing, Titian in colouring, Rembrandt in chiaroscuro, Michel Angelo in composition, expression, grandeur, and Tintoretto for execution."[52] The context of such lists shows that they are not being offered as expressions of personal taste but rather as something like the conclusions of research based on a scientific analysis of the art into its constituents, as Opie implies when he says that all the artists in his list "may be considered as the discoverers of principles, and the givers of features and limbs to the art itself."[53]

Such analysis begins, of course, with observations of individual paintings. Systemized, they might take the form of the chart that Jonathan Richardson assembles for the scoring of a portrait by Van Dyck: (on a scale of 18) "Composition 10 / Colouring 17 / Handling 17 / Drawing 10 / Invention 18 / Expression 18 / Advantage 18 / Pleasure 16."[54] If this analytic program and

[51] *Lectures on Painting*, ed. Wornum, p. 283.
[52] James Elmes (M.R.I.A. Architect), *A General and Bibliographical Dictionary of the Fine Arts. Containing Explanations of the Principal Terms Used in the Arts of Painting, Sculpture, Architecture, and Engraving, in All Their Various Branches* . . . (London, 1826), n. p.
[53] *Lectures on Painting*, ed. Wornum, p. 283.
[54] Quoted in Lipking, *Ordering of the Arts*, p. 115.

its data base are extended, they can be made to yield the kinds of conclusions charted in Roger De Piles' steelyard (weighing machine), here as abstracted in *The Bee* (1788):[55]

	Composition	Drawing	Colouring	Expression
Titian	12	15	18	6
Rubens	18	13	17	17
Raphael	17	18	12	18
Dominichino	15	17	9	17
Corregio [*sic*]	13	13	15	12
Poussin	15	17	6	15
Guido		13	9	12
Carrachi's [*sic*]	15	17	13	13
Angelo	8	17	4	8

Although De Piles' steelyard is one of the more bizarre products of Enlightenment ideas about art, the ground on which it rests is after all the same as that which supports Reynolds' and Opie's lists of qualities: paintings can be analyzed into categories and subcategories of conception and execution that can in turn be measured on a numerical scale to provide data for cross comparisons. Each painter—now a collection of measurable qualities—becomes a bar-graph of individual accomplishment, though of course the accomplishment has little to do with anything Blake would call individual. This for Blake is "intermeasurability," or the technique of using the nonexistent to measure the indefinite (*Letters*, p. 162). A painter's skill is not his skill or her skill but skill abstracted for comparison with the skill of other painters or even with skill itself: Rubens draws at level 13 and colors at 17, while Guido draws at 13 but colors at 9. Clearly Guido needs to correct his coloring.

The values promoted by such a scheme are formulated by Elmes' *Dictionary* in words of advice to the artist: "Let him strive to collect from the works of each of the great masters in art, the peculiar charm by which he was rendered conspicuous, and blend them, so far as may be consistent and harmonious, in his own compositions."[56] We remember this as one fork in the road that Reynolds describes for the student painter: specialize in one skill or combine the skills that others have specialized in.

[55] Anon., *The Bee; or, the Exhibition Exhibited in a New Light* . . . (London, 1788), p. 3.
[56] The entry on "Imitation," n. p.

The metaphors are inevitably mathematical. "Collecting," "amassing," "combining," "varying," "uniting," and "bringing together" come easily: "And as the painter, by bringing together in one piece, those beauties which are dispersed among a great variety of individuals, produces a figure more beautiful than can be found in nature, so that artist who can unite in himself the excellencies of the various great painters, will approach nearer to perfection than any one of his masters" (VI, 168; W 103). The procedure for imitating individual nature is extended to the imitation of individual painters: collect, select, reassemble.

From the idea that different painters have different skills that may be abstracted, amassed, taught, and learned emerges an ideal work of art analogous to an ideal mechanism, an amalgam of various systems tuned where they interface, as in an ideal automobile combining in some measure good handling, efficient fuel consumption, comfort, beauty, durability, and low cost of maintenance. In his lecture on coloring Opie shrugs off critics who want to see Michelangelo and Raphael as anything but an assemblage of excellences and defects: "I confess," he says, throwing up his hands,

I can no longer consider them as improved by defect: I will not be-
lieve that
"Half their beauties to their spots we owe."
But, great as they were in design, invention, and expression, . . .
I cannot but suppose that their merits would have been considerably
augmented by the addition of beautiful and appropriate colour.[57]

Who, then, "augmented" their collection of "merits" by the "addition" of all these qualities? The conventional model of such excellence is the Carracci's eclecticism. Barry, for instance, states his admiration of the Carracci formula of augmentation: Roman draftsmanship + Venetian coloring = perfect style.[58] Opie is more extravagant in his praise of the Carracci who "attempted, by selecting the beauties, supplying the defects, correcting the

[57] *Lectures on Painting*, ed. Wornum, p. 317; the same principle is restated in relation to Rubens, p. 333.

[58] In his lecture on coloring, *Lectures on Painting*, ed. Wornum, p. 228. Though painters of Blake's time conventionally acknowledge the Carracci as the source of formulas of eclectic augmentation, Prof. Jean Hagstrum tells me that the Carracci synthesis itself may ultimately derive from interpretations by Xenophon, Cicero, and others of Zeuxis' method of creating his Helen by selecting the best parts of many beauties.

errors, and avoiding the extremes of their predecessors, to unite all the excellencies of the art, and form a perfect style." He confronts the issue that he himself raises elsewhere in regard to Leonardo's attempt to be more than a specialist: "What if they be, in some degree, inferior to each of those whom they proposed to imitate in his particular way?—to Michelangelo in design, to Raphael in expression, to Titian in colour, and to Correggio in force and harmony of chiaroscuro?" The tireless cataloguing of familiar excellences seems to inject his answer with confidence: "The combination, as far as it goes, is excellent. . . . For where is the proof that all the different beauties of art are not in perfect unison with each other? . . . Had there been more correctness in the drawing, more elevation in the character, and more truth in the expressions of the celebrated picture of Correggio just mentioned, can it be supposed that its effect would therefore have been less splendid and fascinating?"[59]

The Carracci recipe for the successful blending of excellences into a single perfect style is celebrated in a sonnet attributed to Agostino Carracci himself. In Fuseli's prose translation it goes, "Take . . . the design of Rome, Venetian motion and shade, the dignified tone of Lombardy's colour, the terrible manner of Michelangelo, the just symmetry of Raphael, Titian's truth of nature, and the sovereign purity of Correggio's style: add to these the decorum and solidity of Tibaldi, the learned invention of Primaticcio, and a little of Parmigiano's grace: but to save so much study, such weary labour, apply your imitation to the works which our dear Nicolo has left us here."[60]

Fuseli notes that the true literary genre of Agostino's formula is probably "medical prescription" rather than sonnet, and he criticizes the underlying pedagogical principles with a theatrical analogy: "I shall not attempt a parody of this prescription by transferring it to poetry, and prescribing to the candidate for dramatic fame the imitation of Shakspeare, Otway, Jonson, Milton, Dryden, Congreve, Racine, Addison, as amalgamated by Nicholas Rowe." Fuseli's reasoning seems Blakean: "A character of equal universal power is not a human character; and the nearest approach to perfection can only be in carrying to excel-

[59] In Opie's lecture on chiaroscuro, *Lectures on Painting*, ed. Wornum, p. 306.
[60] In Fuseli's lecture on the art of the moderns, *Lectures on Painting*, ed. Wornum, pp. 395-96; see also pp. 403-04.

lence one great quality with the least alloy of collateral defects: to attempt more will probably end in the extinction of character, and that, in mediocrity—the cypher of art."[61] It is not clear whether Fuseli's answer and Blake's are the same, or whether Fuseli is merely espousing a familiar specialist ideal that sometimes seems to contradict an eclectic ideal but is usually a part of it, as indicated by the appearance of the two ideals together in both Reynolds and Opie. Fuseli does indeed ground his objection in character but chiefly, it seems, in a jack-of-all-trades-master-of-none view of human limits. Painters who are only human should not attempt impossible ideals of universal excellence but specialize in their leading talent—presumably, since Fuseli is lecturing to students at the Royal Academy, by imitating the skills of other painters whose specialties match their own.

Blake grounds his position more certainly and severely in the indivisible coherence of an original identity. "Instead of Following One Great Master," Reynolds' student "is to follow a Great Many Fools" (AR; E 633) on the quantitative principle that, as the whole equals the sum of its parts, so many fools make one great master—and the more fools, the greater the master. When Blake is feeling mean and comical, he explains this theory of art education with metaphors of the idiot and the cripple: "The Cripple every step Drudges & labours / And says come learn to walk of me Good Neighbours" (E 504):

Rafael Sublime Majestic Graceful Wise
His Executive Power must I despise
Rubens Low Vulgar Stupid Ignorant
His power of Execution I must grant
Learn the Laborious stumble of a Fool
And from an Idiots Actions form my rule
Go send your Children to the Slobbering School (E 505-06)

Or as he says in the *Public Address*: "Who that has Eyes cannot see that Rubens & Correggio must have been very weak & Vulgar fellows & we are to imitate their Execution. This is like what Sr Francis Bacon says that a healthy Child should be taught & compelld to walk like a Cripple while the Cripple must be taught to walk like healthy people O rare wisdom" (E 569).

[61] In his lecture on the prevailing method of treating the history of painting, *Lectures on Painting*, ed. Wornum, p. 549.

Blake uses his animal fables to the same effect, ridiculing the sight of "One Man Striving to Imitate Another" by calling to mind the sheep trying to walk like a dog and the ox trying to trot like a horse (AR; E 645). The parody implicitly reduces the Carracci formula for the perfect style to a conceptual collage in which the perfect animal = the docility of the sheep + the friendliness of the dog + the durability of the horse, etc.

Fuseli's criticism of the Carracci ideal exemplifies the natural association of the specialist model of skill and a limited human capacity, most commonly with the latter serving as rationale for the former. Moralized into advice, as in academy pedagogy, the motto often evolves into one of its stronger exclusive forms, such as "Great Inventors *Cannot* Execute" (my emphasis, *PA*; E 570), a doctrine preached by "those who separate Painting from Drawing; who look if a picture is well Drawn; and, if it is, immediately cry out, that it *cannot* be well Coloured" (my emphasis, *DC*; E 529). Blake claims that his engraving of *The Canterbury Pilgrims* is a "test" of the notions that "Men of weak [mental] Capacities have *alone* the Power of Execution in Art" and that "to Invent & to Draw well *hinders* the Executive Power in Art" (my emphasis, *PA*; E 560). "Rubens s Luxembourg Gallery is Confessd on all hands to be the work of a Blockhead," yet its execution is put up as a model, while "Julio Rom[ano's] Palace of T at Mantua is allowed on all hands to be the Production of a Man of the Most Profound sense & Genius & Yet his Execution is Pronouncd by English Connoisseurs & Reynolds their doll to be unfit for the Study of the Painter" (*PA*; E 568-69). Blake characterizes Reynolds' fourth and fifth discourses as "Particularly Calculated for the Setting Ignorant & Vulgar Artists as Models of Execution in Art" (AR; E 639) by encouraging faith in the formula of augmentation. With beauties selected, errors corrected, and extremes avoided, excellences can be united: expressionless mind following Michelangelo in drawing + mindless expression following Rubens in coloring = mindful expression in a complete painting that is the goal of instruction. Blake's ultimate objection to the formula is not against the choice of exemplars but against exemplars, that is, against instruction. The emphasis in his "Thank God I never was sent to school / To be Flogd into following the Style of a Fool" (E 502) is less on the fool than on the school. Being forced to imitate Michelangelo is only better than being forced to imitate

Rubens inasmuch as exposure to such masterful identities may remind you of your own identity and give you the courage to flee the school. Rubens is a more appropriate model, the academy's Tom Sawyer to Blake's Huck Finn.

Level and Balance

De Piles' steelyard and Richardson's scorecard are elaborate if harum-scarum versions of *decorum*,[62] the inter- and intra-artistic principle that embodies the Enlightenment attitude toward conception and execution, usually in a set of paired categories. The scheme is most commonly imagined as a hierarchy of contents in one column matched to a corresponding hierarchy of forms in another, vertically expressing the hierarchy of genres, horizontally the relation of content to form. The root metaphors of the scheme are level (vertical hierarchy) and balance (horizontal matching). The relation between the columns is governed by "propriety." Like any such paradigm, decorum can be adjusted to various purposes and stretched toward extremes without disintegrating. The separate but equal relation of content and form, conception and execution, matter and manner, is so rudimentary a feature of the bipartite design of the scheme, however, that in practice the separation is almost always taken for granted.

Opie states the principle of hierarchical matching at its simplest and most conventional in his lecture on invention: "Such, therefore, as is his subject, such must be the artist's manner of treating it, and such his choice of accompaniments."[63] The balanced syntax reflects one of the root metaphors in the scheme. When Reynolds complains that students are allowing their techniques of execution to run away with them, he is implicitly demanding the balance of conception and execution that decorum values. Strutt's evaluation of modern engraving in his *Biographical Dictionary* is made on the same grounds: the abundance of mechanical skills and the scarcity of corresponding ideas indicate the need for a balanced diet. This is in fact one of the

[62] There is an interesting brief discussion of neoclassical decorum in Bate, *The Burden of the Past and the English Poet*, pp. 18-21, pointing out incisively some of its advantages and disadvantages as a critical idea. See also the discussion in Abrams, *Natural Supernaturalism*, pp. 390-99, which emphasizes the literary influence of the Bible in undermining classical decorum.

[63] *Lectures on Painting*, ed. Wornum, p. 280.

most common analyses of the state of the arts—all the arts—in Blake's time: inadequate conception, more than adequate execution. As a symptom of intellectual trends, the fear of an art that is all technique without ideas is of course part of a much more general modern fear of spiritual emptiness associated with a number of familiar themes in intellectual history: Enlightenment anxiety over its own self-assigned status as an age of refinement, perhaps at the cost of powers of invention; the gains of technology and the decline of religion, accompanied by the fear of knowing how to do without knowing what to do; and so on. In the arts, the scheme of decorum suggests that imbalance is the cause of such problems, and balance the solution. Grignion is said to have died as a balanced engraver in an age of imbalance. William Bell Scott projects the metaphor of decorous imbalance into history and finds his own age of refinement preceded by an equally imbalanced age of invention represented by the unrefined conceptions of Blake, who is seen as the remedy for spiritual dryness in an age of high technique. Scott, in other words, offers a late Victorian version of the augmentation formula, and, as executor of another artist's conceptions, he is playing Titian to Blake's Michelangelo.

As a central paradigm in a consensus esthetic, decorum is, at its most radical, public property. That is, both its vertical categories and its horizontal ones are matters of public knowledge and sanction. Indeed, the post-Enlightenment history of the words "decorum" and "propriety"—used today almost exclusively to describe proper behavior, according to rules of etiquette, in social situations—is a good sign of the predominantly social emphasis of the corresponding artistic concepts, and also of course a sign that the artistic theory of the past two centuries has turned predominantly romantic, and consequently away from notions of correct behavior (artistic or social) governed by society. Decorum may be regarded as a social vision in its esthetic phase, involving quite apparent concepts of social class ("low" characters in "low" genres, "high"—i.e., socially as well as ethically high—characters in "high" genres, and so on) translated into artistic equivalents.

There are at least two significant ways of asking questions about decorum, as illustrated by questions about proper dress, which may concern either suitability to occasion (Sunday clothes for church) or suitability to wearer ("That outfit is you," By-

ron's flowing collar, or Prufrock's mounting firmly to the chin). Both versions relate content to form, but in the first, propriety relates individuals to social situations through the agency of clothes; in the second, propriety relates individuals to their clothes. The former is typical of Enlightenment decorum at one phase, the latter at another that I shall reserve for discussion in a moment.

If the human body is artistic content and garments are form— as in the conventional Enlightenment equation—then two questions are important in determining the phase of decorum: whose body is it, and whose clothes? In severer forms of decorum both belong to the culture or to nature, and the artist dresses the body the way a maid dresses a lady, readying a public figure for a public appearance. Works of art are then taken to represent, in an appropriate balance of traditional content and traditional form, something like the body of tradition and culture itself. Traditional Christian ideas and plots may constitute such a body of content, and traditional rhetorical schemes the garments for it.

If both conception and execution are owned by the poet, the result is the phase of decorum that brings a mimetic theory closest to an expressive theory, not necessarily as a romanticism, but as another variety of Reynolds' characteristical style. Blake would fit into this phase if manufactured according to the plan that Tom Phillips outlines in the *Times Literary Supplement*. Blake would then become, with Reynolds' Gainsborough, a member of the family of artists "who, without knowing the appropriate expression of almost any one idea, contrive to communicate the lively and forcible impressions of an energetick mind" (xiv; W 258). The characteristical style, true to the rest of Reynolds' theory, does not express the bodies of artists in their own clothes but contrives imitations of artists in characteristical imitations of artists' clothes.

If the garment, but not the body, belongs not to the public but to the poet, the result is a version of the style-is-the-man formula, by which, as Richard Hurd says, not "the *matter*, but the manner of imitation" displays the artist's individual character. When only the style is considered the legitimate property of the artist, then the formula for judgment is Bishop Warburton's against Young's *Original Composition*: "Dr. Young is the finest writer of nonsense of any of this age. And had he known that original composition consisted in the manner and not the matter, he had wrote with common sense." Discussions that go

far enough finally distinguish "the matter which mirrors the world" from "the manner which mirrors the man." The ultimate product, in the work of art, is a loose amalgam of public with private. Within the context of decorum, propriety allows such an amalgam only in certain genres where a balance of public and private is desirable, as in biography, for instance.[64] The "style is the man" does not mean that "clothes are the man": if the work of art consists of a man plus his garments, the man is not the poet but a body of public ideas dressed in the poet's clothes.

Reynolds employs a variation of the style-is-the-man formula to justify Gainsborough's execution: "His *handling, the manner of leaving the colours* or in other words, the methods he used for producing the effect, had very much the appearance of the work of an artist who had never learned from others the usual and regular practice belonging to the art" (XIV; W 258). Here as usual Reynolds is wary either of lending his wholehearted support to such an irregular thing as characteristical style or of believing it can actually be what it seems. Most important at this point, however, is Reynolds' distinction between the techniques that belong to Gainsborough himself and "the usual and regular practice belonging to the art." For Reynolds, techniques of handling that are usual and regular are not merely conventional; in "belonging to the art" they belong to the public and to its systems of instruction. The public style, regular and usual, is the one truly natural. Reynolds' vocabulary of doubt and contrivance shows that, by comparison, Gainsborough's "methods," invented to produce the "effect" and "appearance" of an artist "who had never learned from others," produce artifice of dubious authority.

The style-is-the-man equation tends to recur whenever the content of a work seems to belong more to the public, or as Reynolds would say, to the art, than to the artist. In our century, that tends to include, for example, certain kinds of writing by formula. The American mystery writer Raymond Chandler insisted that he was bad at "construction" but good at "dialogue," by which he meant that his conception was inferior to his execution, as follows: "If a man writes as well as I do (let's

<hr>

[64] For discussion of the style-is-the-man formula, see Abrams, *The Mirror and the Lamp*, pp. 229 ff. Hurd is quoted by Abrams, p. 230, Warburton quoted pp. 230-31. Biography is discussed on p. 234.

WORKS, PART TWO 149

WORKS, PART TWO 149

face it honestly)," he explains, "he creates a schism between the melodramatic exaggeration of his story and the way he writes about it."[65] For Chandler, stories are things that writers write about in certain ways, not things that they write. Their writing is their style, a personal technique with words that can actually interfere with the story and vice versa. The story belongs not to Chandler but to a tradition of commercial melodrama that he is borrowing in order to put it into words, while the style is his own. Chandler's problem, he thus imagines, is to provide a missing balance by bringing the story up to his own level. The strong separation between conception and execution is especially exaggerated by Chandler's long service as a writer for the movies, where a "story" is something given to writers for "treatment." Of course, Chandler's alienation from the content of his work and his confidence that the aspect of his work that belongs to him is superior and the rest, which belongs to the public world, is inferior, invert typical eighteenth-century values but treat them within the same theoretical framework.

But if the story, or the idea, not the style, is the man, and the content rather than the form is private or original, then the work of art is an artist dressed in clothes appropriate to the public occasion. This is an image considerably commoner in everyday life than in Enlightenment criticism, where typically, as Hurd and Warburton assert, the matter belongs to the public. The influence of romanticism on Enlightenment ideas has made it easier, however, to grant that artists may have their own conceptions while expecting artists to meet certain public standards of skill in execution. In this instance form is conceived as a mediator between the private mind of the artist and the public mind of the audience. Butlin implies as much, judging Blake frequently inferior to other artists in his quality of execution while offering no parallel criticism of his quality of conception. Similarly, after perfunctorily labeling Blake's unconventional "system of thought," Tom Phillips gets down to business: the relentless pursuit of Blake's "visual vehicle" ("Gothicized Neoclassicism"), which becomes the object of severe negative judg-

[65] Quoted in Frank MacShane, *The Life of Raymond Chandler* (New York: Dutton, 1976), p. 149. Other popular writers, less condescending toward the genres in which they write, nonetheless tend to adhere to some version of the style-is-the-man formula to explain their relationship with the genre and the public. Agatha Christie employs the formula more than once in her *Autobiography*.

ments according to some standard of measurement that Phillips, at least, seems to think is publicly recognized. The approach of such commentators requires no assent to Blake's ideas. There is no sign that either of them believes in, or feels any need to believe in, Blake's system of thought, where they apparently grant Blake his originality. They have stronger standards for systems of execution, however, and they require that Blake act according to their standards. Perhaps the closest analogy—and culturally there may be more than an analogy—is with systems of democratic government that sharply distinguish thought from action by establishing a right to believe but not a right to act accordingly if the actions violate certain public standards of conduct. John Gage's approach is related but different. He implies that "the inadequacy of form to content in the romantic period" is a failure to give private conception public execution. But from the severity of his criticism one gathers that there is probably no such execution, that nothing known to the public as adequate form can make sense of these painters' hermetic conceptions. He does not explicitly draw the anticipated conclusion that the romantic painters should have exchanged their conceptions for some others more easily represented by available techniques.

It is instructive to compare Gage's criticism of the failures of romantic execution with Shelley's famous analysis of poetic composition. The mind of the poet is "a fading coal" that is fed by some "power" that "arises from within" but can never endure: "When composition begins, inspiration is already on the decline, and the most glorious poetry that has ever been communicated to the world is probably a feeble shadow of the original conceptions of the poet."[66] Perhaps Gage would accept Shelley's account as an apology for the failures of romantic painters. But there are a number of problems. Shelley's regret for the irremediable division of conception in its "original purity and force" from the "feeble shadow" of itself in execution is simply one romantic version of some ancient regrets—that time passes, that human beings are subject to time, etc.—applied to poetic composition. His metaphor does indeed divide conception from execution, but in a characteristically romantic way. The separation is inevitable but regrettable. Both conception and execution are found in a single artist; there is no question, say, of improving

[66] *Defence of Poetry*, ed. McElderry, p. 30.

execution by learning something from another artist, no question whether the mind that is inspired is the best mind to turn inspiration, flagging or not, into art. The closer execution is to conception, the better—the distance between them is the problem. And, finally, blame is laid, not on the conceptions of the artist for being occult, but on the physical world for inevitably intruding on mental processes.

A particularly modern way of granting the artist control over conception while grounding execution firmly in the exterior world is by relying on the now-familiar metaphors of craftsmanship that have the artist "working with" or "conforming to" the artistic medium, which is said to make "demands" on the artist. Such metaphors may be seen as part of a shift toward romanticism insofar as they envision art as a transaction between the artist and the work, with the artist struggling to meet the demands made by the medium of execution rather than by the patron or the public. As contrasted with the Enlightenment tendency to slight the properties of any particular medium in favor of the search for general ideas (thus making possible very broad comparisons among the arts), this concentration on the medium of execution may be associated with Blake's own practice, as it recently has been. The kernel of this argument is present in the (now common) suggestion that Blake's experience with burins and copper, especially as an apprentice under Basire, makes him love line more and color and tone less. Put most crudely, "the firmness of Basire's method affected Blake so profoundly that he could not bear the least fuzziness of outline, and always demanded from the best art . . . that it should be dominated by what he called 'the bounding line.' "[67] But the historical argument may be used much more subtly and effectively. Essick, for example, proposes that the "exacting requirements" of the antiquarian copy engraving in which Basire's shop specializes has a "shaping influence" on Blake's ideas about art. Blake's objections to Enlightenment notions of generalization may reflect "the values of precision and particularity basic to all copy engraving."[68]

Blake does indeed believe, as he says, that the training and practice in Basire's shop had been good for him, as training

[67] Lister, *Infernal Methods*, p. 9.
[68] Essick, *William Blake, Printmaker*, p. 35.

with another master might not have been. I would want only to distinguish the critic's historicism as applied to Blake, with its concern for his training, his development, the influences that shape this idea and that style, from Blake's own way of thinking about those matters. The historian notices two phenomena related to each other by line: there are lines in engraving shops, and Blake claims that lines are essential to all true art. The historian wants to establish a causal relationship when one is available, and, since Blake obviously does not cause the lines in Basire's shop, the other alternative, that lines in engraving shops cause Blake's preference for line, is the one to study. But clearly Blake would not explain his own beliefs with such causal (and pedagogical) formulas; perhaps in a vision as a child he overheard Dürer championing Basire and Rembrandt championing Woollett, Strange, and Ryland in an argument about English engraving.

If the metaphor for the artist's relation to the medium is altered so that the artist is said to "respect," say, the "integrity" of the medium rather than to obey its laws or meet its demands, a formulation even more characteristic of Blake emerges. The artist then acts in the role of respecter and liberator of other identities—here the identity of the medium—as Michelangelo, respecting the medium of stone, seeks to liberate the identities trapped within it. Blake seems to be close to such a view of his medium when he has the narrator of *The Marriage* claim that by "printing in the infernal method, by corrosives . . . melting apparent surfaces away, and displaying the infinite which was hid," he will expunge the notion that "man has a body distinct from his soul" (E 38). The separation of body and soul thus has some very direct connection with ordinary artistic media, and the reintegration of body and soul with a radically new method of "infernal" printing. The body is traditionally regarded as the property of nature and the soul as the property of God. Reintegrating them in "hell" means, in the terms of *The Marriage*, giving them both back to the original owner, the individual (that I take to be the moral of the tale of the Ancient Poets on pl. 11). The motto of *The Marriage*, "every thing that lives is Holy" (E 44), means that individual identities are whole. Artistically, this constitutes an assertion that imagination should be whole so that works of imagination can be whole, integrating body (execution) and soul (conception). We remember that

Wordsworth's integrative rhetoric uses the same figure to describe the proper relation of poetic conception and execution. Only romantic artists are likely to speak this way, even satirically, of the reintegrative powers of their own media.

But for all Blake's evident attention to technical matters and to the difference between a line in a relief etching and its water-colored correlative, the main direction of his thought is away from the independent integrity and force of materials and techniques as such, and thus away from the accompanying metaphors of the artist as scientist, technician, or virtuoso artisan. Despite variations, his technique is fundamentally uniform, and the uniformity is supported by his often-stated principle that drawing is the basis, "the Foundation & indeed the Superstructure" (*PA*; E 561), of every pictorial medium. The corresponding uniformity of Blake's ideas no matter what the medium—that is, ideas elected by the artist, not by the physical properties of the medium—and his stated abhorrence of inconsistency give art historians their reasons for calling Blake a literary painter, meaning (in his terms) that his images are the emanations of his imagination, not of his media nor of the techniques that manipulate them.

The notion that a medium of execution demands certain treatment from the artist is less a Blakean or a romantic idea than a late evolution of the Enlightenment idea that execution belongs to the art, which thus has its own set of laws that the artist who wants optimum results will learn and obey. Such a view is implied, for instance, in Landseer's theme—woven through his *Lectures on the Art of Engraving* (1807)—that engraving is not the mere copying of paintings but the translation of them into another medium that has its own alphabet, grammar, and idiom.[69] The point is repeatedly made by engravers looking for respect for their art: "The public," complains John Burnet in his testimony to the House Committee of Arts in 1836, "consider engravers only as a set of ingenious mechanics. . . . The art of engraving, the department I talk of, is more a translation of a picture than a copying."[70] But Blake uses "translation" as a synonym for "copying," disdaining both. In its emphasis on the

[69] E.g., *Lectures*, p. 177.

[70] John Pye [II], *Evidence Relating to the Art of Engraving Taken Before the Select Committee of the House of Commons, on Arts, 1836* . . . (London, 1836), p. 18.

rules of execution that belong to the art, Enlightenment mimesis establishes the rationale for a concentration on the discrete properties and laws of each medium and art, and the techniques of execution that they call forth. In the resulting image of the relation of conception to execution, the artist is like a technician obtaining a predictable outcome by applying known laws to materials: "She uses the resources of the language as they are intended to be used," the reviewers might conclude. More venturesome poets adopting the attitude see themselves as scientists observing and exploring the galaxy of their medium, and the vocabulary of scientific adventure begins to appear in the titles of artistic projects, which become "explorations" and "discoveries," "studies" and "experiments." Such metaphors appear at least as early as Wordsworth's definition of his poetic method and aim in the rhetoric of scientific demonstration: *Lyrical Ballads* becomes "an experiment . . . to ascertain, how far, by fitting to metrical arrangement a selection of the real language of men in a state of vivid sensation, that sort of pleasure and that quantity of pleasure may be imparted, which a Poet may rationally endeavour to impart."[71] By the time James Laughlin declares in 1938 that his publishing firm New Directions would serve not as "a salesroom but a testing ground . . . a laboratory" for "the best *experimental* writing,"[72] the tradition has acquired a history that includes Baudelaire and Verlaine, and the metaphors are stock items in manifesto writing. Obviously romantic artists dress up in lab coats to put on the authority of science. The scientific aura, liberating Wordsworth from the trammels of mere poetic traditions and conventions, is from the romantic angle a strategy for defending artists, in the name of their art, from artificial public demands—especially demands for a useful art. Scientific metaphors associate poetry with the pure truth seeking of science in laboratory and testing ground as opposed to the profit taking of business in factory and salesroom.[73] And

[71] Preface to *Lyrical Ballads* (version of 1800), *The Prose Works of William Wordsworth*, ed. W.J.B. Owen and Jane Worthington Smyser (Oxford: Clarendon, 1974), I, 118.

[72] Quoted in chapter 7, "Technology and the Avant-Garde," of Renato Poggioli, *The Theory of the Avant-Garde*, trans. Gerald Fitzgerald (New York: Harper & Row, 1971), p. 136.

[73] For further discussion of these metaphors, see Poggioli, especially chapter 7, and Sypher, *Literature and Technology: The Alien Vision* (New York: Random House, 1968).

of course the notion that artists are scientists and test pilots rather than operatives and clerks touches them with the new romance of discovery in a world that puts Newton and Einstein together with Shakespeare and Picasso in the family of genius.

The Decorum of Jerusalem

As adapted and elaborated by the Enlightenment, the scheme of decorum is comprehensive. It emphasizes the *work* of art: the balance between its parts, matter and manner; its generic category; and the place of the genre in a hierarchy of genres. The *audience* is implicitly but forcefully present in the paradigm as the proprietor of the work and also as its object: matter and manner tend to correspond to the double esthetic aims of teaching (with substance) and delighting (with style). The *artist*'s place in the scheme is the most important clue to the phase of decorum in any instance. In the most public phase, the artist, as agent for propriety (or good matching), is an intermediary between the two sides of the scheme. In Reynolds' "nothing has its proper lustre but in its proper place" (v, 116; W 77), "proper" is defined by the relation of manner to matter, not by the relation of the artist to the work or to the audience. As intermediary the artist is preferably invisible. As the artist becomes more closely identified with the manner of the work, the motto of a new phase emerges in Opie's directive—"Such, therefore, as is his subject, such must be the artist's manner of treating it, and such his choice of accompaniments"—which appoints the artist to choose manner and accompaniments to match matter, but maintains as the principle of choice the nature of the subject, not individual character. The artist's virtuosity in execution may be polished to high degrees of skill, but with the aim of making the skill more and more transparent. Since execution belongs to the art rather than to the artist, the obstacle to transparency is singularity. The artist acts as the agent of execution without identifying personally with it, putting transparent skill in the service of ideas offered up by cultural and artistic tradition. The artist's aim in choosing the appropriate "manner of treating" them is to teach the audience the truth of its own ideas. Artists are the agents appointed to sell historical truths to their generation.

All phases of decorum in some sense turn artists into performers and works of art into performances. In the most public

form the culture not only provides the approved conception—
which becomes a script, or score—but also specifies the skills
required to execute it. It is at such a phase that academies seem
most legitimate and necessary. In what we today call the per-
forming arts—opera, instrumental music, ballet, and so on—
academies may provide a course of systematic instruction in-
tended to carry students through a repertory of conceptions that
they will learn to perform with a repertory of matching skills
of execution shared to some degree by every other student and
every professional performer. The institution, more than the
individual, takes on the responsibility for innovation, which is
thus more closely akin to research and development of the kind
practiced by modern universities and corporations than to the
originality of the romantic artist, which is not transmissible. As
a performer is identified more and more closely with skills of
execution, and as they are allowed to contribute more to the final
product, a star system may develop in which the content may
be regarded simply as the "vehicle" for the performer, while
the audience may focus on the astounding degree of skill that
the performer is able to exhibit, or on the performer's person-
ality as it emerges from the performance (or as it is read back
into the performance from the publicity surrounding the per-
former in everyday life), or both. We easily remember that
musicians, dancers, and actors are performers, but we often un-
consciously read romantic assumptions about art back into pre-
romantic arts to blur the status of Enlightenment poets and painters
as performers. Reynolds' belief that painters are in some impor-
tant respect performers shows up clearly in his review of Gains-
borough's performance in the role of himself. A writer like
Raymond Chandler reveals the actor's fear that he may be merely
a skilled performer of conceptions belonging to the art.

Expressive countermetaphors emphasize the relation of the
artist to the work. The urge to refine the artist out of the work
as an impure presence in the mirror of nature is supplanted by
an urge to identify the artist with the work, which becomes the
true form of the artist. Individual character thus disestablishes
traditional public genres, and the form of the work may be epic
only secondarily, but primarily Blake, an identity that may have
epic as one of its characteristic moods and satire as another but
may just as legitimately synthesize both or for that matter the
full range of expressive possibilities, if that is what it takes to

create a precise image of the "true Man." Thus the romantic
version of what Frye calls "encyclopedic" forms[74] is primarily
a recipe for the total shape of the individual imagination, while
secondarily it may still be a cultural compendium, which the
artistic imagination, however, subsumes. The special character
of Blake's infernal interpretation of the Bible is shaped by his
determination to read it first as an encyclopedic form of the
romantic type. Thus too he labels his own works "*my* Giant
forms" that "*I* again *display* . . . to the Public" (my emphasis,
J pl. 3; E 143). If genres are present at this expressive phase,
they are reestablished with their basis in individual character, as
expressions of imagination rather than imitations of nature.

As Enlightenment mimesis may cause all art to strive toward
the condition of performance, romantic expression may cause it
to strive toward individual expression. As the truly individual
expression strains the powers of Enlightenment accommodation,
the performing arts force romanticism to one of its limits. Ac-
commodation has taken several forms, the most obvious being
straight conversion: self-expressive choreography, "my dance,"
or self-expressive music, "my song." The greater the collabo-
ration, the greater the challenge to the theory. One solution has
been to regard certain performers as real artists, the rest as me-
chanic virtuosos. This has worked especially well with multital-
ented maestros who seem to have eaten whole academies for
dinner. Finally, the *Gesamtkunstwerk* fits here, seen through ro-
mantic eyes not as a composite result of collaborative effort by
a team of specialists but as the total expression of the spirit of a
society operating as a single organism. Titanic masters of the
Wagner type are appropriate directors of such efforts because
they combine the romantic hero with the human microcosm.

As decorum drives toward balance, expression drives toward
synthesis, not simply the local synthesis of conception with exe-
cution, but of those as part of the synthesis of artist with work—
and finally, in a complex way to be described later, with the
audience. Artists are neither the intermediaries between matter
and manner nor the virtuoso artisans who translate cultural sub-
stance into persuasive style. They are the sources of both sub-
stance and style, the creators of the work, the generators of the

[74] In *Anatomy of Criticism: Four Essays* (Princeton: Princeton Univ. Press,
1957).

audience. The style-is-the-man formula of Enlightenment decorum gives autobiography a place in art. But the separation of matter from manner in the scheme insures the maintenance of distinctions between art and autobiography—even if legitimately present in the same work. The controlling metaphors of romantic theory encourage a kind of art that is life and, of course, in the later extension of the principle, toward the life that is a kind of art.

Blake calls Reynolds' remarks about the proper luster of things properly placed "Concessions to Truth for the sake of Oversetting Truth" (AR; E 642). As this concession suggests, Blake's own idea of decorum may in some respects seem to echo Reynolds and Opie. Describing the verse form of *Jerusalem*, he asserts that "Every word and every letter is studied and put into its fit place: the terrific numbers are reserved for the terrific parts—the mild & gentle, for the mild & gentle parts, and the prosaic, for inferior parts: all are necessary to each other" ("Of the Measure, in which the following Poem is written," *J* pl. 3; E 144). Blake's criticism often sounds this way, so much like Enlightenment classicism that commentators are misled. Blake's contemporaries would not fail to recognize that no one with such sane esthetic principles could use them to create such a mad thing as *Jerusalem*. Any version of conventional decorum that can give us the verse form of *Jerusalem* is most certainly decorum gone mad. But what Blake calls a fit place is of course no place known to Reynolds or Opie. In fact Blake is doing here what he does at greater length in his various pieces of Chaucer criticism (which, judging from allusions in print, often remind readers most of Dryden)—not recycling classicism but performing a critical experiment in encoding radical romantic ideas in an Enlightenment vocabulary. It is fair to say that Blake parodies Enlightenment criticism in such instances but essential to see also that the parody is in another way true. The method involves nothing more unusual (though here perhaps unusually pertinent) than retaining the manner of the object of parody while altering the matter, or, more specifically, silently shifting the grounds on which decorum rests. Reynolds' concessions to truth for the sake of oversetting truth are grounded in Enlightenment mimesis, Blake's truth in romantic expression.

There are a number of local clues. Blake says that "When this Verse was first dictated to me I consider'd a Monotonous

Cadence like that used by Milton & Shakespeare & all writers of English Blank Verse, derived from the modern bondage of Rhyming; to be a necessary and indispensible part of Verse. But I soon found that in the mouth of a true Orator such monotony was not only awkward, but as much a bondage as rhyme itself. I therefore have produced a variety in every line, both of cadences & number of syllables." Blake's miniature history of poetry is a three-part romantic plot of liberation from artistic slavery, beginning *in medias res* with the bondage of rhyming, what he elsewhere calls "Monotonous Sing Song Sing Song" (*PA*; E 570), from which is "derived" monotonous English blank verse. Milton knows, as he says, that rhyming is poetic bondage but mistakes blank-verse paragraphs for liberation when they are only new shackles based on an improvement of the old design. Rhyming and blank verse are both monotonous because they are both uniform systems of execution owned by the culture, or by poetic tradition. Blake makes an apparently wild leap from Dryden to the engravers—"Rhyme & Monotonous Sing Song Sing Song from beginning to end Such are Bartollozzi Woolett & Strange" (*PA*; E 570)—because all are users of publicly owned systems of execution.

Here we have the vantage point from which to distinguish Reynolds' complaints against the runaway technical excellence of students from Blake's ridicule of disembodied technique, creating pictures "smoothd up & Niggled & Poco Piud" (*PA*; E 565). Reynolds wants to balance the claims of conception against those of execution just as he wants imagination balanced reasonably with sense. Blake wants the direct expression of conception in execution. Thus he can apply graphic terms like "niggling" and "poco piu," which involve adornments of the subject by techniques of high finishing, to Dryden's translation of Milton into couplets (*PA*; E 570). The countermetaphor of the niggle, to put it somewhat whimsically, is the "minute particular," a Blakean term displayed with alarming frequency in the introductions of scholarly articles as justification for the critic's microscopic scrutiny of details in Blake's works. Niggling is an external system of execution that ornaments general ideas with fastidious attention to appropriate detail. The minute particular is the inevitable technical emanation of precise visions of imagination. Niggles are the technical atoms of a method of art making, and niggling is the systematic amalgamation of stray tech-

nical units. Minute particulars are fundamentally neither units of technique nor units of interpretation; they are atoms of identity. They are what lines make. The artist's identity, working in the personal time and space of the pulsation of an artery, expresses itself in lines, which form minute particulars, which form paintings and poems. Minute particulars are: characteristic.

Systems of execution owned by the public are "monotonous" because they are uniform—adjustable in predictable ways within a set range—no matter what the conception. The "derivation" of one system from the other demonstrates the natural mode of change in a single technical history, usually a history of improvement in which one generation of technique replaces the previous generation, not because the individuals using the techniques change but because techniques "evolve," or "develop." In the *Public Address*, where he complains of Dryden's singsong, Blake goes on to claim that "my Execution is not like Any Body Else" (*PA*; E 571).

Public systems of execution are awkward in the mouth of a "true Orator" because true orators are romantic artists expressing themselves in exactly appropriate execution; public systems of execution are external technical impositions, like computerized systems of translation. They may be convenient on occasion, but never anything but foreign matter "in the mouth." When the true orator trades the monotony of such systems for "variety in every line," the variety comes from the orator's own infinite imagination, which is creating—expressing—execution identical with itself.

For the sake of the parody Blake pretends that both sides of his scheme of decorum are external, and that he is the artist-agent of propriety in charge of choosing, in Opie's words, "manner" and "accompaniment." The conception, Blake says, was "dictated to me," and he, like any good Enlightenment poet, "consider'd" first one system of execution, one manner to match the matter, after another. The effectiveness of the parody of course depends in part upon the ambiguity of such terms as "dictated," which simultaneously images slavish copyist and inspired prophet. But he calls himself instead "orator," the classical public role of the poet. When, to prepare his oration, he "studied" his system of execution to find the "fit place" for "Every word and every letter," he was playing the rhetorician in his

role as student of tropes. The emperor has dictated the matter of a speech, and the hireling orator is translating it into an appropriate and persuasive manner. But, if we don't know it already, we learn from *Jerusalem* itself that the only emperor who dictates to this orator is his own imagination. The poet's problem in choosing a measure for a poem is not solved by adapting Reynolds' formula for amalgamating "the excellencies of the various great painters" (VI, 168; W 103) but by evicting all other artists trespassing in the brain. Thus in studying words and letters Blake is searching for a fit place for himself. True students are scholars of themselves, as true orators, finding all systems of rhetoric awkward in the mouth, are true first to their own speech. A romantic poet trying to imagine such a true student will most likely produce someone like Shelley's Plato, who was not a philosopher as most of us think but "essentially a poet . . . [who] rejected the measure of the epic, dramatic, and lyrical forms, because he sought to kindle a harmony in thoughts divested of shape and action, and he forebore to invent any regular plan of rhythm which would include, under determinate forms, the varied pauses of his style." Shelley contrasts this true orator with Cicero, who "sought to imitate the cadence of his [Plato's] periods, but with little success."[75]

The matter of conventional wisdom or of politicians is of as little use to expressive orators as is the manner of conventional verse forms. They are not comforted by auditors who praise them for using the resources of language appropriately. They want to be told that they conquer their language, that they make their medium their own. They do not strive to blend the excellences of others into the terrific technical monotony of a perfect composite style. With each word and letter sounding in a variety of cadences they mold languages of their own in human styles that express themselves in mental acts, with terrific parts but also with mild and gentle parts and not without parts prosaic and inferior, not balanced or purified into discrete genres but synthesized into identity.

In conventional Enlightenment decorum the subject determines what is fit; in romantic expression the subject is the artist's identity, and the fit is personal. What is fit is what fits the artist.

"The Measure, in which the following Poem is written" is

[75] *Defence of Poetry*, ed. McElderry, p. 9.

liberated by making execution the emanation of conception rather than by shackling, that is, matching, internal conception to external technique. The first sentence announces the principle that makes this new freedom possible: "We who dwell on Earth can do nothing of ourselves, every thing is conducted by Spirits, no less than Digestion or Sleep." The consequence of trying to do things ourselves on earth is an external system. Remembering to let our spirits do things for us is another way of describing the romantic recovery of projection. In his description "Of the Measure" of *Jerusalem*, Blake does not tell the story of how "the following Poem is written" so much as how he learns to let it write itself. And only the liberated poem can liberate: "Poetry Fetter'd, Fetters the Human Race!"

CONCEPTION AND EXECUTION IN PERFORMANCE

Michael Angelo's strength thus qualified, and made more palatable to the general taste, reminds me of an observation which I heard a learned critick [Johnson] make, when it was incidentally remarked, that our translation of Homer, however excellent, did not convey the character, nor had the grand air of the original. He replied, that if Pope had not cloathed the naked majesty of Homer with the graces and elegancies of modern fashions, though the real dignity of Homer was degraded by such a dress, his translation would not have met with such a favourable reception, and he must have been contented with fewer readers. —Joshua Reynolds (xv; W 274-75)

When Blake had produced his cuts [for Thornton's *Virgil*], which were, however, printed with an *apology*, a shout of derision was raised by the wood-engravers. "This will never do," said they; "we will show what it ought to be"—that is, what the public taste would like. . . . —*The Athenaeum*, 21 January 1843

In a culture that divides a natural from a supernatural world and a human world from a divine one, the division of idea from execution and of intent from accomplishment may become one of the signs that our art is as fallen as we are. Thus Jonathan Richardson, beginning with the standard lament that "our hands cannot reach what our minds have conceived," adds that "it is God alone whose works answer to his ideas." What human artists proudly call "an original," then, is merely "the echo of the voice of nature," and what they call "a copy" is nothing more than "the echo of that echo." The only change necessary to turn

Richardson's complaint into Shelley's would be the internaliza-
tion of Richardson's God and, for authenticity, perhaps a bit of
Platonizing in the manner of Shelley. But at this point Richard-
son draws the conclusion, true to his esthetic tradition, that re-
minds us just how far he is from Shelley's romanticism: "But
though it be generally true that a copy is inferior to an original,
it may so happen that it may be better; as when the copy is done
by a much better hand." At the heart of the difference is the
meaning of "better."[76] Read as a theory of artistic creation, En-
lightenment decorum envisions a two-part process of disassem-
bly and reassembly, the former to allow the work of art to take
advantage of the powers of specialism, the latter to harmonize
the specialties in a balanced whole. Such a process is at least
compatible with workshop methods of art production; at most it
suggests that the best art is collaborative. In Blake's time the
respectable opinion—held by Opie and probably by Fuseli, among
many others—is that the real Leonardo can never live up to the
ideal with which he is associated. The "Renaissance man" is
better represented by a team of specialists, in Leonardo's case
perhaps a draftsman, a painter, a photographer, one scientist or
several, an engineer, a diplomat, and, for his private life, a
courtier, a lover, and an accountant. Leonardo might take his
appropriate position as manager. If the audience is found to
harbor a romantic taste for the autographic in art, Leonardo
might imitate Rubens by coming on the scene at the last moment
to add what has been called the Rubens touch, and by lending
his name to the enterprise in the manner of a collaborative art
like cinema—produced in the studio of Peter Paul Rubens.

Such an ideal of practice grows naturally from the theory
behind it. If conception and execution are theoretically separate,
then they are not only potentially separate fields of study and
hence of instruction, and of criticism and hence of evaluation,
but also finally separate areas of endeavor. More specifically, if
Blake is best at artistic invention, then perhaps he will get op-
timum results by turning execution over to someone—or more
than one—properly trained for the job. Cromek's sound busi-
ness sense tells him so insistently that this would be the best
solution to his Blake problems that he breaks his agreement with

[76] *The Theory of Painting* (1725), in *The Works of Jonathan Richardson*, ed.
Horace Walpole (London, 1792), p. 159.

Blake and turns the designs for Blair's *Grave* over to the engraver Schiavonetti for execution; if Thornton had had a peek at Blake's designs for the *Virgil* at a sufficiently early stage, perhaps he could have mustered the courage to add somewhat more "art" to Blake's "genius" by engaging a professional to engrave those woodblocks, though poor Schiavonetti was long dead by the time Thornton needed his services.[77]

This major tradition of Blake criticism takes the performing arts as a model. When the metaphor of relation between artist and subject matter or between artist and work is imitation in any of its forms whether copy, translation, even interpretation or representation, then the execution of the work is likely, in the long run, to be regarded as a performance. The resulting logic is fairly clear in music, for example, where Beethoven can "compose" a symphony for instruments that he cannot himself play. Questions of competent performance immediately follow. Is Beethoven, who does play piano, the pianist we necessarily want to perform "his" concerto? While it is more difficult to say what the "score" and "performance" of a poem or painting might be, in practice preromantic poets, painters, sculptors, and public do indeed often treat their conceptions as scores or scripts for performance. As a consequence artists may regard themselves and their colleagues as part composers, part performers, so that the creation of a work of art is very much an exercise in decorum: matching the best composer to the best performer, since we know that the author Shakespeare, however excellent an actor in certain parts, may not be the best Othello. A strong line of Enlightenment thought extends this logic to John Milton. The man we usually regard as the unshakable author of *Paradise Lost*, to be taken altogether or not at all, is actually a composer of poems living in the same body with a performer of poems. The logic suggests that confusing this mere convenience with artistic necessity would be sentimental folly. Thus Shakespeare is inspired with brilliant dramatic conceptions that are roughly executed and so deserve the improvements of Pope, who similarly undertakes the re-execution of Donne's satires and other works by poets whose ideas are more suitable to poetry than their "barbaric" and "gothic" execution: "Thus Hayley on his Toilette

[77] Thornton did go so far as to have three of Blake's *Virgil* wood engravings recut by another hand.

seeing the sope / Cries Homer is very much improvd by Pope" (E 496).

Since Shakespeare and Donne have survived even the assistances offered them by the eighteenth century, the logical step from theory to performance may seem negligible. But Blake returns again and again to the subject in jingles, letters, essays, speeches, and even in the illuminated books. In the *Public Address* he cites "a Poem signed with the name of Nat Lee which perhaps he never wrote & perhaps he wrote in a paroxysm of insanity [Lee, periodically insane, was confined to Bedlam from 1684 to 1690] in which it is said that Miltons Poem is a rough Unfinishd Piece & Dryden has finishd it" (E 569-70); or, as he puts it in a jingle, "Dryden in Rhyme cries Milton only plannd / Every Fool shook his bells throughout the land" (E 496). These poetic fools are colleagues of the idiots who teach painting in the slobbering school. Since they are mindless, they take their ideas from someone else, in this case making *Paradise Lost* the plan—someone else's story line—that they execute in rhyme ("shook his bells")—someone else's treatment. In allowing for the possibility that Nat Lee never wrote the poem signed with his name, Blake is parodying Lee's own point about Milton. Perhaps Lee only planned *his* poem and turned it over to someone else for executing, as Milton should have had the sense to mail *Paradise Lost* to Dryden instead of to the printer. Or perhaps Lee was not the planner of the poem signed with his name but the executor of someone else's plan—in which case he should be held responsible only for the technique, not for the ideas expressed. Or Lee might have written the whole thing in a fit of insanity—that is, in a state of not being himself and thus not personally responsible, as we say.

However, the focus of the *Public Address* is not literature but engraving, from which Blake offers a number of parallel examples. "[William] Woolett I know," he recalls from personal experience in Basire's shop, "did not know how to Grind his Graver" (*PA*; E 564). "Wooletts best works were Etchd by Jack Brown Woolet Etchd very bad himself"; likewise, "[Sir Robert] Stranges Prints were when I knew him all done by Aliamet & his french journeymen whose names I forget" (*PA*; E 563). Blake is not simply mocking Woollett for lacking technical skill. His ignorance of graver grinding and of etching is a sign that his specialty is elsewhere. The workman's pride in caring for

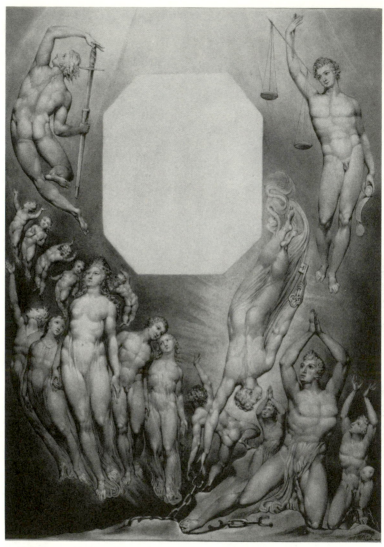

2. William Blake, *The Resurrection of the Dead* (1806), 42.5 × 31 cm., pen, wash, and blue watercolor on thin card. In 1805 Robert Cromek asked Blake to design and engrave a set of illustrations for a projected edition of Robert Blair's poem *The Grave*. But when Blake finished the preliminary designs and at least one trial print, Cromek turned the job of engraving over to Luigi Schiavonetti. The edition was published in 1808. The drawing reproduced here is an alternative design, never engraved, for the title page. It is based on two pencil sketches still extant.

his own tools has nothing to do with the pride of a real special-
ist, who makes a point of being ignorant about everything but
his specialty. Grinding is for grinders, preliminary etching for
preliminary etchers, and finishing engraving for finishing en-
gravers.

Woollett and Strange are, in Blake's version, planners, idea
men who leave technique to technicians like Jack Brown, Alia-
met, and the team of French journeymen. Dryden appoints
himself Milton's Aliamet. The history of Blake's own reputation
is littered with attempts to do for him the favor that Pope man-
ages for Homer. William Bell Scott finds in Blake an artist
whose "work was vitalized by poetic insight" of the kind that

3. William Bell Scott after Wil-
liam Blake, *There Shall be No
More Death*, plate 1 in Scott,
*William Blake: Etchings from His
Works* (London, 1878), 20 ×
13.8 cm. Scott's etching derives
from the group of figures in the
lower-left quadrant of Blake's
alternative design for the title
page to Blair's *Grave*. In his
"Description of the Etchings,"
Scott describes the work as fol-
lows: " 'There shall be no more death, neither sorrow nor crying,
neither shall there be any more pain; for the former things are passed
away.' This group of figures ascending has a certain pathetic expres-
sion, which suggests this quotation as an appropriate title. The origi-
nal is a very highly-finished water-colour in the British Museum, and
contains other figures with an opposite sentiment. It was probably the
drawing done by Blake additional to those purchased by Mr. Cromek,
and published in the series for Blair's *Grave*, but considered unnec-
essary to the completion of the work by that gentleman" (p. 6).

one supposes Pope finds in Donne's satires, but "entirely without
the executive . . . powers." We discussed Scott's separation of
Blake's conception from his execution in section 4. But Scott
proves that he is no mere ivory-tower critic dreaming of Ren-
aissance draftsmanship when he uses his criticism of Blake to
launch a bold project: to perform Blake as Blake would have
performed himself if only he had possessed those "powers of
hand and mind we call talent." (Since Scott's technical revisions
of Blake must be seen to be believed, I reproduce one of them
here beside Blake's drawing; see Figures 2 and 3.) Blake's poems
have received similar amelioration. Many of the *Songs* printed
in the nineteenth century are freely altered to conform to the
editor's or the audience's technical preferences. D. G. Rossetti,
who gets furious with the Dalziel engraving shop for changing
his own illustrations for Tennyson, is nonetheless willing to work
over Blake's lyrics to make them more presentable for publica-
tion with Gilchrist's *Life*, and Yeats puts them through the tech-
nical wringer again for his edition.[78]

Bowdler, as far as I know, devoted himself to the morality
of content and cared not a fig for style. But his spirit lives also
in the Enlightenment tradition of bowdlerization as practiced on
Milton, Homer, Hogarth, and Blake, among many others.
Critics who differ in social class and education share the sense
that conception on the one hand and execution on the other are
at least partly owned by the public. The authorizing public force
can be as focused as institutionalized religion or art, or as diffuse
as the Moral Sense of Twain's America and the Esthetic Sense
of Wilde's England. Authority may emanate from a deity through
the commands of scripture; from communal norms, as in the
Augustan practice of poetry; or from science, as in Reynolds'
belief that the laws of art are discovered and applied. Tolerant
people who would not think of intruding upon someone else's
freedom of thought may wade into a poem or picture with the
censorious, self-righteous authority of a formal decorum as sternly
moral as the conceptual decorum of any bowdlerizing pharisee.

If conception may be so divided from execution in perform-
ance as in theory, the result is not only an artistic theory en-

[78] See Deborah Dorfman, *Blake in the Nineteenth Century: His Reputation as a
Poet from Gilchrist to Yeats* (New Haven: Yale Univ. Press, 1969); and Raymond
H. Deck, Jr., "An American Original: Mrs. Colman's Illustrated Printings of
Blake's Poems, 1843-44," *Blake /An Illustrated Quarterly*, 11 (1977), 4-18.

couraging specialization and collaboration but also a rudimentary method of production, complete with the necessary conceptual and pedagogical underpinnings. We may see this in the example of Shaftesbury, who, as a literary man without the skills of a graphic artist, hires workers with the necessary skills to execute his conceptions.[79] On the scale of a cottage handicraft but with the methods of modern production, Shaftesbury appoints himself the think tank and makes worker-technicians out of his hirelings. It is in such applications as this that Blake's criticism of the state of the arts in his time becomes social criticism, and that he acquires his odd status as one of the first and best critics of modern industrial society comprising the new commerce and its support systems. One might think, from the frequency with which they are quoted, that Blake's comments on society were limited to those few memorable passages of elegiac poetry about labor in satanic mills. In fact the foundations of his social commentary appear in the context of the subjects he almost always chooses to discuss—his own trades, art and literature. Since society enters an artistic theory as audience, I shall end by using Blake's idea of an audience for art as a way back into the wider world.

[79] See Edgar Wind, "Shaftesbury as a Patron of Art," *Journal of the Warburg and Courtauld Institutes*, 2 (1938), 185-88.

IV.

Audiences

ARTISTS EXPRESSING WORKS

EXPRESS AUDIENCES

Give not that which is holy unto the dogs, neither cast ye your pearls before swine, lest they trample them under their feet, and turn again and rend you. —Matthew 7:6

I sing:—"fit audience let me find though few!" —Wordsworth, *The Excursion*, Prospectus; Blake, *Descriptive Catalogue*, Advertisement; Milton, *Paradise Lost*, Book VII

In breaking with all forms of social organization, however, Blake is merely following the logic of art itself, whose myths and visions are at once the cause and the clarified form of social developments. Every society is the embodiment of a myth, and as the artist is the shaper of myth, there is a sense in which he holds in his hand the thunderbolts that destroy one society and create another. —Northrop Frye, "Blake after Two Centuries"

The Problem of the Romantic Audience

When art becomes expression, the importance of the artist increases. Artists, executors as always, are now the content as well; as their works are in a sense the creating of themselves, artists and works are thoroughly intervolved. In an expressive theory of art, one obvious tendency would be for the artist's personality, as it moves toward the center, to displace and even replace the audience. As M. H. Abrams puts it, "The poet's audience is reduced to a single member, consisting of the poet himself." He maintains that "there is, in fact, something singularly fatal to the audience in the Romantic point of view" and

quotes to good effect Keats, Wordsworth, Carlyle, and, most memorably, Shelley: "A poet is a nightingale who sits in darkness and sighs to cheer its own solitude with sweet sounds."[1]

The problem of audience, which has always plagued accounts of romanticism, has been reduced to one of attitude: the artists did not appreciate the value of an audience and barraged what few readers they had with private mythologies that resist rather than promote communication. And the problem has been stated moralistically: as artists think more and more of themselves, they think less and less of others. But no one can dwell long on the private and even antisocial tendencies of romanticism without noticing that there is another side to the picture. Wordsworth's profound concern with his audience appears at least as early as the Preface to *Lyrical Ballads*, which is less an argument against poetic diction, as Coleridge often causes us to recall it, than an argument for the poet's central place in the "vast empire of human society." Likewise, the conclusion that poets are the "unacknowledged legislators of the world" is not, as it is sometimes regarded, an unanticipated purple patch at the end of Shelley's *Defence of Poetry* but the climax of a complex and passionate meditation on the problem of the poet's audience. To these Byron adds *The Prophecy of Dante*, a monologue that uses the mask of a dying Dante, the old exile who yet loved the society that refused him, to dramatize the troubled relations of poets with their societies. And, finally, Keats in his letters worries about the threat of the public to his identity while asserting that as a poet he lacks identity; admires Shakespeare, the great public poet, while regarding the public as his enemy; and claims to write with no thought of the public while aiming to reach it somehow with his poetry.

The most successful attempts to show the public side of romantic concerns have taken a social and historical approach to

[1] Quoted in *The Mirror and the Lamp: Romantic Theory and the Critical Tradition* (New York: Oxford Univ. Press, 1953), p. 25. Frank Kermode discusses the romantic origins of the postromantic separation between the artist and society in chapter 1, "The Artist in Isolation," of *Romantic Image* (New York: Random House, 1957): "These two beliefs—in the Image as a radiant truth out of space and time, and in the necessary isolation of men who can perceive it—are inextricably associated" (p. 2). "The 'difference' of some of the English Romantic poets is almost too well known; they were outcast because they had to pay for their joy and their vision. Sometimes they attributed their condition to some malady in themselves, but they also blamed the age in which they lived" (p. 7).

reconstruct the cultural context in which the writers worked. Raymond Williams' *Culture and Society 1780-1950* leaves no room for doubting the depth of their interest in public issues and in the public role of poets and poetry.[2] Williams' argument assumes that the interest in public issues is primary and thus that the antisocial tendencies of romantic esthetic theory are often psychological compensations for difficulties in public practice. Abrams' more literary interpretation would seem to imply that difficulties in public practice are to some extent the consequence of privatism in the theory itself. At any rate the special power of interpretations such as Abrams' is in giving a theoretical basis to the romantic disregard for an audience that finds its extreme statement in Shelley's avian metaphor or in J. S. Mill's definition of "all poetry" as "soliloquy," "confessing itself to itself" and reducing the audience "to a single member, consisting of the poet himself."[3]

Such statements have a purity that is no doubt one cause of the common misconception that they are the natural products of an expressive theory at its most radical, and that the acknowledgment of an audience will signify a less radical version. But the logic that produces the solitary singers of Shelley and Mill characterizes an expressive theory at one phase only, and that a phase of radical withdrawal by the artist. There is evidence to suggest that the phase of withdrawal finds its opposite extreme in a phase of fulfillment. To say that an expressive theory is singularly fatal to the audience is no truer than to say that a mimetic theory is singularly fatal to the artist. Both assertions are true of their respective theories at one phase only, and for each phase there is an opposite extreme. Whatever difficulties the English romantics had with their audience were not a necessary product of their theories about art. My aim here is to show, first, that romantic expressive theories may, without self-contradiction, generate an idea of an audience for art. Then, because a theory of an audience is often a latent social theory, I show how an expressive theory may generate the idea of a social order.

[2] Almost any study of politics and the arts during the romantic period will have something to say about the audience of the romantic artist. Besides Williams' book (New York: Columbia Univ. Press, 1958) I think especially of the work of David V. Erdman, E. P. Thompson, and Carl Woodring.

[3] Abrams, *The Mirror and the Lamp*, p. 25.

SUMMARY: THE ARTIST'S IDENTITY
AND THE WORK OF ART

"Mental Things are alone Real" (*VLJ*; E 555): to put the human mind at the center of reality, Blake enacts the basic romantic strategy of internalization. Ultimately external reality becomes a projection that must be recovered. *The Marriage of Heaven and Hell* tells one version of a common romantic story: how "men forgot that All deities reside in the human breast" (*MHH*; E 37). All mental acts thus start with the individual and move "outward." Nature, like God, is a mental projection that for various reasons has been given special cultural status and authority, so much so that it has often been used as a measure of other mental acts, like imagination. Nature is simply one potent combination of mental acts tyrannizing over its competitors. Wordsworth's fear of the tyranny of the corporeal eye is in part a fear of this aspect of nature, which he struggled but failed to understand, at least according to Blake.

If the mind is central, its most immediate expression is the individual personality. Recovering projection is recovering imagination, and thus the prominence of the romantic theme of the loss and restoration of identity, or personal integrity. (Wordsworth could not find his imagination because, in Blake's terms, he did not know where he had lost it.) For Blake the imagination is not a processor of external images but the very shape of identity. He says so early and repeatedly in his career, as in the aphoristic Laocoön engraving (ca. 1820), where the full series of identifications internalizes both art and religion: "The Eternal Body of Man" = "The IMAGINATION" = "God himself" = "The Divine Body" = "JESUS we are his Members" (E 271).

With the individual imagination restored to its central place, art can again be, Blake intimates, what it once was (before "men forgot"), not the imitation of nature but the expression of identity. The tendency of an expressive theory is of course to identify the work with the artist, and the evaluative terms that emerge from an expressive theory accordingly evaluate the work of art with criteria that can also be used to evaluate the character of the artist who made it. Blake's advocacy of line is a part of this pattern that has been widely misunderstood. For Blake the line is the indicator of the presence of artistic integrity, which is

personal integrity, in a work of art; thus his remark about the line as a standard of both good art and personal rectitude: "What is it that distinguishes honesty from knavery, but the hard and wiry line of rectitude and certainty in the actions and intentions" (*DC*; E 540). Artistic line is the expression of personal identity: "Protogenes and Apelles *knew each other* by this line" (my emphasis, *DC*; E 540).

The blurring or the absence of line is a sign of "plagiarism," or a composite identity. The plagiarized identity makes harmony; the "true Man" (E 2, 3), the coherent identity that is the direct expression of imagination, makes melody. The composite identity is an identity possessed by the demons of other artists. The same conception of the relationship between personal identity and artistic line is the basis of Blake's jokes about painters who are not people but the trademarks of corporations and the basis of his claim that Macpherson and Chatterton were not plagiarists or forgers. The line is what the organized imagination characteristically makes: "Nature has no Outline: but Imagination has" (*The Ghost of Abel*; E 268). Artists who can make lines are in possession of their faculties. Artists who cover up their inability to make lines with the harmony of tone and color are artistically, and literally, out of their minds.[4] A culture that fears art (that fears the expression of individual personality) often turns this interpretation around, as Blake noticed, to say that true artists are drunk, insane, or possessed because they insist on acting directly from imagination.

The idea that drawing is primary and coloring secondary is thoroughly commonplace in Blake's time. Seen only in that context, Blake's principle may be made to look a good deal more common than it is; at worst he may seem to agree with his enemies. The classical and neoclassical doctrine favoring line over color is easily adapted to scientific ends because of the strong associations of classical line with numerical and geometrical systems, the rational intellect, and the external world: drawing is primary in art because it is best suited to the imitation of Lockean primary qualities in nature perceived by the impersonal human intellect. In Blake's view line is primary for quite a different reason: it is the direct expression of imagination.

[4] I discuss the Enlightenment idea of harmony versus Blake's idea of line in various contexts, including Blake's ideas about art, in "Blake and the Artistic Machine: An Essay in Decorum and Technology," *PMLA*, 92 (1977), 903-27.

Blake's way of reestablishing a standard Enlightenment idea on romantic grounds reappears in his use of the term "expression." Conventionally defined, "expression" in a painting corresponds approximately to character in a literary work. The standard Enlightenment example of an expressive painter is Raphael, in whose work execution, or technique, is said to express exactly conception, or idea, in the figures and faces of his characters. A painter's expressive talents are usually attributed directly to imaginative genius rather than to technical skill. Blake turns expression into a romantic concept by internalizing it. In a typical romantic extension of the standard principle, he identifies the expression of the characters in a work of art with the feelings of the artist: "Character & Expression can only be Expressed by those who Feel Them" (*PA*; E 568). Thus expression, conventionally the specialized power of "exhibiting in the face the several passions proper to the figures,"[5] is made the center of a theory of art in which artists attempt to exhibit in the face of their work, so to speak, the passions appropriate to their identities. Strongly organized identities express themselves in strongly organized works by drawing, which is "Physiognomic Strength & Power" (*PA*; E 560), the power of defining the "true Man" of imagination.

The work of art as the precise expression of the artist's imagination accounts for the artist, for the work, and for a relation between the two that tends toward identification. But the result of the identification would seem to be a closed circle—"confessing itself to itself"—from which the public is excluded. By making the recovery of projection the grounds of a radical expressive theory of art, Blake would seem to be following a common line of romantic thought to its extreme of subjectivity. From this angle he may seem to represent more completely than any of his English romantic contemporaries the artist in the phase of withdrawal.

The Audience Feared

One train of thought makes the romantic dilemma seem inevitable. If art is self-expression, then something is bound to be

[5] Matthew Pilkington, *Dictionary of Painters from the Revival of Art to the Present Period*, rev. ed., ed. Henry Fuseli (London, 1805), p. xviii.

lost in the process. The expression will be inferior to the thing expressed. The artist is the thing expressed, and the romantic sense of loss is always present. As Shelley says, by the time poets put pens to paper their inspired conceptions are already fading. A view of art like Shelley's is thus ripe for expression in Platonic and neo-Platonic metaphors of ideas or souls taking a material form that is defective at best. Just as naturally there is a painful new awareness of the artistic damage that can be done by publishers, producers, actors, reviewers, and the rest of an unsympathetic, obstructionist social world. When personal integrity is identified with artistic integrity, the artist suddenly seems thin-skinned and irascible, and stories of the vulnerable young artist killed by criticism begin to be taken seriously. Shelley's argument in *Adonais* that Keats died young because the reviewers attacked his poetry is true, if not to the facts, then to one anxious romantic vision of the audience for art; and of course we recognize the Keats of *Adonais* as only one of many variations on the myth of Chatterton. Believing that art is expression makes it difficult for the artist to believe any advice about not taking criticism personally.

One radical conclusion to be drawn from the expressive metaphor of art is that, because the true home of the work of art is the artist's mind, any form of publication is a dangerous and unnecessary gamble apt to end in disappointment, humiliation, or even tragedy. This idea contributes considerably to the image of the romantic artist as an eccentric withdrawn from society, whether by choice or by force, loathing publicity; or at least, like Byron, as a person with two faces, one facing the public, the other obsessively facing some private source of poetic inspiration, and appearing to the public therefore as someone in society without being of it, like Hamlet at a ball; or like Beddoes, wildly drunk with friends while contemplating suicide or more revisions for *Death's Jest-Book*, a play meant for production only in the reader's mind and, in the opinion of his friends in England, unpublishable. Sometimes the blame is put on society, sometimes on the poet for inordinate sensitivity and antisocial behavior. Genius and imagination are at any rate conceived of, even by so congenial a poet as Keats or so impressive a monologist as Coleridge, as quite different from anything that helps one get along in public. Shelley's and Byron's and Beddoes' exiles from England can be taken as metaphors of their aliena-

tion from their audiences, and, in another way, so can Words-
worth's isolation in the North and his imaginative devotion to
rural solitaries, "the wanderers of the earth," "strolling Bedlam-
ites." Blake becomes part of this pattern—and characteristically
takes it to an extreme—in his dedication to himself as a "self-
devoting genius" (*DC*; E 520), in his "Cry. I. I." (*PA*; E 569),
and in his protest at his isolation and abandonment, put (also
characteristically) in terms of self-knowledge and identity:

> I found them blind, I taught them how to see;
> And, now, they know me not, nor yet themselves. (*DC*; E 531)

Distinctions between outside-me and inside-me may be drawn
so sharply as to sound pathological, in the manner of a thresh-
old-fear syndrome. In *Jerusalem* Blake describes the intersection
of regions where outside-outside meets inside-outside to form
the "orbed Void" we customarily call the human skull:

> From every-one of the Four Regions of Human Majesty,
> There is an Outside spread Without, & an Outside spread
> Within
> Beyond the Outline of Identity both ways, which meet in One:
> An orbed Void of doubt, despair, hunger, & thirst & sorrow.
> (*J* pl. 18:1-4; E 161)

The contrast between these romantic attitudes and the attitudes
of an earlier generation is sharp. For Reynolds, the public pro-
vides essential verification:

We can never be sure that our own sensations are true and right, till
they are confirmed by more extensive observation. One man opposing
another determines nothing; but a general union of minds, like a gen-
eral combination of the forces of all mankind, makes a strength that
is irresistible. . . . A man who thinks he is guarding himself against
prejudices by resisting the authority of others, leaves open every ave-
nue to singularity, vanity, self-conceit, obstinacy, and many other vices,
all tending to warp the judgement, and prevent the natural operation
of his faculties. (VII, 221-22; W 132-33)

The public offers a "union of minds" that authenticates the per-
ceptions of its members, including its artists, who are thus warned
when they verge on singularity. The "authority of others" rep-
resented by consensus is primary; the artist's sensations must fall
within its limits. But when, as for Wordsworth, "each man's
Mind is to herself / Witness and judge" (1850 *Prelude* XIII:366-

67),[6] the artist's fear of the audience's judgment is a fear of self-betrayal. Keats fears that "if I write a Preface" of the sort expected by the public, "it will not be in character with me." Reynolds' admiration for the general union of minds becomes Keats's "contempt of public opinion" and a "solitary indifference" to "applause even from the finest Spirits." If, as Keats asserts, "that which is creative must create itself," the "authority of others" to which Reynolds would have young artists defer is nothing more than external hindrance. When "the Genius of Poetry must work out its own salvation in a man," all artists must join Keats in saying "I will write independantly."[7]

In his Preface to the second edition of *Lyrical Ballads*, Wordsworth says he must be wary of making revisions on the basis of readers' reactions:

It is dangerous to make these alterations on the simple authority of a few individuals, or even of certain classes of men; for where the understanding of an Author is not convinced, or his feelings altered, this cannot be done without great injury to himself: for his own feelings are his stay and support, and if he sets them aside in one instance, he may be induced to repeat this act till his mind loses all confidence in itself, and becomes utterly debilitated.[8]

Blake's complaint in the *Descriptive Catalogue* of similar debilitation—"his power of imagination weakened so much, and darkened" (*DC*; E 538)—while possessed by the demons of Titian, Rubens, and Correggio shows how the fear of a reader's influence may take the form of a fear of artistic tradition, to the extent that "audience" is a name for the identities of other artists embodied in a tradition that the audience enforces through its collective taste, the prejudice it brings to the work. Coleridge's poem "The Nightingale" is one common kind of romantic protest against such traditions. The audience, acting as agent for the tradition, is regarded as an obstacle between artists and something they desire a direct relation to—here, nature. The literary tradition of the nightingale gets in the way of the poet's

[6] All quotations from *The Prelude* are from *The Prelude 1799, 1805, 1850*, ed. Jonathan Wordsworth, M. H. Abrams, and Stephen Gill (New York: Norton, 1979).

[7] *The Letters of John Keats 1814-1821*, ed. Hyder Edward Rollins (Cambridge, Mass.: Harvard Univ. Press, 1958), I, 267; II, 65; I, 388; I, 374, respectively.

[8] (Version of 1800), *The Prose Works of William Wordsworth*, ed. W.J.B. Owen and Jane Worthington Smyser (Oxford: Clarendon, 1974), I, 152.

ability to perceive and represent, and the audience's ability to appreciate, the real nightingale in the forest. Part of Wordsworth's argument against poetic diction falls into the same category. To "bring my language near to the language of men," he says, it is necessary to cut himself off "from a large portion of phrases and figures of speech which from father to son have long been regarded as the common inheritance of Poets"[9] and the expectation of their readers. Thus artistic traditions, especially recent Enlightenment ones, are a burdensome inheritance, a potential source of interference instead of continuity, and poets, in order to align themselves with their subject matter, seem forced to liberate themselves from their own audience.

Metaphors of relationship again point to the difference. Wordsworth and Coleridge readily describe "man and nature as *essentially adapted* to each other, and the mind of man as *naturally* the *mirror* of the fairest and most interesting properties of nature."[10] Art is the agent and product of that adaptation, or, in Coleridge's words, "the *union and reconciliation* of that which is nature with that which is exclusively human." Art is the "*translation* of man into nature" (my emphasis). Ultimately the adaptation, the reconciliation, union, and translation are artistic acts of remembering that the human spirit has "the same ground with nature,"[11] that human beings are the intellectual life of nature.

By contrast, when the issue is the relation of the poet to the audience rather than to the subject matter, nature, the same metaphors become negative and are used to suggest cheap compromises with the reader—"adaptation," as Wordsworth says, "more or less skilful, to the changing humours of the majority of those who are most at leisure to regard poetical works when they first solicit their attention." Such poets solicit the attention by adapting their poems to the capricious and depraved tastes of the audience, which pursues the false pleasures of this "vicious poetry"—"as if urged by an appetite" for such features as "the glaring hues of diction by which such Readers are caught and

[9] (Version of 1800), *Prose Works*, ed. Owen and Smyser, I, 131-32.
[10] (Version of 1800), *Prose Works*, ed. Owen and Smyser, I, 140.
[11] "On Poesy or Art," in *Biographia Literaria* (and Coleridge's "Aesthetical Essays"), ed. John Shawcross, rev. ed. (London: Oxford Univ. Press, 1954), II, 254-55, 253, 258.

excited."[12] Even a jaded age can sense Wordsworth's moral outrage in the imagery that makes the poet a pimp, the poem a whore, and the audience a mob, like the men of Sodom at Lot's door. Byron with equal force imagines the audience as a tyrant for whom art is a woman kept in luxury: "Art's mistaken gratitude shall . . . / . . . prostitute her charms to pontiffs proud." For themselves Byron and Wordsworth fear a loss of identity to mobs or tyrants, "who but employ / The man of genius as the meanest brute / . . . / To sell his labours, and his soul to boot."[13] In his subject matter Wordsworth seems to see a woman to marry, marriage with her promising a reintegrated identity for him. The poems he writes are in a sense written to her (radically, "with" her or "in" her), inspired by her; they anticipate union with her, reconciliation, and so on. Wandering through her— through nature—he searches for himself. His audience only threatens this potential union. The audience dwells not in nature but in the "close and overcrowded human haunts / Of cities, where the human heart is sick" (1850 *Prelude* XIII:203-04). Poets who adapt to such an audience are its slaves. Wordsworth describes them in figures of misdirection and alienation:

—Yes, in those wanderings deeply did I feel
How we mislead each other; above all,
How books mislead us, seeking their reward
From judgments of the wealthy Few, who see
By artificial lights; how they debase
The Many for the pleasure of those Few;
Effeminately level down the truth
To certain general notions, for the sake
Of being understood at once, or else
Through want of better knowledge in the heads
That framed them; flattering self-conceit with words,
That, while they most ambitiously set forth
Extrinsic differences, the outward marks
Whereby society has parted man
From man, neglect the universal heart.
 (1850 *Prelude* XIII:206-20)

[12] Essay, Supplementary to the Preface of 1815, *Prose Works*, ed. Owen and Smyser, III, 83-84, 83, 83, 64.
[13] *The Prophecy of Dante* IV:85-90, in the Oxford Standard Authors edition of Byron's *Poetical Works*, ed. Frederick Page, new ed. corrected by John Jump (London: Oxford Univ. Press, 1970), pp. 370-79.

THE AUDIENCE REDEEMED

When Byron's Dante asserts "They made an Exile—not a slave of me" (*The Prophecy of Dante* I:178), he implies that exile and slave were his only choices, as in fact they are when relations between artists and audiences are at the abysmally low level envisioned by Wordsworth in the passage just quoted: an audience consisting of a small but powerful wealthy class in love with itself buys pleasure and the lies it wants to hear from poets. His criticism of artists who flatter the few at the expense of the many cannot, however, be taken as implicit praise of the artists we call popular, defining them by reference to their audience. The artist-audience relationship that comes from widespread popularity—the kind that Byron experienced as culture hero of Europe—is not one that a romantic artist finds easy to treasure. An expressive theory of art has no place for the artist's expression of the public taste. If the few become, in Byron's terms, tyrants, the many become the mob.

To define an audience an expressive theory starts not externally, with the choices offered by opposing social theories, autocratic or democratic, but internally, with a distinction between a real and an artificial public. When Wordsworth, in the last paragraph of his Essay Supplementary to the Preface of 1815, raises questions about the nature of artistic popularity, he intimates that readers may after all be something better than intrusive strangers: "Is it the result of the whole [argument of this essay], that, in the opinion of the Writer, the judgment of the People is not to be respected? The thought is most injurious." He distinguishes "the clamour of that small though loud portion of the community . . . which, under the name of the PUBLIC, passes itself, upon the unthinking, for the PEOPLE" from "that Vox Populi which the Deity inspires," the voice of "the great Spirit of human knowledge."[14] A number of remarks by Blake show that he agrees with Wordsworth's distinction between a real and an artificial public. The aim of the artist cannot be "pleasing Every body," as he blames Reynolds for doing; an "Eye . . . on the Many" is really an eye "on the Money" (AR; E 644-45). But he also rails at the "connoisseurs," the few who would have it their way. In the Preface to the *Descriptive Catalogue* and again in the *Public Address* he distinguishes "the Eng-

[14] *Prose Works*, ed. Owen and Smyser, III, 84.

lish Public" itself from its enemies (*PA*; E 567). These are the "Imposters" who undermine the audience's confidence in the judgment of its own imagination and who claim that "The English Public have no Taste for Painting" (*PA*; E 570) when actually they have no taste for bad painting. The technique of the enemies of true art is commercial and political; it is to "Call that the Public Voice which is their Error" (*PA*; E 567). The object is to obliterate the audience's sense of itself. The audience faces the same danger as the artist: a loss of identity to external forces that reduce the mind to such a weakened state, as Wordsworth says of himself, that it will accept anything imposed on it.

In their conceptions of the proper subject for art, Wordsworth and Blake differ sharply, Blake rejecting nature and aligning it with the cultural status quo, not with the artist. For him the ground of being is not nature but imagination, and the two are opposed. But Wordsworth and Blake agree that the artist's fidelity to the subject almost assures alienation from the audience at large. The basis for their agreement lies, of course, in the expressive theory of art that they share. Appeals to Vox Populi and the English public are themselves vague enough to find a place in almost any theory. But the image of the true romantic audience is sharpened by the logic of the theory behind it. The inversion that makes Blake and Wordsworth more alike than different in their ideas of an audience is the natural tendency of an expressive theory to define the artist-audience relationship from the artist's side. An artist-centered idea of an audience may be, as Abrams says, a simple solipsism, circling endlessly from the artist to the work back to the artist. But there is an alternative logic that accommodates distinctions between true and false audiences. It follows the work of art outward toward the audience by extending the metaphor of expression itself: if the artist expresses the work of art, then the work of art also expresses its audience. To speak of a poem expressing its own audience makes no sense until we remember that the radically expressive poem carries the identity of the poet. Thus we are left with a reversal of the usual notion of an audience that exercises its tastes by selecting the books it likes from the shelves, or, historically, by compiling lists of masterpieces. Finally it makes no less sense to think of artists who select their own audiences than of audiences that select their own artists,

though the first idea is considerably more difficult to fit into a marketplace economy than the second.

No romantic manifesto with which I am acquainted actually uses the metaphor of expression to describe the relationship between the artist and the audience. What we find instead are metaphors of personal relationship. In other words, in an expressive theory the focus is not on the artist as a skillful artisan but on the whole personality, which the skills of the craft serve to express. The natural consequence of personalizing the work of art is personalizing the audience in turn. This pattern seems to be the natural one in expressive theories of whatever period. When Keats claims "I never wrote one single Line of Poetry with the least Shadow of public thought," he does not mean that he has no thought of an audience but that the only legitimate audience is his group of friends: "I wo^d be subdued before my friends, and thank them for subduing me," but "the Public" is "an Enemy, . . . which I cannot address without feelings of Hostility."[15] It is immediately clear that an expressive theory is present when a modern commentator like Lewis Mumford begins to draw sharp distinctions between art and technology in terms of personal feeling: "Art springs spontaneously, even in infancy, from the desire for individuation and self-expression— a desire that needs for its fullest satisfaction the warm-hearted attention and loving cooperation of others."[16]

Alexander Pope does not envision the audience as properly warmhearted or loving. He sees that the public interest in poetic matters is entrusted to the critic, as the public interest in legal matters is entrusted to legislators and judges: "thus long succeeding Critics justly reign'd, / Licence repress'd, and useful Laws ordain'd; / Learning and Rome alike in Empire grew." The ideal is social; the ability to act properly in the public interest requires not love but decency, fairness, and detachment, a freedom from personal prejudice:

> Careless of *Censure*, nor too fond of *Fame*,
> Still pleased to *praise*, yet not afraid to *blame*,
> Averse alike to *Flatter*, or *Offend*,
> Not *free* from *Faults*, nor yet too vain to *mend*.[17]

[15] *Letters*, ed. Rollins, I, 266-67.
[16] *Art and Technics* (New York: Columbia Univ. Press, 1952), p. 33.
[17] *An Essay on Criticism* (1711), in *Pastoral Poetry and An Essay on Criticism*,

Speaking for the painters of the age of Pope, Jonathan Richardson describes an ideal spectator who is hard to distinguish from the judge whom an innocent person in the dock prays to find on the bench. The primary requirement is logical turn of mind: "It is as necessary to a connoisseur as to a philosopher, or divine to be a good logician; the same faculties are employed, and in the same manner, the difference is only in the subject." Judges of painting need no special logic especially suited to the art. The kind of logic they employ can serve as an all-purpose social instrument supporting public policies in the public interest. The appropriately public voice that Richardson uses to describe what "we" desire in "our" connoisseurs of painting would serve equally well to urge a sound foreign policy:

The first thing then to be done, in order to become a good connoisseur one's self, is to avoid prejudices, and false reasoning.

We must consider ourselves as rational beings at large, no matter . . . even of what part of the universe we are inhabitants. . . . Opinions taken up early, and from those we have loved . . . must have no advantage with us upon these accounts. Neither must our own passions, or interest. . . . Nor must any thing be taken for granted; we must examine up to first principles, and go on step by step in all our deductions. . . . And as truth is uniform, and evermore consistent with itself, the mind thus finds itself in perfect serenity.[18]

Richardson spends his rhetoric on the advantages of detachment. Connoisseurs become citizens of the universe, "rational beings at large," by divesting themselves of prejudice, which is conceived as a product of parochialism inflicted by "those we have loved." "Our own passions" are included with self-interest as a form of prejudice, and unsettling passion contrasts unfavorably with the "perfect serenity" that accompanies truth, which is not characteristic but "uniform," always and everywhere the same when freed from the contaminations of personality.

Romantic descriptions of the ideal reader and spectator start

ed. E. Audra and Aubrey Williams, Twickenham Edition of the Poems of Alexander Pope (New Haven: Yale Univ. Press, 1961), vol. I, pp. 316-17, 326, ll. 681-83, 741-44.

[18] Jonathan Richardson, *The Theory of Painting* (1725), in *The Works of Jonathan Richardson*, ed. Horace Walpole (London, 1792), pp. 169, 108-09. Richardson's "connoisseurs" are—in the broad eighteenth-century sense of the term—knowledgeable judges with good taste, of course, not the expert specialists who practice what is called "connoisseurship" in the jargon of modern art history.

closer to home, with attachment rather than detachment. The ideal is not a logical and socially responsible judge but an intimate personal relation tied emotionally to the author. Even "axioms in philosophy are not axioms until they are proved upon our pulses: We read fine—things but never feel them to thee full until we have gone the same steps as the Author,"[19] Keats writes. As for that author, says Wordsworth, the poet is "an upholder and preserver [of human nature], carrying every where with him relationship and love."[20] Shelley identifies imagination with "love; or a going out of our own nature." The good man is the man of intense and comprehensive imagination, who can "put himself in the place of another and of many others."[21] Byron's Dante imagines his audience as a woman and himself as one "who *for* that country would expire, / But did not merit to expire *by* her, / And loves her, loves her even in her ire!" (*The Prophecy of Dante*, 1:70-72). The idea that the poet in any sense loves the audience, or the audience the poet, is alien to fundamental tendencies in Enlightenment classicism.

Thus the powerful association of expression with emotion extends beyond the work to the audience, suggesting a relationship not of entertainer to public, performer to judge, thoughtful person to thoughtful person, or teacher to student, but something closer to the relationship of lover to beloved, a deep, sympathetic communion that requires sexual, religious, or sometimes for Blake, chemical metaphors to describe it. Love is the feeling that governs the relationship, which will necessarily include, however, other feelings and other relationships as well; lovers who love each other profoundly will not fail to entertain, teach, inspire, and even debate each other. Ultimately, in theories as radical as Blake's, metaphors of personal relationship move toward metaphors of identity.

THE AUDIENCE OF JESUS AND OF BLAKE'S "JERUSALEM"

The themes of Blake's illuminated works can be divided into two, which are ultimately one: the battle to reintegrate the dis-

[19] *Letters*, ed. Rollins, I, 279.

[20] Preface to *Lyrical Ballads* (version of 1850), *Prose Works*, ed. Owen and Smyser, I, 141.

[21] *A Defence of Poetry*, in *Shelley's Critical Prose*, ed. Bruce R. McElderry, Jr. (Lincoln: Univ. of Nebraska Press, 1967), pp. 2-3.

integrating identity of the artist and thus reunite the artist with the work under the constant threat of interruption from such externals as the demons of Titian and Rubens; and the battle to reunite the artist and the work with the audience of art.[22]

Blake begins *Jerusalem* with an address "To the Public" that immediately asserts an intimate personal relationship with the reader: "After my three years slumber on the banks of the Ocean, I again display my Giant forms to the Public: My former Giants & Fairies having reciev'd the highest reward possible: the love and friendship of those with whom to be connected, is to be blessed: I cannot doubt that this more consolidated & extended Work, will be as kindly recieved" (*J* pl. 3; E 143).[23] The reader and the artist are friends; they love each other, and their friendship is a blessing to both. But the embrace of beloved friends is intended to be read with the words that bracket the title:

SHEEP GOATS
To the Public

There are some "with whom to be connected, is to be blessed"; there are other connections less beneficial. *Jerusalem* is the agent of a Last Judgment. Blake is thinking of his art as a way of finding the true "Public Voice" of his audience as opposed to "their Error," very much as the Gospels are a way of finding the true form of the Christian community. The Bible as a whole, in fact, offers a model of the artist's relationship to the audience

[22] I discuss the reunion of artist with work in more detail in the *PMLA* essay cited in note 4 and in "What Is the History of Publishing?" *Publishing History*, No. 2 (1977), pp. 57-77.

[23] At some point after etching "To the Public," Blake made a series of relevant but puzzling deletions that involve virtually every reference to his or the audience's love, friendship, etc. Thus, for instance, the italics in the following quotation represent deletions on the copper plate: "the *love* and *friendship* of those with whom to be connected, is to be *blessed*" (E 143). Yet he left intact his "hope" that "the Reader will be with me, wholly One in Jesus our Lord" (E 144). Obviously Blake was not completely satisfied with the relation of artist to audience described in the etched text of "To the Public" and intended to compose substitutions for at least some of the deleted words and passages. But he never did, not even in the only copy of *Jerusalem* that is elaborately colored (copy E). A number of the sentences on plate 3 thus remain nonsensical unless the deleted words are reinstated (as they are in all modern editions). If related to Blake's suppression of the Preface to *Milton* in the two later copies, the excisions in the address "To the Public" may be part of a pattern of evidence suggesting a withdrawal of faith in the audience.

that Blake could modify to the requirements of his expressive theory.[24]

Everyone recognizes the tendency among romantic poets to favor comparisons between themselves and the Old Testament prophets and, for that matter, between themselves and God, insofar as they are creators. It has not been noticed, I think, that prophets are particularly well suited to romantic expressive theories in search of an audience. For Blake, the Bible is "the Great Code of Art" (*Laocoön*; E 271) in that respect even more obviously than in others. He uses prophets as artists as early as *The Marriage* (ca. 1793), where Isaiah and Ezekiel are interviewed by the narrator at dinner (*MHH* pls. 12-13; E 37-38). He quizzes them on their belief in God, on the Jews as a chosen people, and on the shocking behavior of prophets. Isaiah answers that he "saw no God, nor heard any, in a finite organical perception." With his senses he "discover'd the infinite in every thing," a discovery that gave him the authority of "firm perswasion," that is, artistic certainty, which issued in "the voice of honest indignation" that he identifies with "the voice of God." The special status of the Jews as the chosen people of God is merely an error of interpretation by "the vulgar," who, mistaking fanatical art for fanatical militaristic religion, "came to think that all nations would at last be subject to the jews." King David was an artist, "our great poet," whose mission in life was to organize individuals and nations around "the Poetic Genius . . . the first principle." But when he described his mission imaginatively, saying "by this he conquers enemies & governs

[24] Some recent studies have defined Blake's idea of the audience in a biblical context. In Joseph A. Wittreich, Jr.'s *Angel of Apocalypse* (Madison: Univ. of Wisconsin Press, 1975), the discussions of Blake as a prophet, and his works as part of a prophetic strain in English literature, sometimes turn on a conception of the prophetic audience: "The real dialectic of *The Marriage of Heaven and Hell* occurs not in the prophecy itself but in the antagonism Blake establishes between it and its prospective audience" (p. 195). A romantic context can lead to comparable conclusions. For example, in *Blake's Composite Art* (Princeton: Princeton Univ. Press, 1978) W.J.T. Mitchell interprets the illuminated books as episodes in a romantic "epic of consciousness" that makes the reader a participant rather than a judge. Essentially, Mitchell's argument extends Frye's notion of literary anagogy to the audience, so that the "ultimate effect" of Blake's narrative invention "is to draw the reader into it, or what is the same thing, invite the reader to incorporate the pictures into himself" (p. 140). I discuss Mitchell's audience-centered approach to Blake's "antinarrative" in a review in *The Wordsworth Circle*, 10 (1979), 275-78.

kingdoms," the cunning and the foolish took up weapons. As for the bizarre antisocial behavior of prophets, who call attention to themselves by eating dung and lying in odd positions when by all ordinary standards they should be performing useful work to support their families, Ezekiel explains that his actions were the result of "the desire of raising other men into a perception of the infinite."

Blake's satire turns Old Testament prophets into models for the romantic poets by making a few minor adjustments and a single major one. The prophets are ripe for such adjustment in the first place because they are in society without being a part of the status quo. They do not operate by consensus; that is, they do not get their values from the audience that they address. Thus Isaiah says, "I cared not for consequences but wrote." (Neither do they derive their values from nature—a fact more important to Blake than to Wordsworth, who describes himself and Coleridge as "Prophets of Nature" who "will speak / A lasting inspiration" [1850 *Prelude* XIV:446-47].) The source of their values is not nature, the audience, or tradition but God, with whom they profess a direct connection. They do not speak about God, they speak with the voice of God: "And the word of the Lord came unto me, saying, Son of man, prophesy against the shepherds of Israel, prophesy, and say unto them, Thus saith the Lord God unto the shepherds" (Ezekiel 34:1-2). (Or, as Blake says at the beginning of *Jerusalem*, "When this Verse was first dictated to me" [*J* pl. 3; E 144].)

One major change—call God the "imagination"—will turn a prophet into a poet with two results: religious becomes artistic, and external internal. The biblical formula for the relation of poet to audience becomes artist-centered when God, standing behind and above and speaking through the prophet, becomes the poetic genius speaking from within. The Old Testament prophets show poets how to have an audience without being subjugated to it. They also demonstrate the expressive relation of subject matter (God, or the poetic genius) to the work (prophecy). In *The Marriage* Ezekiel, by eating dung and lying on his right and left side, is his work; likewise, the voice of Isaiah is the voice of God. But the Old Testament prophets are not complete; they are fulfilled in the New Testament version of a prophet, Jesus, who is for Blake the ultimate exemplar of the self-expressive artist. While the Old Testament prophets claim

to speak with the voice of God, Jesus claims to be God. While they know that their subject matter is in the human breast, he knows that the audience itself is in the human breast. They show the way to the artist's internalization of the subject matter; Jesus shows the way to the artist's internalization of the audience itself. The most informative example of the uses of Jesus for the artist who wants to express a vision of the audience in its true form is, again, Blake's address "To the Public" at the beginning of *Jerusalem*.

A public with no imagination that it can call its own is a public asleep. In a letter to Lady Beaumont, Wordsworth describes his potential audience as "grave, kindly-natured, worthy persons, who would be pleased if they could. I hope that these Volumes are not without some recommendations, even for Readers of this class, but their imagination has slept; and the voice which is the voice of my Poetry without Imagination cannot be heard."[25] The underlying metaphor is biblical: "Awake thou that sleepest" (Ephesians 5:14) is the cry of the prophets to an audience whose spirits have been hypnotized by the world. In the Preface to *Milton* Blake had called on the "Young Men of the New Age"—who seem to be the younger generation of artists—to "Rouze up" (E 94). But he begins *Jerusalem* with the admission that he himself has spent three years slumbering on the banks of the ocean. His admission is a call for a reciprocal admission from the public. He begins chapter one of *Jerusalem* with the epic announcement of his subject: "Of the Sleep of Ulro! and of the passage through / Eternal Death! and of the awaking to Eternal Life" (J pl. 4:1-2; E 145). Presumably the sleep is both the narrator's and the audience's. Reciprocality is a theme of "To the Public": "The Spirit of Jesus is continual forgiveness of Sin. . . . I am perhaps the most sinful of men! I pretend not to holiness! yet I pretend to love, to see, to converse with daily, as man with man. . . . Therefore Dear Reader, forgive what you do not approve, & love me for this energetic exertion of my talent" (J pl. 3; E 145).

The assumption is that acts of imagination, to be complete, must be mutual. The conditions for them are the same as for any profound human relationship—the forgiveness and love that

[25] *The Letters of William and Dorothy Wordsworth*, ed. Ernest de Selincourt, 2nd ed. rev. Mary Moorman and Alan G. Hill (Oxford: Clarendon, 1970), vol. II, p. 146, letter of 21 May 1807.

assure mutual commitment and engagement—because complete human relationships are also imaginative acts. If mimetic arts, tending toward the condition of performance, envision an audience of spectators and judges, expressive arts, tending toward the condition of personal relations, envision an audience of loving friends. A work of art is one kind of profound human relationship and in essential ways a model for all others. Wordsworth recognizes this as early as the Preface to *Lyrical Ballads*, where he calls for the reader to resist the judgments of others and to "decide by his own feelings genuinely," to "abide independently by his own feelings."[26] Wordsworth is not merely calling for unprejudiced reviewers. He is asking the reader to react to poems as persons, with the emphasis on "feelings." In his extensive analysis of the relationship between poets and their audiences, the Essay Supplementary to the Preface of 1815, he spends considerable effort categorizing bad readers much as a father might categorize bad prospective husbands for his daughter: they may be young with strong but undependable enthusiasms, older but jaded and in search of strong stimulation, religious but cold and doctrinaire, and so on. The basis for an imaginative relationship between poet and reader must be mutual love. Thus he warns of the religious reader whose interest is less in the poet expressed in the poem than in the search for erroneous doctrines, with the result that "love, if it before existed, is converted into dislike; and the heart of the Reader is set against the Author and his book."[27] This is the line of thought leading to Mumford's requirement that the audience give works of art "warm-hearted attention and loving cooperation" and to Blake's request that the audience love him for the energy it took to turn his talent into a work of art.

The ideal reader for both Blake and Wordsworth is someone with a fully developed mind and heart whose powers of intellect and passion are equal to those of the poet. The reader is not a passive receptacle or an impassive judge; the poem is not an instrument of stimulation or an object to be judged by a set of external standards. To judge a poem, the reader must enter into an intimate relationship with it.[28] Thus Wordsworth arrives at

[26] (Version of 1800), *Prose Works*, ed. Owen and Smyser, I, 154.

[27] *Prose Works*, ed. Owen and Smyser, III, 65.

[28] In "The Ideal Reader: A Critical Fiction," *PMLA*, 93 (1978), 463-74, Robert DeMaria, Jr. rightly contrasts the "profoundly judgmental" reader im-

the idea of "a corresponding energy [of imagination]," or "the exertion of a co-operating *power* in the mind of the Reader . . . without this auxiliar impulse elevated or profound passion cannot exist." The poet initiates the action, but the reader must reciprocate: "Passion, it must be observed, is derived from a word which signifies, *suffering*: but the connection which suffering has with effort, with exertion, and *action*, is immediate and inseparable." The number of readers capable of responding in kind to an original poet, however, is very small; profound friendships are rare. "The Poet must reconcile himself for a season to a few and scattered hearers" because original poets are not only strangers, but strangers demanding acceptance on their own terms. "Genius is the introduction of a new element into the intellectual universe," and that introduction represents "a conquest, made by the soul of the poet." Original poets are in a difficult position. Rather than conform to the pre-established artistic taste of their audiences, they must, Wordsworth says, "create taste."[29] They must create their own traditions. They must express their own audiences. When Blake quotes Milton's "Fit . . . tho' few" on the advertisement for his 1809 exhibition, he indicates that, like Wordsworth, he understands the unusual demands of expressive art on the reader.[30]

Blake uses Christian metaphors to carry the logic of expression even further. If artists express their identities in their works—

plicit in Johnson's criticism with Coleridge's ideal reader, who "enters into a kind of collaboration with the poet" (p. 468). DeMaria also points out that while Johnson's reader is part of an "external tribunal" (p. 467), Coleridge's is a reflection of himself.

[29] Essay, Supplementary to the Preface of 1815, *Prose Works*, ed. Owen and Smyser, III, 82.

[30] Modern reviewers provide fine examples of the difficulties that poets face in trying to "create taste" by expressing fit audiences. Jenijoy La Belle, in *The Echoing Wood of Theodore Roethke* (Princeton: Princeton Univ. Press, 1976), argues that Roethke's poems are often about his own problems as a writer trying to establish his own tradition. One reviewer objects that "such an interpretation diminishes the poems by converting them from statements about 'life' and the human condition into allegories of Roethke's personal difficulties in writing poetry" (David H. Hirsch, *Contemporary Literature*, 19 [1978], 246). It is difficult to tell whether Hirsch is criticizing La Belle's book or the romantic tradition. He clearly believes life and the human condition to be something more important and more public than mere "personal difficulties" in writing mere poems. The opinion that autobiography is somehow less than politics and war is often the basis of reactions against romantic poems.

if artistic integrity is an expression of personal integrity—then
the relationships between the work of art and its audience will
be expressions of personal relationships. The closest personal
relationships are the ones named by Blake in the introduction to
Jerusalem, love and friendship. The profoundest form of love
and friendship is identity: as the artist is the work, the artist is
also the audience. We are most familiar with such extreme forms
of love in religious contexts that require the believer's absolute
love, which is said to be returned by a God who is love. In
Jerusalem, therefore, Blake goes to the New Testament for his
appeal to the reader: "I also hope the Reader will be with me,
wholly One in Jesus our Lord" (E 144). Blake's model for the
relationship between artist and audience is Jesus and his follow-
ers: "Henceforth I call you not servants; for the servant knoweth
not what his lord doeth: but I have called you friends; for all
things that I have heard of my Father I have made known unto
you. Ye have not chosen me, but I have chosen you" (John 15:
15-16).

If, as Blake claims, Jesus was an artist (*Laocoön*; E 271), he
was an unusually demanding one. Considering Jesus as an artist
with an audience is a good way of discerning Blake's own artistic
purposes. To begin with, we can eliminate the following three
conceptions: that the audience, no matter how well informed and
discriminating in its tastes, determines the values of the artist
("Ye have not chosen me, but I have chosen you"); that the
artist manipulates the audience with rhetoric; and that the artist
must withdraw to become a solitary singer. In the New Testa-
ment the Pharisees and Sadducees are appointed to represent the
dangers of the first two points of view—with the Essenes per-
haps offstage representing the third—while Jesus speaks for a
new relation between the Word and the receivers of the Word.
"Now ye are clean," he says, "through the word which I have
spoken unto you. Abide in me, and I in you. . . . If ye abide
in me, and my words abide in you, ye shall ask what ye will,
and it shall be done unto you" (John 15:3-4, 7). We can inter-
pret Jesus' remarks by the light of Blake's Preface to *Milton*,
which identifies "those Worlds of Eternity in which we shall
live for ever; in Jesus our Lord" as "our own Imaginations" (*M*
pl. 1; E 94). In the world we may be denied what we want
most; we deny others what they want, and we may even deny
ourselves. But in the imagination is the gratification of all de-

sire: "If ye abide in me, . . . ask what ye will, and it shall be done unto you." The ultimate gratification is imaginative identity. Jesus prays for his disciples, "that they might have my joy fulfilled in themselves," and "that they all may be one; as thou, Father, art in me, and I in thee, that they also may be one in us. . . . I in them, and thou in me, that they may be made perfect in one" (John 17:13, 21-23). The meaning is this, as Jesus would say: the Father is the poetic genius, I am the artist, and you are the audience. The relation between us is love, and persons who love each other are in each other.

Using this metaphor in describing the duty of a spectator of one of his paintings, Blake sounds as if he might be writing vows for mystical marriage: "If the Spectator could Enter into these Images in his Imagination approaching them on the Fiery Chariot of his Contemplative Thought if he could Enter into Noahs Rainbow or into his bosom [as these images appear in the painting] or could make a Friend & Companion of one of these Images of wonder . . . then would he arise from his Grave then would he meet the Lord in the Air & then he would be happy." The obligation to "enter into" is mutual. Thus the rule that "he who enters into & discriminates most minutely . . . the Characters . . . is the alone Wise or Sensible Man & on this discrimination All Art is founded" (*VLJ*; E 550) applies to artists as well as spectators. Artists enter artistic images from one side, spectators from another; presumably there they find one another. Works of art are not performed imitations of nature that teach spectators delightfully but created human environments that provide occasions for artists to meet their audiences—congenially, as Coleridge might say.

The idea that the poet and audience are in each other, are in fact each other, stands behind the startling assertions in Blake's Laocoön: that Christ is an artist, his disciples are artists, and all true Christians are artists (E 271, 272). That is, expressive theories like Blake's tend to carry the logic of their root metaphors toward absolute identification, beginning with the personal identity of the artist, extending it to the identity of the work and finally to the audience of the work. We are most accustomed to find artist identified with audience in the moderate form of assertions such as T. S. Eliot's, that poets are the best readers of poems, a proposal advanced more energetically by Thoreau: "The works of the great poets have never yet been

read . . . for only great poets can read them."[31] More radically, the apostles and disciples were artists because they were Jesus.[32] All true artists, like "the Ancients [who] entrusted their love to their Writing,"[33] by making their works themselves—entrusting themselves to their works—make their works the agents by which artist and audience coalesce in a single identity, a single body of imagination that is the furthermost expression of physiognomic form, to become one in "the Saviours kingdom, the Divine Body" (*J* pl. 3; E 144).

The Society of Imagination

At this point, with paradoxical force to match Jacobean wit, a theory of art capable of producing artists utterly self-enclosed becomes a social theory. In Christian terms, Christ creates a church in his image, because what we have been calling his audience, when it finally takes its true form, becomes a community of believers "in" him rather than a crowd of spectators gathered around the artist at the center. If they grant him what Jesus usually calls faith, or what Blake calls love and friendship, he then creates coherence from the center outward until a community forms in his image or imagination, until finally the distinction between the artist at the center and the audience on the circumference becomes irrelevant. In the New Testament the works of art responsible for the organization of a crowd into some kind of social order are the miracles and the parables. Finally we recognize that the miracles and parables are Christ and that he is the organizing force. The question implicit in his curious actions and difficult parables is usually who am I, and

[31] *The Illustrated Walden*, ed. J. Lyndon Shanley (Princeton: Princeton Univ. Press, 1971), p. 104.

[32] Blake's claim that Jesus and his followers are artists probably depends partly on the old tradition of attributing actual paintings to Luke, patron saint of painters. According to Wornum, ed., *Lectures on Painting by the Royal Academicians: Barry, Opie, and Fuseli* (London: Bohn, 1848), p. 4, Luke was supposed to have painted several pictures of the Virgin and Child.

[33] The transcription of this deleted passage is very uncertain. G. E. Bentley, Jr. transcribes with Erdman and Keynes while confessing lack of confidence in the result; *William Blake's Writings* (Oxford: Clarendon, 1978), I, 419, n. 5. Most recently, Erdman has collaborated with Michael J. Tolley to arrive at a new reading in which "the Ancients *acknowledge* their love to their *Deities*."

the correct answer is usually Christ. Most of his actions are parables and miracles of identity rather than rehearsals of morals and doctrines; the fundamental doctrine of Christianity simply recognizes the identity of Christ. This is an emphasis well suited to an expressive theory of art such as Blake's, in which the fundamental artistic act, drawing a line, establishes the identities of artists, who are known by their lines.

In the New Testament the term for the social order expressed by the identity of Jesus is the body of Christ, as we hear of it from Paul: "So we, being many, are one body in Christ, and every one members one of another" (Romans 12:5). Blake applies this pattern to get the most radical version of artistic expression. Christ is internalized as imagination, the source of personal identity; Christ's words and deeds are the work of imagination; and the church, the body of Christ, is the community created and sustained by such works, "wholly One in Jesus our Lord." As a social theory this formula (as Blake interprets it) has the advantage of starting where many romantic social contracts start, at the individual, in search of a social order capable of embodying the expression of individual desires. In theories that generate a social order from the individual, public is an expression of private, in contrast to a theory like Marxism, in which the true form of the individual is an expression of social need. By defining the individual in terms of imagination, the theory produces a social order of imagination, just as, by defining the individual in terms of economic needs, other theories produce an economic order for "economic man." Under the social contract generated from economic values, individuals are bound one to another by the cash nexus; in the religious and artistic versions the nexus is love or some other strong emotion that conditions all other relationships.

In the societies of "economic man" imagination is a faculty that clever people use to make more money, and art is a commodity to be bought and sold with other commodities. What is called art is a specialized activity that has its place in a structure of economies. When artistic values are subsidiary to economic values, the mythical pattern of social and cultural development is the one that Reynolds outlines at the beginning of the *Discourses*, in his Dedication "To the King" (1778): "The regular progress of cultivated life is from necessaries to accommodations, from accommodations to ornaments." Art is ornament, the superficial decoration of economic essentials, or, in Reyn-

olds' words, "the arts of elegance, those arts by which manufactures are embellished, and science is refined" (ii; W 3). A chair is a manufactured accommodation; a beautiful chair is ornamental. Ornament is something that a privileged class can afford but that a less privileged class can do without. People who try to reverse this order by eating luxuriously when they can afford only to eat plainly end up in the poorhouse. The "regular progress of cultivated life" is a pattern of economic improvement. "Cultivated" thus has strong associations with "rich." In such a culture, the audience for art is simply the group of consumers who decide that they want to "cultivate" their lives by purchasing the services of a class of workers called artists to "embellish" their "manufactures" with "ornaments." In this context a painting is an ornament that embellishes an accommodation—a house or palace—that has evolved from a necessity—a shelter.[34] The dynamic principle of such a system, if we accept Adam Smith's description, is the give and take of supply and demand. In fact, demand, located in the audience that holds the pursestrings, tends to shape supply in the arts of ornamentation.

Since Reynolds' formula describes the societies we live in, we are habituated to it. But unhabituated Blake, on the basis of assumptions he finds in the Bible, comes back hard: "The Bible says That Cultivated Life. Existed First—Uncultivated Life. comes afterwards from Satans Hirelings." Adam and Eve do not begin life as savages on the lookout for their daily bread, and Christ does not come to urge humanity to solve its economic problems before turning to refinements like the life of the spirit. The Bible begins with a vision of a complete life: "Necessaries Accomodations & Ornaments are the whole of Life" (AR; E 626). And it ends with the same: a vision of life restored to wholeness.

"Art is the First in Intellectuals & Ought to be First in Nations." If the life of the spirit is the essence of human life rather than a late and superficial refinement or improvement of life, then the imagination organizes the identity of the individual and

[34] Cf. Fuseli's description of the arts in relation to the necessities of life, in his lecture on the present state of painting: "Nations pay or receive tribute in proportion as their technic sense exerts itself or slumbers. Whatever is commodious, amene, or useful, depends in a great measure on the arts: dress, furniture, and habitation owe to their breath what they can boast of grace, propriety, or shape: they teach elegance to *finish* what *necessity invented*, and make us *enamoured* of our *wants*" (my emphasis, *Lectures on Painting*, ed. Wornum, p. 550).

should organize the community: "The Foundation of Empire is Art & Science Remove them or Degrade them & the Empire is No More—Empire follows Art & Not Vice Versa as Englishmen suppose" (AR; E 625-26).[35] By "Empire" Blake of course means the true form of society, as Shelley does when he claims that "the true poetry of Rome lived in its institutions." Shelley makes similar claims for the social forms of ancient Athens and, for that matter, of Christian Europe: "Whatever of evil their agencies may have contained sprang from the extinction of the poetical principle." The true social order is poetical in the sense that it is a projection of the imagination. Thus art and civil life rise together: "The drama at Athens, or wheresoever else it may have approached to its perfection, ever coexisted with the moral and intellectual greatness of the age." Thus the "kindred expressions of the poetical faculty" include "architecture, painting, music, the dance, sculpture, philosophy, and, we may add, the forms of civil life." Shelley is implicitly contradicting Peacock's proposal in *The Four Ages of Poetry* that poetry declines as real civilization, characterized by useful knowledge, rises. Blake, Shelley, and Wordsworth see the pattern of evolution that Peacock sees but deplore it. Shelley speaks well for them all: "The cultivation of those sciences which have enlarged the limits of the empire of man over the external world, has, for want of the poetical faculty, proportionally circumscribed those of the internal world; and man, having enslaved the elements, remains himself a slave." Shelley's idea that "the creative faculty . . . is the basis of all knowledge"[36] agrees with Wordsworth's that "poetry is the breath and finer spirit of all knowledge," in fact "the first and last of all knowledge."[37]

THE PHASES OF EXPRESSION

In English romanticism, where there is no school and no program, deep commitments to individual identity and artistic

[35] Cf. Fuseli: "To prosper, the art [of painting] must not only feel itself free, it ought to reign. If it be domineered over, if it follow the dictate of fashion, or a patron's whims, then is its dissolution at hand" (*Lectures on Painting*, ed. Wornum, p. 552).

[36] *A Defence of Poetry*, ed. McElderry, pp. 20, 21, 16, 13, 29, 29.

[37] Preface to *Lyrical Ballads* (version of 1850), *Prose Works*, ed. Owen and Smyser, I, 141.

originality do not encourage the search for representative poets or ideas. The center is likely to be no more representative than the extremes. Accounts of romantic ideas are tested for adequacy by their ability to accommodate Wordsworth and Coleridge comfortably without cramping Blake and Shelley. With that in mind, we are now in a position to arrange romantic attitudes toward the audience along a scale of possibility whose poles are self-centered withdrawal, or soliloquy, and imagination-centered fulfillment, or community, and whose midpoint is occupied by a poet of the sort described by Wordsworth as "a man speaking to men."

The romantic artists' picture of themselves as solitary singers or as social outcasts, raging in the wilds, as Blake says in *The Marriage* (pl. 2), derives from the logic of an expressive theory of art at one phase. The logic is natural but incomplete and should not be mistaken for the whole. Perhaps its ultimate extreme appears in *The Prophecy of Dante*, in the picture of an entire class of poets—"perchance the best," Byron says—who have never written at all. Here, romantic internalization by these mute, inglorious Miltons may take the form of complete suppression: "They compress'd / the god within them" (*The Prophecy of Dante* IV:4-5). At the same phase but seen by the opposition, this view becomes the "realistic" one taken by the status quo: Jesus, perhaps, as seen by Roman officials or the young artist as seen by Reynolds. Internalizing this view of himself, Jesus doubts his own mission. In artistic terms, he takes the point of view and the preestablished tastes of the audience and wonders if perhaps they are not correct in thinking him a charlatan, or, in Reynolds' terms, a creature of "singularity, vanity . . . and many other vices."

One phase further Jesus might quote Blake: "I taught them how to see, but now they see me not, nor yet themselves." Artists are doubting the audience but maintaining faith in themselves. They may fear what Byron calls "the harlotry of genius" that will please the public but sacrifice "self-reverence" (*The Prophecy of Dante* III:77, 78). At this phase, when the public attempts to force preestablished principles and techniques upon artists, the artists are likely to fire back antiprinciples in words such as Zola's—"I have the profoundest contempt for the little skills, . . . for anything study can teach"—and to look for consolation in the kind of advice that naturally follows: "You cannot

formulate any rule or offer any precepts; all you can do is to surrender yourself to your own nature and try not to lie."[38] When the choice seems to be isolation with integrity or popularity without it, the question becomes the one that Byron has Dante ask: how is that poets "must pass their days in penury or pain, / Or step to grandeur through the paths of shame" (*The Prophecy of Dante* IV:104-05). At such a phase the center of activity is between the artist and the work. The accompanying esthetic principle will resemble the one that Wasserman has attributed to Shelley: "Denied the purpose of communicating explicit ethical ideals, the poem attains its final cause . . . simply by coming into existence; and the poetic transaction involves only the poet and his poem, not the audience."[39] The principle legitimizes an audience of auditors only, who may be privileged to overhear the poet's song but who are in no position to contribute anything of their own.

Yet another phase and artists are distinguishing the true audience from the false, the public from its error, and hoping for a fit audience while understanding that it will be few: "Prometheus," as Shelley says, "was never intended for more than 5 or 6 persons."[40] Here artists freely acknowledge what Blake calls their "Public Duty" (*PA*; E 571). They realize that their role is not that of self-protective exemplar of integrity (always on guard against "selling out" to the audience), nor that of sacrificial victim. Suspending their hostility toward the public, artists cease to cling to friendly inner circles. They no longer perceive the public as a foreign enemy that threatens domestic peace— "the crowds of Shadows in the Shape of Man and women that inhabit a kingdom" in opposition to "the Soul [of the poet, which] is a world of itself and has enough to do in its own

[38] Quoted in Gombrich, *The Ideas of Progress and Their Impact on Art*, Mary Duke Biddle Lectures (New York: Cooper Union School of Art and Architecture, 1971), p. 79.

[39] Earl R. Wasserman, "Shelley's Last Poetics: A Reconsideration," in *From Sensibility to Romanticism: Essays Presented to Frederick A. Pottle*, ed. Frederick W. Hilles and Harold Bloom (London: Oxford Univ. Press, 1965), p. 504. Wasserman, however, concentrates on the poetics outlined in Shelley's *Defence*. There is a larger picture. See, for example, Stuart Curran's discussion of Shelley's desire and his attempts to find a poetic mode that will allow him to address a mass audience; in *Shelley's Annus Mirabilis: The Maturing of an Epic Vision* (San Marino, Calif.: Huntington Library, 1975).

[40] *The Letters of Percy Bysshe Shelley*, ed. Frederick L. Jones (Oxford: Oxford Univ. Press, 1964), II, 388.

home." They learn instead to recognize in the unknown public the potential bond of identity that Keats recognizes in "those whom I know already and who have grown as it were a part of myself."[41] The result is the attitude that Blake expresses in a letter to his brother: "I know that as far as Designing & Poetry are concern'd I am Envied in many Quarters, but I will cram the dogs, for I know that the Public are my friends & love my works & will embrace them whenever they see them" (30 January 1803, *Letters*, p. 65).

Artists see that they are the agents of a Last Judgment on the audience, in the mode of Blake's statement to Dr. Trusler: "You say that I want somebody to Elucidate my Ideas. But you ought to know that What is Grand is necessarily obscure to Weak men. That which can be made Explicit to the Idiot is not worth my care" (23 August 1799, *Letters*, p. 29). Such assertions sound arrogant and intolerant only when read out of their true context, which is an idea of art that requires equality between artist and audience as the basis of mutual love. An art that assumes a worthy audience of equals is the only authentically democratic art. Its opposites are the arts of flattery and condescension described by Wordsworth and Byron, with the poet "bound to *please*,— / . . . to smooth the verse to suit his sovereign's ease" (*The Prophecy of Dante* III:86,88). This art is the kind that follows empire. It begins not inside the mind but outside, with "Extrinsic differences, the outward marks / Whereby society has parted man / From man," not creating a new order based on imaginative equality but enforcing an old one based on external inequality.

Finally the vision of the artist as assertive judge between sheep and goats recedes in favor of the world of imagination that the vision produces, in biblical terms the Kingdom of God, the Divine Body, the society in which artist and audience become one. Previously artists have had to recognize that their only chance of achieving identity with the community is to die into it: "We can have but one country, and even yet / Thou'rt mine— my bones shall be within thy breast, / My soul within thy language" (*The Prophecy of Dante* II:19-21). But now artists are able to envision a society built on the premises stated by Blake— "Art is the glory of a Nation, . . . Genius and Inspiration are the great Origin and Bond of Society" (*DC*; E 518)—and

[41] *Letters*, ed. Rollins, II, 146.

glimpsed in Wordsworth's visionary claim that "the Poet binds together by passion and knowledge the vast empire of human society, as it is spread over the whole earth, and over all time."[42] The artist moves into the center. The value of the artist's year becomes "the Criterion of Society: and as it is valued, so does Society flourish or decay" (Chaucer prospectus; E 556).

When fully imagined, the idea of artists at the center of a society for whose coherence they are responsible becomes the physiognomic vision of human life offered in *Jerusalem*, plates 98-99, which begins with the artist's imagination, organized by the senses, at the center. The senses are not passive instruments of reception but aggressive arrows of intellect that move ever outward,

> Circumscribing & Circumcising the excrementitious
> Husk & Covering into Vacuum evaporating revealing the lineaments of Man
> Driving outward the Body of Death in an Eternal Death & Resurrection
> Awaking it to Life among the Flowers of Beulah rejoicing in Unity
> In the Four Senses in the Outline the Circumference & Form, for ever
> In Forgiveness of Sins which is Self Annihilation. it is the Covenant of Jehovah (*J* pl. 98:18-23; E 255)

The vision is generated from the imaginative center relentlessly, flowing, driving outward, expanding, "going forward forward irresistible from Eternity to Eternity" (*J* pl. 98:27; E 255) until, in our terms, the individual identity expresses its social form, and the center identifies with—loves—the circumference. The result is not the nightmare of selfishness that the audience has been led to fear, the ever-enlarging romantic ego imposing its tyrannical form on everything in its path, subsuming all differences under its sameness until finally there is only silence. Rather the opposite, as here in *Jerusalem*, where the commercial connotations of "exchange" and "mutual" test the force of images of body-sharing:[43]

[42] Preface to *Lyrical Ballads* (version of 1850), *Prose Works*, ed. Owen and Smyser, I, 141.

[43] Kurt Heinzelman, "William Blake and the Economics of the Imagination," *Modern Language Quarterly*, 39 (1978), 99-120, concerning Blake's ideas about economics, includes some discussion of his conception of the audience.

> In my Exchanges every Land
> Shall walk, & mine in every Land,
> Mutual shall build Jerusalem:
> Both heart in heart & hand in hand.
>
> ("To the Jews," *J* pl. 27:85-88; E 172)

In the exchanges of imagination, the basis for a conversation is mutual identification, as Los tells Enitharmon:

> When in Eternity Man converses with Man they enter
> Into each others Bosom (which are Universes of delight)
> In mutual interchange. . . . (*J* pl. 88:3-5; E 244)

Humanity wholly one in the divine body of Jesus is Blake's version of that favorite romantic ideal of multeity in unity, of a community that in imagination expresses the collective shape of individuality.[44] This is the body of Christ that Paul describes as "one" that "hath many members": "If the whole were hearing, where were the smelling? . . . And if they were all one member, where were the body? But now are they many members, yet but one body? . . . Now ye are the body of Christ, and members in particular" (1 Corinthians 12:12, 17-27). Amalgamated with aspects of visions from Ezekiel and Revelation, Paul's metaphor of a body of Christ in which all Christians may dwell becomes Blake's "One Man" fourfold. Blake's vision illustrates the meaning of what Isaiah in *The Marriage* calls "a firm perswasion." Nothing more complicated underlies the vision than Wordsworth's simple dictum that the "original poet" must "create taste" for original work. Taken seriously—or, as philosophers say, carried far enough—such principles assume their ultimate imaginative shapes in visions of individual, social, and universal coherence such as this one:

> And they conversed together in Visionary forms dramatic which
> bright
> Redounded from their Tongues in thunderous majesty, in Visions
> In new Expanses, creating exemplars of Memory and of Intellect

[44] Thomas R. Frosch discusses Blake's idea of the body, and its romantic and modern contexts, in *The Awakening Albion: The Renovation of the Body in the Poetry of William Blake* (Ithaca: Cornell Univ. Press, 1974). Although Frosch seldom mentions the artist's audience, his final chapter, "The Body of Imagination," considers the question of a renewed community capable of accommodating renewed bodies—that is, the community "beyond the dualism of the community and the individual" (p. 154).

Creating Space, Creating Time according to the wonders Divine
Of Human Imagination, throughout all the Three Regions im-
mense
Of Childhood, Manhood & Old Age[;] & the all tremendous
unfathomable Non Ens
Of Death was seen in regenerations terrific or complacent varying
According to the subject of discourse & every Word & Every
Character
Was Human according to the Expansion or Contraction, the
Translucence or
Opakeness of Nervous fibres such was the variation of Time &
Space
Which vary according as the Organs of Perception vary & they
walked
To & fro in Eternity as One Man reflecting each in each &
clearly seen
And seeing: according to fitness & order.

<div align="right">(J pl. 97:28-40; E 255)</div>

EPILOGUE

In a way Blake's artistic principles are like his poetic narratives, most of which seem to have a single simple action at the center, or at least a simple pattern, which is made as hard to locate as that moment in each day that Satan's Watch-Fiends are always looking for but never finding. It is only a paradox to say that Blake's narratives are so difficult as a direct result of simplification so great that our minds resist it. Fall and redemption organize Blake's narratives. Since the pattern occurs at all levels, it organizes Blake's artistic ideas as well. The creative moment that Satan cannot corrupt is the expressive moment defined in these pages: the moment in which the artist's imagination expresses itself in clear outline; the moment in which readers find themselves in those outlines; the moment that reveals the potential integrity of artist, artistic work, and audience. Seen properly, any one of the three can be seen from the perspective of the others; as, in Coleridge's formula, multeity in unity, unity in multeity.

INDEX

Abrams, M. H., 24n, 32n, 46n, 62n, 80n, 145n, 148n, 171-72, 173, 183
academies and academic art, 13-15, 17, 20-22, 59-60, 92, 96, 113, 144, 145, 156, 157
accident, 88-91
accusation, 116
Adams, Hazard, 61n, 95n
affectation, 136-37
Aliamet, François Germain, 165, 167
alienation, 115, 116, 149, 177-78, 181, 183
allegory, 57-58, 121
"All Pictures thats Panted with Sense & with Thought," quoted, 26, 27-28
All Religions are One, quoted, 35, 65, 65-66, 67, 72, 175
Ancient Britons, 50
Angels Ministering to Christ, 132
Apelles, 35(2), 40, 44, 175
apocalypse, 120-21
apostles as artists, 30, 193-95
appearances, 15-18
Aristotle, 89-90
artist: roles of, 153-55, 188-90, 193-98; in theories of art, 51, 155, 156-58
Artist's Assistant, 101
Artist's Year, *see* creative time and space
Athenaeum, 162
audience: biblical idea of, 188-90; color entices, 11, 16; Enlightenment ideal of, 135, 155, 178, 184-85; expressive theory of, 173, 183-84, 198-204; false, 182-83; fear of, 176-81; internalization of, 188-90; as lover, 186, 191; problem of, 171-76; romantic ideal of, 185-86, 191-92. *See also* consensus; society; tradition
augmentation formula, 138-45, 161
"Auguries of Innocence," quoted, 115
autobiography, 107-23, 148, 158, 192n
autographic component in art, 41-42, 163. *See also* identity

Bage, Robert, 101n
balance as metaphor, 73, 145-46, 155, 157, 161, 163
Barry, James: critics' evaluation of, 123-24, 126, 127, 134, 137; lectures quoted, 14, 52, 141
Bartolozzi, Francesco, 42
Barton, Bernard, 128
Basire, James, 151-52, 165
Bate, W. J., 103, 145n
Baudelaire, Charles, 154
beauty, 36, 61-64, 83
Beddoes, Thomas Lovell, 177(2)
Bee, 48, 50, 51, 59, 60, 127, 140
Bentley, G. E., Jr., 28n, 195n
Berkeley, George, 56; Blake's annotations to, quoted, 56(2), 90
Bible in theories of art, 72, 89, 120-21, 145n, 157, 187-90, 193-98. *See also* Christianity; God; Jesus; religion

Bindman, David, 13n, 19n, 22n, 38n, 95n

biography, 107-23, 148, 158, 192n

Blair, Robert, *The Grave*, Blake's illustrations to, 163-64, 166-69

Blake, William: dating his works, 117-18; development of his art, 38-43; development of his career, 110-23; development of his ideas, 42-43; 1809 exhibition, 76; letters, quoted, 22(2), 33, 46, 58, 87, 88(3), 92, 122, 138, 140, 201(2); viewed by art historians, 122, 153

"Blakes apology for his Catalogue," quoted, 164-65, 165

blood, *see* creative time and space

Bloom, Harold, 24n

body and soul in illuminated printing, 152-53. *See also* human form

Bosse, Abraham, 89

Boswell, James, 123-24

Brooks, Cleanth, 6

Bunyan, John, 38

Burke, Edmund, 95n

Burnet, John, 153

Burney, Charles, 101

business, *see* commerce

Butlin, Martin, 13n, 38n, 42n, 118n, 133-34, 149

Byron, George Gordon, Lord, 177; *Prophecy of Dante*, 172, 181, 182, 186, 199(2), 200, 201(2)

Canterbury Pilgrims, 64, 85, 119; prospectus, quoted, 64, 82, 85, 103, 117(2), 202

Carlyle, Thomas, 108, 172

Carracci family, 141-43, 144

Chandler, Raymond, 148-49, 156

character: Enlightenment degradation of, 86-87, 93; expression associated with, 46, 47, 48-49, 51-52; face as index to, 47, 49, 50, 65-66 (*see also* physiognomic form); feeling ties work to, 54, 56-57; line expresses, 36-38, 60-61, 72, 142-44; intention and, 67; romantic transformations of, 49-51; as standard of significance, 82-83; summary of,

176; universal vs. individual, 52-53; work of art as, 156-58, 160. *See also* identity [self]; Reynolds, Joshua, characteristical style in

characteristical style, *see under* Reynolds, Joshua

Chatterton, Thomas, 175, 177

Chaucer, Geoffrey, 66, 158; *Canterbury Pilgrims*, 64, 85, 119

child in romanticism, 120

Christianity, 30, 32, 111-21, 147; as esthetic theory, 111-12, 187-90, 192-98. *See also* Bible; God; Jesus; religion

Christie, Agatha, 149n

church, 187, 195-96

Cicero, 141n, 161

classicism, 72-73, 92, 160-61; Enlightenment transformations of, 4, 83, 90, 92, 93, 100; and linearism, 9-11, 22. *See also* Enlightenment theory of art

Coleridge, Samuel Taylor, 172, 199; audience in, 180, 192n, 194; *Biographia Literaria*, quoted, 45, 54, 70, 91, 125; "Dejection" ode, 119; feeling in, 70; form and content in, 80-81; nature in, 32-33, 63, 65, 179-80; "Nightingale," 179-80; "On Poesy or Art," quoted, 32, 46, 55-56, 80-81, 180; way of Shakespeare and Milton in, 54-56

color, 11-18, 82, 140, 141, 142, 175

color printing, 23n, 41-42

commerce, 73, 154, 169, 183, 183-84, 196-97, 202-203

conception, *see* form and content

connoisseurs, 182-83, 185

connoisseurship, 133-34, 185n

consensus: as basis of esthetic pedagogy, 92-96; on content and form, 124-27, 134, 135, 137; in decorum, 146-50, 155-56, 159-60, 162, 168; in Enlightenment idea of audience, 178-79, 184-85, 189; originality and, 74-77; as standard of invention, 84, 87; uniformity and, 63, 64(2). *See also* society; tradition

Enlightenment theory of art (*cont.*)
38; form and content in, 83-88,
103; performance in, 155-56, 162-
69; romantic transformations of,
49-51, 55, 62-63, 65, 82, 149,
151, 153, 158, 161-62. *See also*
classicism; consensus; education; de-
corum; imitation (of nature); im-
provement; singularity
Ephesians, Epistle to, 190
epistemology, Blake's, *see* identity;
imagination; internalization
Erdman, David V., 195n
Essick, Robert N., 19n, 23n, 38n,
118n, 151n
ethics, 36-37, 52, 58, 67, 70, 172,
175, 196
evaluation of art, 45, 191-92
Evelyn, John, 51
Everlasting Gospel, quoted, 114
execution, *see* form and content; skills
of execution
Experience, state of, 41n
experiment pictures (*Descriptive Cata-
logue*), 29, 112-18
expression and expressive theory of
art: audience in, 171-73, 183-84;
beauty in, 61-64; Christianity
transformed in, 187-90, 192-98;
connotations of, 47-49; defined, 47,
48, 60-61; education in, 97-98,
110; energy in, 71-72; feeling in,
47, 48, 49n, 50-51, 54, 58-62,
67, 68; form and content in, 80-
81, 83; genius in, 48, 51, 53, 127;
genres in, 156-57; human form in,
47, 48, 65; performance in, 157;
phases of, 173, 198-204; poetry in,
128-29; preromantic use of, 46-49;
and sublimity, 59, 60; romantic
transformations of, 49-51, 55, 62-
63, 65, 174-76, 198-99; as social
theory, 195-98, 201-204; summary
of, 176; synthesis promoted by,
69, 70-71, 157-58, 161; tradition
in, 88, 122-23; work of art in,
156-58, 160; mentioned, 4, 6, 23,
147. *See also* character; identity;
imagination; internalization; phy-

siognomic form; Reynolds, Joshua
(characteristical style in)
externalization, 32-33, 55-56, 73,
116. *See also* consensus; imitation;
systemization
Ezekiel, 188-90
Ezekiel, Book of, 189, 203

Farington, Joseph, 15, 16
fear, 114-15
feeling: artist related to audience by,
184-86, 191-92; expression associ-
ated with, 47, 48, 49n, 50-51, 54,
58-62, 67; as sign of integrity, 67-
70; as standard of evaluation, 45
Fellini, Federico, 97-98
female, 12, 17-18, 36, 59, 94
finishing, high, 64, 117, 127
Flanders and Flemish art, 37, 38, 60,
114, 119n
Flaxman, John, 22, 39, 42, 88, 134
foppery, 136-37
form, *see* physiognomic form
form and content: in critics' evaluation
of Blake's work, 123-38; decorum
embodies, 145-55; in histories of
art, 99-107; integrity of, 79-91,
133, 150-51; in romantic educa-
tion, 114-23; separated in perform-
ance, 162-69. *See also* decorum;
propriety
formlessness, 59-60
Four Zoas, 109; quoted, 115, 116
Fréart, Roland, 51, 52
Friedrich, Caspar David, 134-35
friendship, 184, 186, 187, 191-92,
193, 195, 201
Frosch, Thomas R., 203n
Frye, Northrop, 10, 24, 46, 110,
133, 157, 171, 188n
Fuseli, John Henry: on art and soci-
ety, 197n, 198n; on augmentation,
138n, 142-43, 144; on color and
line, 12-13, 17, 36, 37; critics'
evaluation of, 124, 125, 126; on
expression, 48n, 49n; on Michelan-
gelo and Raphael, 54n; *Nightmare*,
124, 125; on specialization, 163;
Thunder-Storm, 124

Lister, Raymond, 127n, 151n
Locke, John, 14, 88, 89, 92-93,
 95n, 96, 111, 175
love, 184, 186, 187, 190-91, 193,
 194, 195, 196, 201, 202
Lovejoy, Arthur O., 62n
Luke, St., 195n

Macaulay, Thomas Babington, 103-
 104, 105
Macdonald, Dwight, 11
machine of art, 114
Macpherson, James, 175
MacShane, Frank, 149n
male, 36, 59
Malkin, Thomas, 35, 36, 37, 40;
 Blake's comments on, quoted, 9,
 35, 36, 37, 38
Mannings, David, 95n
Marriage of Heaven and Hell, 23-24,
 89, 120, 188-90, 199, 203;
 quoted, 24, 63, 65(2), 71, 72, 73,
 73-74, 107, 108, 152(2), 174,
 188-90 throughout
Marxism, 196
mathematics, 14, 25, 34, 41, 141,
 175
Matthew, Book of, 171
media, combinations of, 70-71, 157
medium in decorum, 151-55, 161
Mellor, Anne K., 66n
melody, 175
memory, 29-30, 37-38, 58, 84-88, 91
metaphors, 4-6, 31, 56; of decorum,
 141, 145-46, 151-55; of line and
 color, 5, 18-19(chart), 20, 40-42;
 relating poet to nature, 180-81; re-
 lating artist to audience, 180-81,
 183-84, 186, 192-98, 202-204
Michelangelo, 13, 49, 54n, 63, 86,
 96-97, 98, 139, 141, 144, 146,
 152, 162
Mill, John Stuart, 173
Milton, John: Macaulay on, 103-104;
 in *Milton*, 114-15; *Paradise Lost*,
 111, 159, 165, 167, 168; quoted,
 171, 192; *Paradise Regained*,
 Blake's illustrations to, 132; the

way of, 54-55; mentioned, 88, 98,
 118, 199
Milton, 114-15, 117-18, 120; Preface
 to, 120, 122, 187n, 190, 193;
 quoted, 34, 79, 112, 115, 122,
 123, 190, 193
minute particulars, 66, 85, 86, 90,
 159-60
miracles, 195-96
Mitchell, W.J.T., 17n, 19n, 38n,
 188n
moderation, 73
moment, *see* creative time and space
Mortimer, John Hamilton, 30
multeity in unity, 203, 205
Mumford, Lewis, 14n, 105, 184,
 191

naturalism, 54
natura naturans, 32-33
nature: artist marries, 179-81; Blake's
 view of, 32-33, 65, 66, 174, 183,
 189; form and content in, 80; line
 not in, 13; in the mind, 34; in ro-
 manticism, 27, 65, 66; as standard
 of beauty, 36. *See also* imitation (of
 nature)
negative capability, 55
neoclassicism, 10, 13, 22, 57-58. *See
 also* classicism; Enlightenment the-
 ory of art
Newton, Isaac, 14, 88, 116, 155
Newton, 42n, 118
niggling, 159-60

objective correlative, 59
objectivity, 11-15, 33-34, 184-85
obscurity, 43, 60
"One Man," 203
"On Homers Poetry," quoted, 133
"On Virgil," quoted, 89
Opie, John, 14, 49, 138-45, 145,
 155, 158, 160, 163
oration, 160-61
order in art, 31-34
organicism, 46, 65, 70, 77, 81, 157
origin, myths of, 73-74, 89
originality, 52, 67-78, 93, 122-23,

PRINCETON ESSAYS ON THE ARTS

Library of Congress Cataloging in Publication Data

Eaves, Morris, 1944-
 William Blake's theory of art.
 (Princeton essays on the arts; 13)
 Includes index.
 1. Blake, William, 1757-1827—Aesthetics.
 2. Aesthetics. 3. Romanticism. 4. Arts. I. Title. II. Series.
 PR4148.A35E2 1982 700'.1 81-47914
 ISBN 0-691-03990-9 AACR2
 ISBN 0-691-00340-8 (pbk.)